Empire of the S
General Editor: Mike Mitchell

Sébastien Roch

Octave Mirbeau

Sébastien Roch

translated by Nicoletta Simborowski
and edited by Margaret Jull Costa

Dedalus

Dedalus would like to thank The Arts Council of England and The Burgess programme of The French Ministry of Foreign Affairs for their assistance in producing this translation.

Published in the UK by Dedalus Ltd, Langford Lodge, St Judith's Lane, Sawtry, Cambs, PE17 5XE

ISBN 1 873982 43 7

Dedalus is distributed in the United States by Subterranean Company, P.O. Box 160, 265 South Fifth Street, Monroe, Oregon 97456

Dedalus is distributed in Australia & New Zealand by Peribo Pty Ltd, 58 Beaumont Road, Mount Kuring-gai, N.S.W. 2080

Dedalus is distributed in Canada by Marginal Distribution, Unit 102, 277 George Street North, Peterborough, Ontario, KJ9 3G9

Dedalus is distributed in Italy by Apeiron Editoria & Distribuzione, Località Pantano, 00060 Sant'Oreste (Roma)

Publishing History
First published in France in 1890
First English translation in 2000

The translation of Sébastien Roch copyright © Nicoletta Simborowski 2000

The right of Nicoletta Simborowski to be identified as the translator of this work has been asserted by her in accordance with the Copyright, Designs and Patents Act, 1988.

Typeset by RefineCatch Limited, Bungay, Suffolk
Printed in Finland by Wsoy

THE TRANSLATOR

Nicoletta Simborowski read Modern Languages at Oxford and then worked in publishing and as a teacher at Westminster School in London.

She has translated several books from French and Italian, including for Dedalus *The Late Mattia Pascal* by Luigi Pirandello and the Octave Mirbeau novels *Abbé Jules* and *Sébastien Roch*.

She combines a career as a lecturer in Italian at Christ Church, Oxford with freelance interpreting and translating for television and video.

THE EDITOR

Margaret Jull Costa is a freelance translator and editor. She is the winner of the Portuguese Translation Prize for *The Book of Disquiet* by Fernando Pessoa and with Javier Marías The International IMPAC Literary Award for *A Heart So White*.

Her translations for Dedalus include novels by Valle-Inclán, Eça de Queiroz and Mario de Sá-Carneiro. She edited and translated with Annella McDermott *The Dedalus Book of Spanish Fantasy*.

The books she has edited for Dedalus include, *Misericordia* by Galdos and the Gaston Leroux novels *The Mystery of the Yellow Room* and *The Perfume of the Lady in Black*.

institut français

French Literature from Dedalus

French Language Literature in translation is an important part of Dedalus's list, with French being the language *par excellence* of literary fantasy.

Séraphita – Balzac £6.99
The Quest of the Absolute – Balzac £6.99
The Experience of the Night – Marcel Béalu £8.99
Episodes of Vathek – Beckford £6.99
The Devil in Love – Jacques Cazotte £5.99
Les Diaboliques – Barbey D'Aurevilly £7.99
The Man in Flames (L'homme encendie) – Serge Filippini £10.99
Spirite (and Coffee Pot) – Théophile Gautier £6.99
Angels of Perversity – Remy de Gourmont £6.99
The Book of Nights – Sylvie Germain £8.99
Night of Amber – Sylvie Germain £8.99
Days of Anger – Sylvie Germain £8.99
The Medusa Child – Sylvie Germain £8.99
The Weeping Woman – Sylvie Germain £6.99
Infinite Possibilities – Sylvie Germain £8.99
Là-Bas – J. K. Huysmans £7.99
En Route – J. K. Huysmans £7.99
The Cathedral – J. K. Huysmans £7.99
The Oblate of St Benedict – J. K. Huysmans £7.99
The Mystery of the Yellow Room – Gaston Leroux £7.99
The Perfume of the Lady in Black – Gaston Leroux £8.99
Monsieur de Phocas – Jean Lorrain £8.99
The Woman and the Puppet (La femme et le pantin) – Pierre Louÿs £6.99

Portrait of an Englishman in his Chateau – Pieyre de Mandiargues £7.99
Abbé Jules – Octave Mirbeau £8.99
Le Calvaire – Octave Mirbeau £7.99
Sébastien Roch – Octave Mirbeau £9.99
Torture Garden – Octave Mirbeau £7.99
Smarra & Trilby – Charles Nodier £6.99
Tales from the Saragossa Manuscript – Jan Potocki £5.99
Monsieur Venus – Rachilde £6.99
The Marquise de Sade – Rachilde £8.99
Enigma – Rezvani £8.99
The Wandering Jew – Eugene Sue £10.99
Micromegas – Voltaire £4.95

Forthcoming titles include:

The Book of Tobias – Sylvie Germain £7.99
L'Eclat du sel – Sylvie Germain £8.99

Anthologies featuring French Literature in translation:

The Dedalus Book of French Horror: the 19c – ed T. Hale £9.99
The Dedalus Book of Decadence – ed Brian Stableford £7.99
The Second Dedalus Book of Decadence – ed Brian Stableford £8.99
The Dedalus Book of Surrealism – ed Michael Richardson £9.99
Myth of the World: Surrealism 2 – ed Michael Richardson £9.99
The Dedalus Book of Medieval Literature – ed Brian Murdoch £9.99
The Dedalus Book of Sexual Ambiguity – ed Emma Wilson £8.99
The Decadent Cookbook – Medlar Lucan & Durian Gray £8.99
The Decadent Gardener – Medlar Lucan & Durian Gray £9.99

OCTAVE MIRBEAU CHRONOLOGY

1848 Born February 16, in Trévières (Calvados)

1859 Sent for schooling by the Jesuits in Vannes

1870 Joined the army

1885 Conversion to anarchism. Stopped writing for the pro-monarchist newspaper *Le Gaulois* and started writing for the radical paper *La France.*

1886 Published *Letters from my Cottage* and *Le Calvaire*

1888 Published *Abbé Jules*

1890 Published *Sébastien Roch*

1894 Dreyfus affair

1898 Published *Torture Garden*

1900 Published *The Diary of a Chambermaid*

1901 Published *Twenty-one days in the Life of a Neurasthenic*

1903 *Business is Business,* Mirbeau's most notable play is performed. Adapted for the English stage in 1905. A bitter satire on an unscrupulous financier who deals ruthlessly with his financial associates and his family.

1917 Died February 16

These pages are respectfully dedicated to Edmond de Goncourt, the venerable and magnificent master of the modern novel.

<div align="right">O.M.</div>

BOOK ONE

CHAPTER I

Around 1862, the school of St Francis Xavier in the picturesque town of Vannes was at the height of its renown, and was, as it still is, run by the Jesuit fathers. Today, the school is just one of several diocesan seminaries, a decline in fortunes that is due to one of those caprices of fashion which affect and shape governments, female royalty, hats and schools, rather than to the recent wave of political persecutions, which, in any case, led only to a brief change of personnel – since restored to their posts. At that time, however, there were few such flourishing schools, either religious or lay. As well as the sons of the noble families of Britanny, Anjou and the Vendée, who formed the basis of its usual clientèle, this famous institution attracted students from every right-minded corner of France. It even attracted students from other Catholic countries, from Spain, Italy, Belgium and Austria, where the impulsiveness of revolutions and the cautiousness of political parties had, in the past, forced Jesuits to seek refuge, and where they have put down the deepest of roots. This popularity derived from the Jesuits' curriculum, reputed to be paternalistic and conventional, and derived, above all, from their educational principles, which offered exceptional privileges and rare pleasures – an education in lofty ideals, both religious and worldly, well-suited to young gentlemen born to cut a dash in the world and to carry on the tradition of proper doctrine and perfect manners.

It was no mere chance that, on their return from Brugelette, the Jesuits had settled in the very heart of Brittany. No other physical or social setting could have been more congenial to their aims of moulding minds and manipulating souls. There, the mores of the Middle Ages are

still very much alive, memories of the Chouan revolt are respected as though they were articles of faith. Of all the areas in Brittany, taciturn Morbihan has remained the most doggedly Breton, in its religious fatalism, its stubborn resistance to change, and the harsh, unspeakably sad poetry of its soil that delivers up to the voracious and omnipotent consolations of the Church men brutalised by poverty, superstition and sickness. These moors, these rocks, this barbaric, suffering land, planted with pale wayside altars and sown with sacred stones, exude a rough mysticism and an obsession with legends and epic history, ideally suited to impressing young, delicate souls and to imbuing them with that spiritual discipline and that taste for the marvellous and the heroic which form the very basis of the Jesuit strategy, by which they hope to impose their all-encompassing power upon the world. The school's prospectuses – masterpieces of typography – adorned with pious drawings, alluring views, sonorous names, prayers in rhyme and certificates of hygiene, were full of praise for the moral superiority of Breton society, while lyrical descriptions of the surrounding countryside and various historic monuments were sure to excite the interest of archaeologists and the curiosity of tourists. Along with these glorious evocations of local history, of Breton battles and martyrs, these prospectuses also pointed out to families that, by a great stroke of good fortune, owing to the proximity of Sainte-Anne-d'Auray, miracles were by no means uncommon at the school – especially around the time of the baccalaureat examinations – that the students went sea-bathing at a special holy beach, and that they dined on lobster once a week.

Faced with such a prospectus and despite his modest means, Monsieur Joseph-Hippolyte-Elphège Roch, the ironmonger in Pervenchères, a little town in the Department of Orne, dared to entertain the proud thought of sending his son Sébastien, who had just turned eleven, to the Jesuits in Vannes. He mentioned it to the parish priest, who gave his hearty approval:

'Goodness, Monsieur Roch, that's a bold idea. . . When a student graduates from a place like that, you know. . . Well!. . . When a student graduates from a place like that. . . Oooph!'

That favourite exclamation of his became a long, whistling exhalation, whilst, at the same time, he opened his arms wide in a sweeping gesture that embraced the whole world.

'Of course, I know, I know,' agreed Monsieur Roch, who echoed the priest's gesture, only on a still grander scale. 'Of course, you don't have to tell me that. But it is *very* expensive. . .too expensive really.'

'Too expensive?' replied the priest. 'Indeed. But, listen. . . All the nobility, all the élite. . .that's quite something, Monsieur Roch! The Jesuits. . .my word. . .I beg you, now, make no mistake about it. . .I myself have met a general and two bishops. . .well, they went there, you see! Not to mention marquesses, my friend, there'll be plenty of them there, plenty! That kind of thing costs money, though, oh yes.'

'Of course, I'm not denying that,' protested Monsieur Roch, impressed. 'And of course you get what you pay for!'

Then he added, puffing up with pride:

'Anyway, why should they offer it cheaper? For, let's be fair, Father, I'm no different. Look at this lamp, for example, it's a fine lamp you'll agree. Well, I'd certainly sell it for more than I would an ugly one . . .'

'Exactly!' went on the priest, patting Monsieur Roch's shoulder affectionately, encouragingly. 'My dear parishioner, you have put your finger on it. Oh yes, the Jesuits! My goodness, that's no small thing.'

They walked along together for some time beneath the lime trees outside the priest's house, engaged in wise, wordy talk, mapping out for Sébastien a splendid future. The sun filtered through the leaves, dappling their clothes and the grass along the avenue. The air was heavy. They proceeded slowly, hands behind their backs, stopping every few steps, red-faced and sweating, their souls filled with grandiose dreams. A little lame dog trotted behind them, its tongue hanging out. . .

Monsieur Roch said again:

'With the Jesuits on your side, you're bound to go a long way.'

To which the priest added his enthusiastic support.

'You certainly are! Because they have fingers in every pie, those fellows! Oh, yes indeed, people have no idea.'

And then, in a confidential tone, his voice trembling with respect and admiration, he murmured:

'You know, people say they tell the Pope what to do. . . . as simple as that!'

Sébastien, who was the subject of all these marvellous plans, was an attractive child, fresh-faced and blond, with a healthy complexion from hours spent in the sun and the fresh air, and very gentle, honest eyes, which, until then, had only ever shone with happiness. He had the spry greenness, the supple grace of young shrubs full of sap that have sprung up in fertile soil; he shared too the untroubled candour of their vegetable lives. At the school he had attended since the age of five, he had learned nothing; he had merely run about, played and developed strong muscles and a healthy constitution. His dashed-off homework, his lessons – quickly learned and even more quickly forgotten – were merely a mechanical, almost physical task, requiring no more mental effort than a sheep would when leaping. They had failed to develop in him any cerebral impulse, any spiritual feelings. He enjoyed rolling in the grass, climbing trees, watching for fish by the river's edge, and all he asked was that nature should be an eternal play-ground for him. His father, absorbed all day in the many details of a successful business, had not had the time to sow the first seeds of intellectual life in that virgin mind. It did not even occur to him, preferring instead, in his moments of leisure, to pontificate to the neighbours who gathered outside his shop. A lofty figure obsessed with matters of transcendental stupidity, he could never have brought himself to take an interest in the naive questions of a mere child. One should add straightaway that had he done so he would have been utterly at a loss, for his ignorance equalled his pretensions, and these knew no bounds. One stormy evening, Sébastien wanted to know what thunder was. 'It means the Good Lord is

14

unhappy,' explained Monsieur Roch, taken aback by this unexpected question. He extricated himself from many other situations which taxed his knowledge by resorting to this unchanging aphorism: 'There are some things a lad your age doesn't need to know.' Sébastien would not persist, for he had little taste for unravelling life's secrets or for making any further pointless incursions into the moral domain. And he would go back to his games, without enquiring any further. At an age when children's minds are already stuffed with sentimental lies, superstitions and depressing poetry, he was lucky enough not to have suffered any of the normal distortions which are part of what people call a family upbringing. As he grew, far from becoming a sickly child, his complexion became still rosier; far from stiffening up, his mobile limbs became more supple, and his eyes retained their depth of expression, like a reflection of wide, open spaces, the same expression that fills the mysterious eyes of animals with a look of infinity. But local people said that for the son of a man who was as spiritual, wise and 'well-to-do' as Monsieur Roch, Sébastien was rather backward, which was most unfortunate. Monsieur Roch did not worry. It did not cross his mind that his child, flesh of his flesh, could belie his birth and fail to achieve the brilliant destiny that awaited him.

'What's my name?' he would sometimes ask Sébastien, fixing him with an aggressive stare.

'Joseph, Hippolyte, Elphège, Roch,' the child would reply, as if reciting a lesson learned by heart.

'Always remember that. Keep my name – the name of the Roch family – always in your thoughts, and all will be well. Say it again.'

And in a gabble, swallowing half the syllables, the young Sébastien would start again:

'J'seph..p'lyte . . . phège . . . Roch.'

'Very good!' the ironmonger would say, taking pleasure in the sound of a name which he considered to be as fine and magical as a charm.

Monsieur Roch lived in the Rue de Paris, in a house easily identifiable by its two storeys and its shopfront, painted dark

green with a broad red border. The window display gleamed with copperware, porcelain lamps and hosepipes with bronze fittings, whose rubber tubing, loosely coiled into garlands, created intriguing and appealing decorative shapes alongside the funeral wreaths, lacy lampshades and red leather, gilt-studded bellows. The house was the only one in the street to have two storeys and a slate roof and it was, thus, a source of great pride to him, as was the shop itself, the only one in the area to display a dazzling crest inscribed upon a black marble background, with gold, relief lettering. His neighbours envied the air of superiority and rare comfort lent to this luxurious accommodation by the roughcast façade in two shades of yellow, and the windows, their frames embellished with mouldings, painted the dazzling white of new plaster. But they were proud of the house on behalf of the town. Monsieur Roch was not in any case just an ordinary individual; he was an honour to the district as much on account of his character as his house. In Pervenchères he enjoyed a privileged position. His reputation as a rich man, his qualities as a fine talker, and the orthodoxy of his opinions raised him above the status of an ordinary tradesman. The bourgeoisie mingled with him with no fear of demeaning themselves; the most important local officials willingly paused at the door of his shop to chat with him on 'an equal footing'; everyone, according to social status, showed either the most cordial friendship towards him or the most respectful consideration.

Monsieur Roch was fat and round, pink and fleshy, with a tiny skull and a square, flat, gleaming forehead. His nose was geometrically vertical, and, without diversions or projections, it continued the rigid line of his forehead between two entirely smooth, unshadowed cheeks. His beard formed a woolly fringe linking his two ears, which were vast, deep, involuted and soft as arum lilies. His eyes, sunk into the fleshy, bulbous capsules of their lids, reflected the regularity of his thoughts, his obedience to the law, his respect for established authority, and a particular kind of tranquil, regal, animal stupidity which sometimes achieved a kind of nobility. This bovine calm, this heavy, ruminant majesty impressed people

greatly, as they felt they recognised in him all the character-
istics of good breeding, dignity and strength. But what really
earned him universal esteem, even more than his physical
characteristics, was his ability, as a dogged reader of news-
papers and legal journals, to explain things by repeating gar-
bled, pompous phrases, which neither he nor anyone else
understood, but which nevertheless left his listeners with a
sense of admiring unease.

His conversation with the priest had excited him a great deal.
All day he was more serious than usual, more preoccupied,
distracted from his work by a host of chaotic thoughts which
wrestled long and hard with each other inside his narrow
skull. In the evening, after dinner, he kept little Sébastien by
his side for a while and observed him on the sly, deep in
thought, without addressing a word to him. The following
day, he merely said confidentially to a few select customers:
 'I think something of significance might be about to hap-
pen here. Be prepared for some important news.' The result
was that people went home intrigued, and indulged in the
most improbable conjectures. The rumour went from house
to house that Monsieur Roch was about to remarry. He was
obliged to clear up this flattering misunderstanding and
inform Pervenchères of his plans. Besides, whilst he liked to
arouse public curiosity by means of ingenious little mysteries
that led to comment and discussion about himself, he was
definitely not a man to keep secret for many days something
from which he could derive direct and immediate admiration.
However, he added:
 'It's still just an idea. Nothing's been settled yet. I'm pon-
dering, weighing everything up, considering.'
 There were two powerful motives behind his extravagant
choice of the school in Vannes: Sébastien's future, in that
he would get a 'smart' education there and could not fail to
be shaped in the right way so that he would achieve great
things; but, mainly, his own vanity, which would be delight-
fully flattered whenever people referred to him as 'the father
of the little chap who's being educated by the Jesuits'. He was

fulfilling a duty, more than a duty, he was making a sacrifice which he intended should weigh heavy on his son whilst giving himself the opportunity to flaunt his superiority in the face of everyone else. It would all greatly increase his standing locally. It was tempting. It also merited serious and lengthy consideration, for Monsieur Roch could never resign himself simply to taking a decision. It was always necessary to go over everything again and again, looking at things from every angle, until, finally, he got lost in an absurd, unlikely tangle of complications which had nothing whatever to do with the matter in hand. Although he knew how much he was worth down to the last centime, he was determined to count up his funds once more, go through his inventory of stock, check all incoming revenue in minute detail. He made calculations, balanced budgets, came up with irrefutable objections, then countered them with equally irrefutable arguments. But it was not the healthy state of his accounts that eventually made his decision for him, it was the words of the parish priest, continually ringing in his ears: 'Not to mention marquesses, my friend, there'll be plenty of them there, plenty!' As he composed the letter to the Rector of the school in Vannes, it seemed to him that he was gaining immediate admission to France's nobility.

However, it was not as easy as he had at first supposed, and his self-respect was put to some harsh tests. The Reverend Fathers, at the height of their popularity and obliged to enlarge their premises every vacation, proved very severe in their choice of students and rather fussy. In theory, they only took as boarders the sons of the nobility and those whose social position might bestow honour on their roll. They asked for more time from everyone else – the small fry, the obscure, hard-up bourgeoisie – after which, more often than not, they would refuse a place, unless, of course, they were offered some little genius, and these boys they generously took on, with an eye to their future prospects. Monsieur Joseph-Hippolyte-Elphège Roch, though passing for rich in Pervenchères, was not at all in the same league as those favoured by fortune, as those whom an accident of birth placed beyond any competition; he may

have been a churchwarden, but he was unquestionably amongst the second rank, and Sébastien showed absolutely no signs of genius. The first year, the Jesuits responded to Monsieur Roch's repeated approaches with polite but specious objections: overcrowding, the pupil's extreme youth and a whole series of questions beginning, 'Has Monsieur considered. . . . ?' It was a cruel disappointment for the vainglorious ironmonger. If the Jesuits refused to take his son, what would people in Pervenchères think of him? His position would surely be diminished. Already he thought he discerned a touch of irony in the eyes of his friends when they enquired: 'So, you're not sending Sébastien away after all?' He put a brave face on it and replied: 'It's still just an idea. Nothing's been settled yet. I'm pondering, weighing everything up, considering. As for the Jesuits, well, I haven't made my mind up yet . . . I fear they may be overrated . . . what do you think?' But his heart was heavy. Poor Sébastien would probably have been reduced to taking intellectual sustenance from the vulgar and leathery dugs of a parish school or a regional lycée, if his father, in a series of memorable letters, had not laid vigorous claim to a glorious family history at the time of the Revolution.

He explained that in 1789, in a desire to please God and as attested by a black marble memorial plaque, the Count of Plessis-Boutoir – whose vast domain encompassed all of Pervenchères and its neighbouring counties – had paid for the restoration of the parish church, a Romanesque structure dating from the 12th century, renowned for the fine, sculpted tympanum above the main door and for the admirable design of its arcature. The Count brought some stonemasons from Paris, amongst whom was a young man, by the name of Jean Roch, originally from Montpellier, and, according to flattering, but sadly unconfirmed theories, a descendant of St Roch who lived and died in that town. This Jean Roch was undoubtedly an artisan of rare talent. He was responsible for the repair of two capitals depicting the Massacre of the Innocents, and of the symbolic beasts adorning the portal. He settled in the area and married, for he was a level-headed man, and founded the present Roch dynasty, creating several

important works of art, including the choir of the Lady Chapel in the local convent of a teaching order of nuns, which connoisseurs consider to be an artistic marvel. In 1793, the revolutionaries, armed with pickaxes and burning torches, attempted to demolish the church, and Jean Roch and a handful of companions defended it. After a heroic struggle, he was captured by the ruffians, beaten till he bled, and then tied to a donkey so that he was facing its rump and holding its tail upright in his hand, like a candle. They then released him and the donkey into the streets, where both were bludgeoned to death with sticks. Monsieur Roch, recalling every detail of the tragic death of this martyred ancestor, whom he compared to Louis XVI, to the Princess of Lamballe and to Marie-Antoinette, begged the Jesuits to take into account 'such forebears and credentials' which for him constituted true nobility. He also explained how, if Jean Roch had not been sacrificed at the height of his talent – not that he would dream of complaining about this – Robert-Hippolyte-Elphège Roch, his son, founder of the hardware store, and Joseph-Hippolyte-Elphège Roch, the undersigned, his grandson, who carried on the business, would not have vegetated in obscure trades, where they had, however, worked hard, by their probity, love of God and fidelity to the old beliefs, to honour the traditions of their venerable father and grandfather. Then there was the story of his own life, recounted with grandiloquent bitterness and comic sadness: his youthful aspirations stifled by a father who, though very devout, it was true, was miserly and narrow-minded; his resignation to a kind of work unworthy of him; the brief joys of his marriage; the sorrows of widowerhood; the terror of his paternal responsibilities; finally the hope – which a refusal would destroy – to revive through his son his own noble, defunct ambitions, his fine long-vanished dreams: for Monsieur Roch had always dreamed of being a civil servant. These tales, these supplications, bristling with parentheses and larded with the most extraordinary phraseology, overcame the Jesuits' initial reluctance and, at last, the following year, they consented to take charge of young Sébastien's education.

The morning that Monsieur Roch received the news was one of the most joyful moments of his life. But for him joy was an austere business. In this serious man, so serious that no one could boast of ever having seen him laugh or smile, joy manifested itself only by a redoubling of his seriousness and a twitching of the mouth which made him look as if he were crying. He went out into the street, his head held high, and stopped at every door, dazzling his neighbours with his sententious accounts and knowledgeable exegeses of the Society of Jesus. Mouths gaped in respectful astonishment. People surrounded him, proud to hear him discourse on St Ignatius of Loyola, of whom he spoke as if he had known him personally. And escorted by numerous friends, he went first to the presbytery, where interminable congratulations were exchanged, then to his sister, Mademoiselle Rosalie Roch. She was a shrewish, spiteful old maid, paralysed in both legs, with whom he argued even more than usual over the happy event he had come to announce to her.

'That's just like you,' she cried, ' you always were too big for your boots. Well, I'll tell you, you'll make your son unhappy with your stupid ideas.'

'Be quiet, you silly old fool! You don't know what you're talking about. First of all, the way you talk, anyone would think you actually knew something about the Jesuits. And where might someone like you have learned that? Ask the priest if you like, he may just know a bit more than you. The priest will tell you that the Jesuits are a great power, he'll tell you that they even tell the Pope what to do . . .'

'But don't you see, poor imbecile, that people put such stupid ideas in your head just to make fun of you? I'd like to know how come you're so rich though? Where did all that money come from?'

'What money?'

And Monsieur Roch drew himself up to his full height and put on his most serious voice.

'I earned that money,' he said very slowly, 'by hard work and in-tel-li-gence, in-tel-li-gence, do you understand?'

When he was back in his shop and had taken off his suit and

slipped on his grey cotton overall, he called Sébastien, to whom, while he was sorting out some brass hooks, he addressed a pompous speech. Monsieur Roch, naturally eloquent and scornful of casual conversation, never expressed himself other than in the form of solemn harangues.

'Listen,' he commanded, 'and remember what I am about to say to you, for we are entering upon a very serious stage in your life, a decisive moment, if you like . . . Listen carefully . . .'

He was even more majestic than usual, against the sombre background of the shop, full of ironware, where the pots stuck out their fat, black bellies and the brass saucepans gleamed, their round, homely brightness creating a transient halo around him. The largeness of his gestures, when not sorting the hooks, made his shirt puff out in the gap between waistcoat and trousers.

'I did not keep you informed of the negotiations undertaken between the Reverend Jesuit Fathers in Vannes and myself,' he began. 'There are some things a lad your age doesn't need to know. These negotiations . . .'

He emphasized this word which, in his eyes, ennobled the whole process and conferred on himself the importance of a diplomat dealing with matters of peace or war, and his voice gurgled slightly as he enunciated the word, savouring every syllable.

'These negotiations, difficult and sometimes painful as they were, have now, happily, reached a satisfactory conclusion. Henceforth, you may consider yourself an alumnus of the college of St Francis Xavier. This school, which I have chosen above all others, is situated in the county town of Morbihan. Do you know where Morbihan is? It is in Brittany, that most excellent of regions! Thanks to me, you are going to be educated alongside the flower of French youth. It may even be, if my information is correct, that you will have the sons of princes as your schoolmates. You will be surrounded only by fine examples of the wealthy and the illustrious of the land, if I dare express myself thus. That, my dear child, is not given to everyone. And that places on you important responsibilities . . . Besides, did you know that a Jesuit, even the least amongst

the Jesuits, is almost a bishop? He does not have the title, I admit, but he does have the power, and, I permit myself to add, the distinction. As for the Jesuits considered as a whole, a brief word will suffice. They even tell the Pope what to do. I am not sure whether I am making myself clear, whether you realise what the Jesuits actually are. You do, don't you? Well, try by your dedication to work, your piety, your behaviour in general, try to deserve the great honour to which you have been called. Above all, do not forget the enormous sacrifices which I am making for your education, and thank the Lord for having such a father such as I, because I'm being bled dry, you know . . .'

And, leaving aside the hooks for a moment, he indicated with four rapid clicks of the fingers imaginary stigmata on his two hands and feet.

'Bled dry, I say.'

After a brief pause during which he savoured the look of horror on his son's face, he continued slowly, in a slightly different tone of voice.

'This very day, I'm going to sort out your clothes with old Madame Cébron. You will need suitable clothing for I do not want to expose you to shame in front of your new friends and I do realise that, bearing my name, the name of the Roch family, and living amongst the élite, in a world which is essentially aristocratic, you need to cut a respectable figure . . . anyway Madame Cébron and I will sort through my old things and see which of them, once altered to fit you, would prove most suitable and stand up best to wear and tear. Concentrate on being relaxed in manner and well-groomed. Elegance accords well with tidiness. In fact, I still have my wedding suit. Ah, your poor mother!'

Overcome by tenderness just long enough to allow this emotional note momentarily to interrupt the unusual length of his speech, he immediately went back to sorting the hooks, trotting out advice and insisting, above all, on his own lofty qualities and paternal virtues. Sébastien was no longer listening. He was not sure what he was experiencing: it felt like grief, a terrible tearing sensation, the pain of which left him

gasping, his hands gripping the edge of the counter. Of course, he was perfectly used to his father's eloquence. It had always seemed to him just another sound of nature, and he had never paid it any more attention than the humming of the wind in the trees or the gurgle of water flowing ceaselessly from the spout in the municipal fountain. Today, it fell upon his body with the crackling roar of an avalanche, the thud of rolling boulders, the violence of a torrent, the boom of thunder, that blinded and deafened him, leaving him with an unbearable feeling that he was slipping into a ravine, tumbling down an endless flight of stairs.

Dizzy with panic, he gazed at Monsieur Roch's stomach, vast and threatening beneath the cotton overall, then at the smaller paunches of the cast iron pots which, ranged along the top shelf near the ceiling, seemed to be turning on their trivets and giving vent to furious rumblings. The red glow of the copper saucepans, where reflections cavorted and danced, took on the unlikely appearance of angry stars. When he had exhausted his supply of both words and hooks, Monsieur Roch concluded thus:

'That is why, my child, right up until the day of your departure, it will be necessary to break off all relations with your friends here. I am not claiming that one should be proud with small children, but there are limits to everything. And society imposes on its members certain hierarchies which it is dangerous to transgress. Those mischievous lads, for the most part sons of poor and simple workers – I am not blaming them, note, merely observing – are no longer on the same level as you. Between them and you from now on there is an abyss. Do you understand the significance of what I am saying? An abyss, I tell you.'

In order to illustrate that abyss, he measured out the width of the counter separating him from Sébastien and said again, raising his voice:

'An abyss, do you understand me, Sébastien, an unbridgeable abyss! And damn it, where would a country be without the aristocracy?'

Monsieur Roch climbed up on a stool, pulled out, one after

the other, several numbered boxes filled with padlocks, and whilst he compared them with each other and tested their rusty locks, he gave a melancholy sigh:

'Ah, I envy you! You're still very young and you know nothing. But I envy you all the same. Where might I have got to if I had had a father like yours? Now you're part of that aristocracy, you can do anything, anything! And look at me! A future ruined! Ruined . . .'

At that point, the door of the shop opened and a customer came in.

'I'll be with you this instant!' cried Monsieur Roch, immediately climbing down both from his stool and from the idealistic heights where his imagination trailed vague, boundless dreams of glory for ever lost.

Despite these lofty sermons and brilliant promises, Sébastien felt neither proud nor happy. He was stunned. From his father's words, from the morass of incoherent, discordant phrases, he retained only one definite fact, that he would have to leave his home town and set out for an unknown destination which neither the Jesuits nor the ancient frock coats in which old Madame Cébron was going to rig him out could succeed in making attractive or even comprehensible. On the contrary, his natural suspicion, proper to a small wild animal, peopled this place with a thousand dangers, a thousand confusing duties too onerous for him. Up until now, he had grown freely in the sunshine, the rain, the wind and the snow, fully and physically active, without thinking about anything, without imagining anywhere other than his home town, any house other than his own, any air other than the air he breathed. He had never got used to the idea of boarding school, or, rather, he had never seriously thought about it. The only relationship he had established between primary school and boarding school was this: that primary school was for small children and boarding school for big children, much bigger children than himself, and he had not considered that one day he might grow up. When his father had spoken of it, it had seemed so distant to him, so vague, that his mind, responsive only to what was immediate and present, did not

dwell upon it; now, however, faced with the imminent threat, the implacable date, he trembled. He looked with dread upon this separation from himself and from everything he was used to as if it were a catastrophe. Neither could he understand why he was being asked to sacrifice the friendships he had had since his earliest childhood in favour of some sudden, mysterious necessity, and why he should do so at that precise moment, already painful enough, when he felt an even greater need of protection and of closer contact with those things that were most familiar and most dear. All this made him very sad and very vulnerable. With a heavy heart, he retreated into the room at the back of the shop, which served as their dining room, and at which, when not at school, he would sit to learn his lessons and prepare his homework.

It was a dark room where the sun never entered. It froze before his eyes as if he were entering it for the first time. He paused on the threshold, startled by the objects in the room and the furniture, amongst which he had lived all his life, but which, disconcertingly, he no longer recognised, for they had grown suddenly ugly, sullen and hostile. In the centre of the room was a table covered with an oilcloth, upon which were printed, in a circle and in chronological order, the 'likenesses' of all the kings of France, with their family trees, the dates of their accession to the throne and of their death. 'One can learn even whilst eating,' Monsieur Roch was wont to say, and, with his mouth full, in the cold silence of mealtimes, he would often recite the resounding names of Clotaire, Clovis and Pharamond, immediately followed by a gesture punctuating them with exclamation marks. There were a few straw-seated chairs and a walnut dresser, piled with chipped crockery, which stood facing an old wardrobe. Now everything reflected back at him the debased, ridiculous image of his father; now everything was reduced to grotesque, demeaning little scenes. Hanging on the green-papered walls mottled with damp was an arrangement of daguerrotype photographs of Monsieur Joseph-Hippolyte-Elphège Roch in various poses, each more oratorical and august than the last. In his mind's eye, Sébastien could see his father pausing

26

complacently in front of each one, comparing them, striking up the same poses and sighing with a shrug of the shoulders: 'They say I look like Louis Philippe. Of course, he had rather more luck than I did.' He could see his father lighting – as he did every evening with the same methodical, obsessive care – the tarnished zinc lamp that a customer had returned as faulty, an episode about which Monsieur Roch still felt an unforgiving bitterness and which, ten years on, he would still recount, in the same indignant tone, insisting: 'Fancy daring to call it trash, as if a Roch could possibly sell trash! Trash! Me!' And he cited in support of his argument the solid mechanism of the lamp, the pretty metal chains, the efficacy of the smoke extractor and the opinions of his friends. On the mantelpiece, between two blue vases won at the fair, there stood a photograph of the mother whom Sébastien had never known. She was a frail young woman, posing somewhat stiffly, her face almost faded away, her temples adorned with long, looped tresses of hair, and, in her hand, a lace handkerchief held affectedly in the tips of her fingers. He could hear his father saying as he did every day: 'I really ought to put your poor mother back up in my room and put a clock in her place.' All this he relived in a single moment, his heart dull with sorrow, disillusion and disgust, and all overlaid by the gloomy clarity of day coming in from outside, tinged by the grubby light shining through the glass bricks that chequered this dark cubbyhole. Sébastien looked out of the window, as if to catch a glimpse of sky. The sole, curtainless window looked out onto a narrow courtyard, and his gaze collided with the walls of the neighbouring houses, filthy, festering, covered in greenish mould, crazed with oozing fissures, pierced by the occasional squalid window offering a view of neighbouring yards piled high with rubbish and seething refuse. Pipes continuously disgorged stinking water; black mouths spewed forth a viscous sludge, flowing towards a common gutter, between piles of old metal and debris of all kinds. This repellent spectacle lit by the dingy, wretched light, this intimate view of familiar things, stripped of the veil of habit and revealed in their depressing, naked state, quickly changed his mood. Without his being

aware of it, his father's incoherent speech about the Jesuits and the princes' sons had awakened in him a dream of something beyond, stirred something latent in his imagination which crept to the fore now when he was faced with the horror of reality revealed. At the very thought that he might have stayed here all his life, amid these glutinous shadows, staring at these hideous walls which hid the glory of the sky from him, a feeling of retrospective melancholy overtook him. Forgetting his previous tranquil insouciance, he convinced himself that he had been miserably unhappy and that what he was feeling at that moment he had always felt. Whilst he stagnated in that wretched life, others had been allotted joy, beauty and magnificence. He now knew – his father had told him so with such certainty and wonder – that he had only to stretch out his hand to grasp such marvels for himself. The idea of boarding school no longer frightened him. He was surprised to discover in himself an actual desire for that unknown world which, though still troubling, also drew him on, like the shadowy approach of some unspecified liberation.

Sébastien sat at the table, his back to the window and opened a schoolbook which he did not even attempt to read. His chin resting on his hand, his eyes grave, distant and dreamy, he mused at length on other skies, new friends, new teachers. Gradually, the objects in the room, the yard, the walls, all faded into the background, just as the things around us fade in the drowsiness of half-sleep, and the child saw himself transported into a land of light, a sort of enchanted palace, through airy vaults and colonnades where kind, charming beings glided towards him in a rustle of silks, whilst, incongruously, the vast bulk of his father moved about behind the blurred glass of the door separating the dining room from the shop.

The days passed, full of various anxieties. Sébastien stayed at home and only went out accompanied by Monsieur Roch, who kept a careful watch lest any of his son's friends managed to come near: 'The Jesuits wouldn't like it. Get away with you!' he would shout at them when, surprised at not seeing Sébastien out and about, they came to find him at the shop.

The apprentice, a lad of fifteen, was ordered not to speak familiarly to the boss' son any more and to show him greater respect. 'From now on, you call him Monsieur Sébastien. Things have changed,' explained the ironmonger. Even on his own account he had judged it necessary and dignified to treat his neighbours with a new loftiness, to keep them at a distance, without, however, depriving them of the daily gift of his conversation. On the contrary, his eloquence grew by the day and became more and more extravagant. He cranked out the same old advice, preposterous aphorisms, magisterial judgements that merely threw the child into deep confusion. Exhausted with hearing him repeat at every moment: 'I'm not sure if I'm making myself clear. Do you understand the full significance of what I am saying?', their walks, visits and more frequent one-to-one conversations became a torment to Sébastien. Eventually, merely to escape it all, he started to long for the day of his departure. But alone in his little room in the evening, surrounded by familiar things of no consequence but to which he attached naive and precious memories, he would once again be gripped by terror of the school, and he would have liked the brutal hour never to come when he would have to say goodbye to all that had become an integral part of himself, half his flesh and half his soul. Thinking hurt him even more than the painful choices facing him. Since thinking had been introduced into his brain, he had become consumed with anxiety. By injecting the seed of a new life into him, this brusque violation of his intellectual virginity had also injected him with the germ of human suffering. His peaceful lack of awareness had been destroyed, his senses had lost the simplicity of their perceptions. The least word, object or fact, which before had had no moral significance or consequence, now, like a series of brutal slashes, opened up in his mind infinite and fearful horizons. All kinds of questions, pregnant with mystery, presented themselves before him, and he was too feeble to grasp them. Beyond the limits imposed by the physical reality of his childhood, he could see the rudiments of shifting ideas, the embryonic contours of life in the outside world, a whole unexplained, discordant machinery made up

of laws, duties, hierarchies, relativities, each interlocking with the next, set in motion by a multitude of gears in which his frail personality would inevitably become caught and mangled. This caused him violent headaches and, sensitive child that he was, nearly drove him to a nervous breakdown.

The house adjoining the hardware shop also belonged to Monsieur Roch. The post office was based there. The postmistress, Madame Lecautel, was the widow of an alcoholic general who, it was said, had died insane, and she was considered an educated, superior sort of woman. She was tall and thin and had a sad face, as if constantly suffering beneath the perpetual black of her widow's weeds. However, compared to the local women, she seemed unusually distinguished, and she aroused the kind of respectful, gossipy sympathies that people accord to those who once led a brilliant existence and have now fallen into misfortune. She had a daughter, Marguerite, who was the same age as Sébastien. The two children had formed quite a warm friendship. Monsieur Roch, proud of this relationship with his son, encouraged him to visit her. On his son's account, he outdid himself, showering Madame Lecautel with tiresome favours and treating her with obsessive politeness, gallantly referring to her as 'my beautiful lodger'. None of this, however, made him any the readier to do the repairs she asked of him. For her part, sensing the state of moral abandon in which the boy found himself, reserved and silent as he was, Madame Lecautel had taken a motherly interest in him. It was agreed that every Thursday and Sunday he should spend a few hours at her house. Often, when the weather was fine, and her post office was closed, she would take him out for walks with her daughter.

In his current crisis, Sébastien felt a real sense of release in the company of his friend Marguerite. Some tender, protective instinct, engendered by the warmth of a gentler atmosphere, drew him strongly towards her. It was not that he became more talkative or confiding. He was too shy for that. Besides, given the tumult of confused emotions and undefined distress seething within him, he would not have known what to say or,

indeed, what he needed to express. But the mere sight of Marguerite calmed him. Near her, his heart found peace, his aching head was soothed. Little by little, he rediscovered the pleasure of not thinking about anything any more. She was charming and full of inventively tender gestures. She had large, dark eyes that were almost too bright, too shining, and always circled by dark shadows, but they illumined her pretty face with the precocious but profound light of love. Her ways were not those of a little girl either, even though her language had remained childlike and contrasted with the knowing, almost perverse grace she emanated, the grace of sexuality that had burst too soon into ardent, unhealthy flower. Ever since she had learned that he would have to go away, she had become more attentive to him, more audacious in her gestures and caresses. She talked and talked, uttering sweet nothings that would fill her young friend with pleasure. Then, she would look at him with those big, possessive eyes, which awoke in the depths of Sébastien's soul an obscure but powerful emotion, so powerful that it rose up within him, leaping and bounding, as restless as an imprisoned life demanding to emerge from the shadows. Sometimes it made his chest heave and his throat go dry. Her shoulders thrust back, her body swaying beneath her black, pleated, flounced smock, she would walk towards him with the movements of a pretty animal, smoothing her ill-kempt hair with her long, thin hands already veined with blue, and re-tie the knot in his tie. Her little fingers ran over his skin, light and supple, burning him like wings of flame, touching him with a thousand tiny caresses, leaving him almost faint with fear and joy. He felt intoxicated with her in fact. So intimate, so magnetic was the bond between her life and his that very often, if she bumped against the edge of a piece of furniture or pricked her fingers on a needle, he immediately felt the same physical pain.

'Will there be little girls in the school you're going to?' she would ask.

'Oh, no.'

'I would love to go with you and be with you always.'

And her eyes grew larger and more brilliant:

31

'So, there are lots of little boys, just boys . . . like you – as nice as you?'

'Oh, yes.'

'What fun that must be. I would love school.'

Suddenly she would run to her mother, her face contorted, in tears:

'Mama! Mama! I want to go with him! I do. . . .'

These all too brief hours spent in the company of this strange child bestowed a warmth on Sébastien which he took back home with him, but which evaporated as soon as he found himself once more with his father or alone in the chilly room at the back of the shop.

He also suffered agonies of apprehension regarding that wild place, Brittany, that mysterious land of legend, about which Monsieur Roch, in order to prepare him, made him read gloomy, terrible stories. The harsh landscape, the tragic sea, the old haunted castles, the wicked fairies hovering above dark pools, the shipwrecked sailors shaking their matted locks like Caliban on the howling shores, all the fantasy and melodrama combined in his mind with his father's lectures, conveying a dazzling, superhuman image of the Jesuits and their school. He would never get used to living in such a place, in daily contact with beings so removed from himself, of whom the most humble had the 'unbearable radiance of a bishop'. Embroidering on Monsieur Roch's hyperbolic comparisons, he pictured the Jesuits in an ecclesiastical blaze, wearing bejewelled vestments, haloed with incense, revered as Popes, unapproachable as gods. Ceaselessly torn between undefined fear and fleeting hope and deprived of his friends – the only pleasure that might have helped him through the difficult days of waiting – irritated by Madame Cébron's daily fittings and worn down by his father's hectoring, he was unimaginably unhappy. Apart from Thursdays and Sundays, he did not know what to do with the long days. There were no more games of hopscotch in the main square, no more rambles through the fields along the hedgerows full of birdsong and flowers, or by the river, where he used to follow shrimpers with their nets and, arms bare, his trousers rolled up to the

knees, go deep into the water to turn over the stones beneath which the shrimps slept. What heartbreak for him, in the depths of that backroom or in his bedroom, to hear the familiar shouts of his friends, setting off on the prowl, seeming to call out to him.

Sometimes, he took refuge in the gardens, just outside the town, near the cemetery. But even there he was unable to savour a single instant of peace. The absence of flowers or of shady trees, the dull flowerbeds, the absurdly artificial decorative features which, thanks to the ironmonger's horticultural fantasies, were everywhere, reminded him inevitably of the heavy-handed invective, the laboured figures of speech, the prolixity and incoherence of his father's rhetoric, which he had hoped to escape and instead encountered again increased tenfold amidst the silence. The cypresses, their grey summits peeping over the walls, the crosses on the graves, some hung with wreaths, only added a sharp sense of unease to his domestic obsession. Having paced the avenues a couple of times, between the boxwood borders adorned with ironwork snail-shells, painted with bright colours and alternating with diamond shapes containing the intertwined initials J.R., he returned home feeling only more miserable and more perplexed, a prey to painful doubt.

Every day, after dinner, he also went to visit his Aunt Rosalie, a further torture to which his father condemned him. Stretched out near the window in a kind of bathchair, with some knitting in her hands, the old maid spent her sedentary life speaking ill of other people and tormenting her maid whom she kept bound in her service with promises of an inheritance. Her plump, soft, pallid face, like that of an old procuress, her chin and lips darkened by a few greying hairs, her ribald, malicious gaze, the cynicism behind everything she said, all embarrassed Sébastien, who, though still extremely innocent, could not help blushing at words he did not understand, but in which he nevertheless divined reprehensible meanings and shameful intent. Often, he found her surrounded by friends, old maids like herself; like her, they were both coarse and sanctimonious, obsessed with the obscene,

33

and, in the guise of morality or injured virtue, they would invent local adulteries, imagine saucy stories, discuss the love lives of their cats, all the while themselves exuding the faint odour of soiled underwear and stale beds.

'Jesuits!' Aunt Rosalie would bellow, at the sight of her nephew. 'I ask you, does this lad really need the Jesuits? Ah, if it had been up to me, I'd have signed you up for an apprenticeship, my boy! The Jesuits! It's unbelievable. All this fuss merely to play the grand gentleman, to prove he's rich. It's just too . . . And I've warned him about showing off about his money, that father of yours . . . It's easy enough to get rich when you sell for twenty sous something that only cost you two. Come here, you, nearer!'

Sébastien would approach timidly, his elbows tight against his body, terrified of the two white bows that fastened the old woman's frilled bonnet and stuck up on top of her head like devil's horns.

'Ha! Isn't he a lovely little man?'

She gripped his arms, twirled him like a top and fixed her sharp, spiteful little eyes on him:

'Isn't he a handsome little man? Just look at him, will you? What will the Jesuits do with that? Do you really think they will keep you with your oafish look and built the way you are? Certainly not. The moment they see you, they'll start laughing and they'll send you back here. Shall I tell you something? Shall I? Answer, you ninny, speak! Do you want me to tell you something?'

'Yes, aunt.'

'Yes, aunt!' continued old aunt Rosalie in a mocking, sing-song voice. 'Yes, aunt. Is this child stupid or something? Well now, your father, the dear thing, is an idiot, a great idiot. You understand? And you can tell him so from me. You can tell him: "Aunt Rosalie said you're an idiot." My God, a fool like that sends his son to the Jesuits and yet he's so stupid he doesn't even know how to clean a lamp properly. And he gets up to all kinds of filth with his maid at night.'

She shrugged her shoulders scornfully and laughed a nasty laugh, while the eyes of the old maids glinted ambiguously.

On his return home, ever more discouraged, the child would wonder if in fact he was not indeed too short, too ugly, too misshapen to be accepted by these terrible Jesuits, whom the old woman's mockery invested with an even more troubling, more inexorable severity. He wondered if he really would not have been happier as an apprentice. For a full minute he wanted precisely that, then he did not. He did not understand anything any more, everything now seemed equally unpleasant to him. All he knew was that, in the persistent struggle between two opposing wills, in the incessant antagonism of resolutions taken and renounced, he had lost his peace of mind and his happiness. Pursued by his aunt's words, dully troubled by the demoralising revelations that life brought him, more numerous with every day that passed, despite his revulsion at the old woman's calumnies and his remorse for even listening to them, he felt his respect and affection for his father diminishing. In the hope of reinforcing the feelings of tenderness which his father now so thoroughly undermined, he got into the habit of watching him, in an effort to understand him. But he lost his footing in the void of the man's mind, crashed against the barrier erected by that selfish heart, which rose like a wall separating their two natures. More by intuition than by reason, he discovered that no exchange of similar emotions, no intimacy based on mutual love was possible between them, so estranged were they from one another. Everything about his father's actions and words disillusioned and wounded him. During meals, often interrupted by the shop bell clanging and the coming and going of customers, he noticed the way his father ate, greedily and messily, the noise he made drinking, a host of tiny details, which he was not yet capable of analysing properly, but which revealed his lax habits and inconsistencies of behaviour, so out of keeping with the rigid pomp of his principles; all this provoked in Sébastien an irritation which he found hard to conceal. He suffered genuine physical pain seeing the degrading manner in which his father treated the boy apprentice: the special dark, coarse bread allotted to him, the stringy, fatty scraps of food which Monsieur Roch threw to him as if to a dog and

which the apprentice devoured in silence, ogling the fine slabs of meat and chunks of white bread his masters ate. He did not know what his aunt Rosalie meant by the 'filth' that his father supposedly got up to, but mulling obsessively over these words had led him to suspect him of blameworthy and dishonourable acts. Often, in the night, he would get up and press his ear to the thin partition dividing his room from Monsieur Roch's and stay there for hours, listening, relieved to hear only a dull snoring, calm and regular, the nasal, guttural breathing of a man plunged into the profound sleep of a navvy. Nevertheless, the prestige of paternal authority, which, in the person who submits to it, is accompanied by a need for protection and instinctual confidence, was gradually fading, destroyed bit by bit by this watchfulness and also by a thousand little intimate, debasing habits, whose ludicrousness and vulgarity no longer escaped him, afflicting him as if they had been his own. Hour by hour, the most precious parts of his own self perished; other feelings crowded into his heart, creating a new anguish, a bitterness and an unfamiliar sense of pity.

As for Monsieur Joseph-Hippolyte-Elphège Roch, he experienced none of this inner strife and he awaited future developments with blessed calm. He was happy; he ensconced himself in his own eloquence, rejoiced in the apotheosis of his own genius, convinced that, by his will, an unheard-of feat, an historic feat was about to be accomplished. On Sundays, after vespers, dressed entirely in black, he would entertain his neighbours outside his shop, astonishing them with his matchless tales. With calm, dignified authority, rhythmically swaying his torso this way and that, he would utter lengthy perorations, full of colossal lies that only earned him ever-increasing respect.

At last, the fateful day arrived.

The day before, Monsieur Roch, who had been officially warned a few days earlier of the arrival of a Jesuit Father specially assigned to pick up the pupils, had sat up far into the night, consulting the railway timetable. He checked and rechecked the times of the arrival of the train at the main stations, counted the number of kilometres between the

different towns, studied the prices of the seats in the various classes, lost himself in the maze of branch lines and connections, which were, in any case, absolutely irrelevant to his son's itinerary. One fact astonished him: the line stopped at Rennes. This unknown area between Rennes and Vannes, this striking out of an entire celebrated region, in an enumeration of indifferent, unfamiliar towns, troubled him greatly. He could not accept that the railway companies had not extended their line as far as Vannes for the sake of the Jesuits.

'For after all,' he explained to Sébastien, 'a school of that quality creates quite a bit of traffic. Apart from the question of what is proper, there is also, if you catch my drift, a wasted opportunity to make money. I will complain. In the meantime, you will be leaving tomorrow, from Pervenchères, on the 10.35 train. Yes, my boy, tomorrow night at 10.35, you will set out on life's path. Do not forget what I have told you. Always remember that you have a father who is being bled dry . . . in fact, tomorrow evening, at the station, I have to buy you a first-class ticket. It seems, and I understand it to some extent, that the Jesuits never travel any other way, which does not, however, alter the fact that it costs a great deal, a great deal. I, your father, have never travelled first class.'

The following day, after a restless night, Monsieur Roch got up very early. He put on the jacket he reserved for special occasions, and, memorably, put on his top hat, an ancient hat carefully preserved in the bottom of a wardrobe, whose silk, clumsily brushed and repeatedly rubbed, now shone with a dull, yellowish gleam. Thus attired, he led his son to the church, so that he could attend mass; a mass said for him and solemnly announced the Sunday before from the pulpit by the parish priest. Monsieur Roch took communion. The service over and his prayers said, he guided Sébastien through the naves, the side chapels and the choirstalls. His steps rang out augustly on the paving slabs, and his gestures had the priestly amplitude of the saints blessing the crowds from the depths of their stone niches.

'Look,' he said, 'look at all this. It was Jean Roch, your illustrious ancestor who restored this church. I have told you

about it several times. These columns, this ceiling, everything you see, is his work. Feast your eyes on this noble sight. I tell you that, in moments of weakness, you will only have to recall this to feel consoled and fortified. That is how I, your father, gained all my strength. Look! Jean Roch was a great martyr, my child. Try to follow in his footsteps. Look! They don't build like that nowadays.'

Sébastien was not at all moved. He felt no pride at all. Indeed, he felt quite the opposite. Accustomed as he was to peculiar harangues, he listened to this one with astonishment and suffered to find it so ludicrous. Despite himself, he heard his aunt's words resounding in his ears like an echo of his own thoughts: 'Your father is an idiot, do you understand, an idiot.' He felt sorry for him. He would have liked to close his mouth for him, gently, as if his father were a child. Out in the square in front of the church, shaded by the shifting foliage of a double row of acacias, Monsieur Roch stopped, more serious than ever:

'That is where he fell,' he said, indicating the ground with a dramatic flourish. 'He spilled his blood there, the blood of the Roch family. Fix these places firmly in your memory, so that you can recount to your friends the glorious history of our family. Doubtless they too had relatives killed in the revolution. Together, I tell you, you will remember your dead. Ah, how I envy you.'

The day went by in dull visits, interspersed with interminable advice. Aunt Rosalie gave her nephew a five-franc piece, adding in a gruff voice:

'Here, take this. You can buy some common sense with it.'

At the priest's house, the goodbyes were most touching. Sébastien was given a brand new scapular and some medals freshly blessed by the Pope. Madame Lecautel proved very affectionate. Marguerite, very pale, had an attack of nerves and cried. The evening finally came. It was an October evening, pleasant and mild.

'Right then,' said Monsieur Roch, testing for the last time the strength of the ropes binding the trunk. 'It's time.'

Dressed up in his fine clothes, gloved in silk, Sébastien set

out towards the station, accompanied by his father. Behind them came the apprentice, pushing the trunk in a wheelbarrow. Despite the late hour, several people appeared in their doorways to say a final goodbye to the child.

'Bon voyage, Monsieur Sébastien. Look after yourself.'

Contrary to his normal habit, Monsieur Roch walked along in silence, responding to these popular demonstrations with only brief gestures. He had lost some of his self-assurance and dignity and was moved. He was worried too about what manner he should adopt before the Reverend Jesuit Father into whose care he was about to consign his son. He pondered over grandiose ideas, prepared droning sentences, interrupted by brusque moments of tenderness when his orator's verve floundered and failed. As they crossed the bridge, Sébastien could see the river all white in the moonlight; behind a clump of willows, the mill stream sang. His heart was drowning in sorrow.

They went into the station with half an hour to spare. The ticket bought, the luggage registered, they reached the waiting room, sat down next to one another on a bench and, without speaking, inhibited and awkward, stared at the yellowing notices, the illuminated advertisements garishly decorating the walls. Monsieur Roch held Sébastien's hand in a trembling grip and squeezed it frequently. Sébastien, who had dreaded a flow of words, a tumult of final pieces of advice, was grateful to his father for this silence, this trembling, which were simultaneously very painful and very sweet. His regret at leaving grew.

'I have put four bars of chocolate in your trunk,' said Monsieur Roch, with a visible effort. 'Make them last. Have we forgotten anything? Your compass? Oh yes, I packed it myself. And your marbles? Yes, I put the marbles in too, I remember. It was Madame Cébron actually; they're in a silk cloth bag, look after them, they're made of agate. Well, anyway, I've done what I can.'

After a silence, he sighed.

'It's unbelievable. I would never have thought it would come so quickly . . .'

39

Sébastien, shuddering beneath the weight of an enormous sorrow, pressed up closer to his father. He was terribly sorry for having been unjust towards him. His spirits sank, his heart melted in remorse and recognition. He wished he could beg his father's pardon, tell Aunt Rosalie that she was a nasty woman and that he hated her. All of a sudden, he thought of Marguerite who must be asleep by now; in his mind's eye, he saw Madame Lecautel, very tall, very thin, stamping letters in her office and sealing leather bags. The bus from the Hotel Chaumier jolted clumsily to a halt outside. There were conversations, oaths, the sound of parcels being unloaded. The horses snorted and shook their harnesses.

'You will be in Rennes tomorrow morning at 5.59,' went on Monsieur Roch. 'There, you will be met by carriages that will take you all on to Vannes. Thirty leagues! It is really quite far. Be good. Above all, do not lean out of the windows. Do what the Reverend Father tells you.'

He consulted his watch.

'Only ten minutes to go. Goodness, how time flies. I put some honey cake in your trunk too, in between the woollen socks. Make it last. Don't share it with everyone. There may come a moment when you will be glad of it yourself. Anyway. Well, now, this Jesuit Father . . . I wonder.'

He gave a long sigh and said little more, apart from asking occasionally:

'What about your ticket? Have you got your ticket? It's a first-class ticket, so don't lose it.'

Or else:

'Above all, don't lean out of the windows. It only takes a moment for an accident to happen. There's one every day in the paper.'

Sébastien was crying. He could sense how much clumsy, keenly felt affection there was concealed behind these banal, disconnected phrases, whose very ridiculousness was now precious to him. He had never seen his father like this. If he had dared, he would have flung himself into his arms and begged him to forget about the train, the Jesuit priest, Brittany and the sons of princes; he would have suggested that both

40

should turn round and go back to the shop where they could be very happy loving one another. He too would stand in shirtsleeves, with a cotton overall on, and would look after the customers, count the money, weigh out the nails. What a joy it would be to see the river again, the upside-down reflection of the poplars, the flowing tresses of the reeds. And to see his friends again! His Thursday walks with Marguerite! The fields and the flowers, the hop-scotch games in the main square . . . The minutes flew by painfully.

Whilst his thoughts were drifting like this, two farmwork-ers came into the waiting room and recognised Monsieur Roch; they were wearing long blue smocks, their cloaks under their arms, their ugly, vinous faces half-hidden by the caps they wore with a strap under the chin. They approached them. After the usual greetings, they pointed to Sébastien.

'So, this'll be the son and heir, then,' said one.

'Oh yes, this is my son . . . Monsieur Sébastien Roch.'

'Good, good. So, we're off on a little trip, are we?'

The ironmonger drew himself up to his full height, and in a dignified but peremptory tone, emphasising every word, he said:

'I am accompanying my son, who is about to set off for college . . . for the college of St Francis Xavier, the Jesuit school in Vannes.'

'Well now, that's good, very good.'

And, backs bent, limbs leaden, they slowly withdrew to the other side of the room.

Monsieur Roch was indignant that his declaration had not been greeted by these rustics with a little more surprise and admiration. Was it, then, such a natural thing, something quite normal, that his son should be travelling first class to a Jesuit school? Was it something that happened every day to every-one? He thought of going over to them and explaining to them who exactly the Jesuits were; he even reproached him-self for not giving his son's departure greater solemnity, for not having invited the priest, the notary, the doctor and all the other distinguished people of the town to join them.

But his annoyance soon dissipated. He contented himself with murmuring very quietly with a disdainful shrug of the shoulders:

'Peasants!'

Sébastien was still crying, and his father consoled him, saying:

'Come along now, don't cry. You can see those people are peasants. They don't know anything, people like that. You shouldn't take any notice of what they say.'

Suddenly, a station employee came and opened the door.

'Train's on its way, Monsieur Roch. Hurry up now. Over to the other side.'

They heard the clear tone of an electric bell ringing out a single, uninterrupted note, and a dull rumbling, like the sound of a storm approaching. Both crossed the track, holding hands, fearful, stumbling slightly. The dark, terrifying machine, with its red eyes, advancing through the night, whistled, swayed, then stopped, gasping wildly, its flanks shuddering. Stunned, they stood motionless and stared stupidly at the mass of carriages.

Opposite them, a carriage door was flung open and a priest leaped nimbly onto the platform. Unhesitatingly and with a gracious gesture, he greeted Monsieur Roch.

'This dear child must be our precious Sébastien,' he said. 'Good evening, my young friend.'

He lightly stroked Sébastien's hair, then stretched out his hand to the father, smiling:

'What a delightful child, Monsieur Roch. We shall surround him with love.'

Beneath his biretta, which the momentum of his leap had displaced so that it sat slightly at an angle over one ear, he had a young, very sweet face, laughing eyes and an attractive air of benevolence and humorous good nature.

Monsieur Roch would have liked to say something. He was prevented by the excitement of being in the presence of a Jesuit, by his astonishment at having been recognised by this Jesuit who did not even know him. He could not find a word, a single phrase. All his eloquence was dissipated in

embarrassed bowing, frantic gesturing, comic scraping, faced with this simplicity, this youth, this grace, which he had not foreseen and which disconcerted him more than the solemn, priestly, imposing image he had revelled in. He could not believe that this Jesuit had leaped from the train like a boy, when he had imagined vague images of processions and mysterious pomp. He could not believe either that a Jesuit could be dressed in black, just like a parish priest, without the least embellishment to indicate the power of the Order. All this paralysed him. However, he made an effort and stuttered:

'Reverend Father . . . I am a father . . . a father . . . a father who . . . Well, I certainly didn't expect . . . what an honour . . . And of course it's so difficult to see in the station in the dark . . .'

He froze. The words died in his throat. The train was about to set off again. Awkwardly, he kissed his son, who was still crying, sought some definitive phrase, and finding none, mumbled, his mind confused, his mouth twisted into a grimace:

'I am happy . . . very happy to have met you . . . And his poor mother would have been . . . very . . . happy . . . to . . . to . . . make your acquaintance.'

He had barely noticed that Sébastien had climbed into the carriage with the Jesuit, when the train started off again and disappeared, leaving the track empty. Head bare, hat in hand, Monsieur Roch remained on the same spot for some while on the now deserted platform. He was still waving, still repeating:

'Very happy . . . very happy . . .'

The station master had to intervene before he could make up his mind to go. Nothing remained of the pain, the suffering, nothing of that sincere emotion which shortly before had made of him a humane and sensitive creature; now he merely felt irritation at not having found the right words for a unique occasion. Unhappy with this misfortune and a little ashamed of himself, he reached home. Already he thought no more of his son, whose image was overlaid by that of the Jesuit. He kept saying to himself:

'These Jesuits! What power! He recognised me, he did. It's unbelievable. They recognise people they've never even seen before. What an organisation!'

At home, Monsieur Roch had no sense at all of a void left behind, of the absence of something precious – habit, affection, a small innocent, restless life mingling every day with his own – no sense that something would be missing from then on. When he walked past the half-open door of the room where his son had lived side by side with him, he did not pause to gaze sadly in, and he felt no tug at his heart. He went to bed and fell, as usual, into a deep sleep, a sleep punctuated by dull snores.

CHAPTER II

The young priest's encouraging welcome and affectionate words did nothing to restore calm to Sébastien. Stumbling over hostile legs and tripping over footwarmers, he managed to install himself in a corner, the eighth passenger to get into the carriage. He sat very stiffly, his palms pressed flat on his knees, not daring to stretch out on the seats, make any movement or raise his eyes, still wet with tears, to look around him. Ill at ease in the luxury of a first-class compartment, realising that he was being observed and stared at, he felt horribly embarrassed, and this embarrassment became a sharp pain that eclipsed the other pain, the pain of separation. However, after a few minutes, he made so bold as to cast a cautious, sideways glance at the priest, who was sitting opposite, to the right, his chin lifted, his head aslant against the seat back. He looked very thin, with a long, bird-like neck, prominent cheekbones, a narrow, unsmiling mouth, and eyes that had grown severe again, with no hint of tenderness. But the sleeve of an overcoat, hanging and swinging as it protruded from the netting of the luggage rack, cast a dark, brief, agile shadow that flickered across his face, distorting his features, which were now drowned in ink, now ablaze in a harsh, almost supernatural light. Sébastien amused himself by following the play of this shadow which came and went like the wing beats of a bat. All of a sudden, he had to abandon this distraction, which was also helping him to put on a brave face, because, to his terror, the priest asked him a banal question, intended to put him at his ease. A blush suffused his face, as if he had been caught out doing something wrong. In order to reply, he had to make a violent effort of will and summon up all his courage.

Soon, noisy conversations filled the silence that had greeted his arrival. The Jesuit took part in them, his tone playful,

friendly and familiar. However, beneath this free and easy manner, he was clearly respectful of the social rank and the money which these young students represented. As they were all older boys, he had known them for some time and showed an interest in their enthusiastic accounts of their holidays. There was talk of horse-riding, hunting, trips away, plays put on at the chateau, coachmen, nannies, dogs, ponies, guns, bishops – an evocation of happy, cherished, elegant lives, in such marked contrast to Sebastien's own monotonous and vulgar existence, that it only increased his embarrassment, and added to that feeling a bitter, barely conscious tinge of jealousy. There was also news of the school, given by the Reverend Father: improvements to the grounds, the chapel, restored in honour of the magnificent reredos donated by the saintly Marchioness of Kergarec . . . the pond extended for skating . . . the theatre rebuilt in what had previously been the junior real tennis courts . . . a major reform by the Prefect of Studies: the permanent display in the parlour of a tablet showing in engraved gold letters the names of all the pupils accepted at Saint-Cyr. Finally, the acquisition of a yacht, the *St Francis Xavier*, for sea trips on days out, a white yacht, bearing on its prow the image of the saint, supported by two angels with gilded wings.

'Great! Wonderful!' said one of the pupils.

To which the Father added:

'It's still a secret . . . but there is going to be a wonderful celebration for the blessing of the *Saint Francis Xavier*, with a sung mass, a procession, a banquet and a raffle . . . Father Gargan is going to recite a fine piece of poetry:

> O *Saint Francis Xavier*, you will sail at last
> With Father Malherbe at the helm as guide,
> And your foaming prow and your conquering mast
> Will cleave the azure waves with ardour and pride . . .

And all jigged about joyfully and sang in chorus, with the Jesuit beating time:

'There was a little boat
Which never never had . . .'

This gaiety, so out of keeping with Sébastien's state of mind, was mortifying to him. It repelled him to think that songs could emerge from lips that were still warm from a last parental kiss. He forced himself not to listen. The train rattled along at top speed. From his corner, where he sat motionless, the child looked out at the night countryside through the half-raised window of the carriage door: the swift passage of shadows, then, above, a fleeting glimpse of sky studded with gold which seemed to reflect the landscape, like snapshots of elusive memories. For a long while, he concentrated dreamily on contemplating that sky, concealed occasionally by the thick smoke from the engine, one moment gilded by the glare of the lamp, the next melting into the night, turn and turn about. The night was beguiling; at ground level, gentle shifting patches of white floated in the darkness; glints of silvery plush flickered over the banks of shadow; the fields were like sleeping lakes, drowned forests, gardens in which flowers turn to vapour; hills rose up clad in vast, jumbled towns, bristling with turrets, belltowers, spires; barbaric towns, magical towns, fading to the very borders of space and to the edges of dream, in the ceaseless metamorphoses worked by the mists.

Gradually, calm was restored to the carriage, tired faces relaxed into slumber, and the priest announced that it was time to go to sleep; he recited a brief prayer and lowered the shade on the lamp. Everyone wrapped themselves up in the rugs, seeking a comfortable position, usually to the detriment of his neighbour. Sebastien was emboldened by the surrounding silence, more especially by the half-darkness that bathed the carriage in mystery, so that faces appeared to be no more than shivers of light set against patches of intense shadow. Glad to be free now of the ironic curiosity of so many alien stares, he ventured to make himself comfortable on the cushions, to stretch his numb limbs, and, propping his head against the padded edge of the armrest, he wrapped the tails of his coat around his knees and closed his eyes. Now, deliciously rocked

by the orchestral roll of the carriage, which filled his ears with music, with strains of unknown songs, with the rhythms of forgotten dances, he felt a great sweetness descend upon him, almost a sense of joie de vivre, of pleasure at being carried off somewhere. His embarrassment, fear and pain all vanished, just as the billowing steam had vanished, interposing itself between the sky and him. He listened too with confidence to the clear, pretty, light, metallic tinkling of a rosary as, for a whole hour, the beads slipped through the priest's fingers. As each turn of the wheels put an ever greater distance between him and everything he so missed, he saw again, without anguish now, but with a resigned, beneficent melancholy, as if in affectionate reverie, the little main street in Pervenchères, the good people in their doorways, greeting him as he left, the station and the yellowing notices, his father holding him tenderly by the hand and the Jesuit smiling and saying: 'What a delightful child, sir! We will surround him with love.' With this consoling vision of a multitude of teachers all devoted to ways of loving him, he fell into a deep sleep.

He did not wake until Rennes, where they left the train. The cold dawn tinged the glass vault of the station with pale pink. An immense arch at one end opened onto a gloomy sky, smudged with dirty, yellow fog; submerged in the fog was a landscape of black roofs, sooty walls, smoking machinery and blurred silhouettes. Amid the sounds, the whistles, the rumbling of engines on turntables, in the tarnished clarity of the gas lamps, there stirred a throng of shadows, a jostling mass of indistinct bodies and pale faces. Terrified, Sébastien kept close behind the priest.

In Rennes, other groups of pupils were waiting, having arrived from different directions. There was an indescribable commotion, a tumultuous muddle of hand-shaking, hugs, impatient confidences, which the supervisors had difficulty in quelling. After a summary meal, served promptly in the station buffet, they crammed into five large horse-drawn cabs, all squashed together, elbowing and kicking so as to secure a better position. Sébastien was still not thinking clearly, his eyes puffy with sleep. Although he was very hungry, he had not

dared to eat any of the food provided. Since no one had specifically invited him to, he feared he might not be entitled to it. In the carriage, he let people stamp on his feet, push him from one seat to another, stunned, confused, but trying, in his disarray, not to lose sight of the Jesuit's soutane, as a lost traveller gazes at a guiding light glimpsed in the darkness. With great difficulty, he managed to install himself between two other boys. The cab set off.

'Are you new?' asked the boy to his right, a handsome adolescent, wrapped in an ample overcoat with a fur collar.

'Yes,' he replied, trembling, but glad that someone should bother with him. 'I'm from Pervenchères.'

'Ah, you're from Pervenchères are you? Really now? And what are you called, Monsieur de Pervenchères?'

'I'm called Sébastien Roch.'

'That's amazing you know, to be called that. And what about your dog? You've forgotten your dog. Where's your dog? I was just thinking I'd seen you somewhere before, St Roch, old chap. It was above the door of our garden, in a niche . . . except you were made of stone and you had your dog with you. What do you say?'

He thumped him hard and elbowed him.

'What do you say, then? There's no call to sit on my overcoat.'

As the others started laughing, Sébastien, very red and confused, bent his head.

'Now then, Chateauvieux,' said the priest in an indulgent almost conspiratorial tone. 'Leave the child alone.'

Chateauvieux turned his head away with a look of cheerful disdain. He stroked his fur collar, carefully pulled on his gloves and began telling stories about hunting.

The journey was long and exhausting. Beneath a grey sky, like a taut canopy of grey cloth, a motionless sky, bereft of even a single, wayfaring cloud, a low, undulating landscape passed by, harsh and dry; there was field upon rutted field, enclosed within stone walls, broken at intervals by stunted apple trees dangling their mops of mossy hair. Occasionally there were hunched, blackened hovels, bathed in mud and

49

ordure, their foundations sunk into the slurry from the stables; here and there the buckled roofs and crumbling chimneys of delapidated houses peeped out from amongst the hills. Then there were squalid villages where a bestial, servile species of humanity swarmed, ashen-faced, clothed in miserable rags and walking with a slow, painful gait. There were woods of squat oaks, then woods of stunted firs, that made the dreary day still drearier, weeping beneath their sombre branches. Beyond, Sébastien could see the bare moorlands consumed by weeds, wretched fever-lands, as far as the eye could see, where nothing living seemed to grow or bloom, where even the grass seemed to emerge from the earth already withered and dead. Skeletal cows and spectral brown horses, with hairy muzzles like goats, wandered grimly past pale, glassy pools of water, grazing on the illusory shoots of reeds. Black sheep, lame, half-starved, strained against their tethers and walked in ceaseless circles. Here and there, like petrified animals, like strange carcasses, stood blocks of granite, evoking previous lives, vanished races, the unfinished, fabulous forms of a prehistoric age. The view was sometimes relieved by little green valleys of lush grass, where, beneath leafy boughs, brooks flowed swiftly and joyously along; but these oases soon passed, soon forgotten, soon lost in the vast sterility. Then death breathed again in the dense air, carrying on it heavy, marshy emanations, whirling cosmic dust and the invisible maggots of eternal decay. At crossroads, at junctions, misshapen crucifixes reared up, stelae loomed and giant stones crouched, guarding the memory of the murderous gods who had once reigned there.

Everyone got out of the carriage at the bottom of the hills. Some crowded round the priests, who now behaved in an even more brotherly and playful way; others leaped over the ditches and threw pebbles, gripped by the need to move. Some linked arms and sang hymns. No one spoke a word to Sébastien, who noted, not without some bitterness, that the young priest who was going to 'surround him with love' did not pay him the slightest attention. Crushed by the desolation and harshness of the countryside, whose wild and savage beauty he did not yet comprehend, prey once more to fears about the school which

was soon to appear out of the depths of the mists, he walked alone along the side of the road, wretched, more alone in the company of his schoolfellows than a beast wandering the infinite silence of the moor. 'We will surround him with love,' he kept repeating to himself, in the hope of stifling the involuntary and persistent sense of betrayal which overwhelmed him and which made the inhospitable nature of his surroundings, the indifference of his teachers and the mocking, haughty scorn of his companions seem even crueller. The phrase kept coming back to him and seemed to contain an element of hypocritical mockery, of treacherous irony, and he said to himself, 'No, they will never love me . . . how could they, when they love so many others already, boys they know better than me, boys with horses, furs, fine guns, whilst I have nothing?' He suddenly felt like running away; as they rounded a corner, he slowed his pace. He would wait until the cabs and the band of pupils had disappeared and then he would start to run. But a thought paralysed him. Where could he go? Before him and behind him, everywhere, there was only grim solitude; it was deserted. Not a house, no shelter in this nightmarish space, amidst this spectral, earthly nakedness. On the horizon, where purplish mists now encroached, there was not a single belltower to be seen; above his head was an implacable sky, a sky now leaden, heavy and opaque, across which crows flew ceaselessly back and forth in starving flocks. A small figure, his long frock coat forming ridiculous folds in the small of his back, its ludicrous tails flapping comically about his legs, he rejoined the carriages, following the others, hoping that they might never arrive.

At Malestroit, near an old bridge, they stopped to change horses and to dine; it was a gloomy meal, in a grimy inn, beneath smoke-stained beams, amid the sickening odours of sour cider and rancid fat. No one spoke, worn out by the journey, and Sébastien ate nothing at all, relegated to one end of the great table, served by women in embroidered bodices and winged headdresses like nuns. Physical exhaustion and a kind of moral prostration replaced his overwrought, nervous state, and he was now quite calm but profoundly tired. His

head was empty, his will paralysed. He no longer thought about the past or the present; he felt nothing, neither the pain in his legs, nor his aching back, nor the leaden weight in the pit of his stomach. Dazed, his hands concealed beneath the table, he stared straight ahead, without seeing or hearing anything or understanding why he was there and what he was doing.

Four hours later, he found himself in a little iron bed, sealed off by wooden partitions and a white curtain. The partitions reached half-way to the ceiling, leaving above them a gap where pools of trembling lamplight glimmered. Next to the bed was a narrow table, bearing a washbasin and a pitcher; against the partition, within reach, stood a stoup for holy water, with a crucifix above it; opposite, against the other partition his clothes hung on a hook, like the skins of a flayed beast.

He could not remember exactly what had happened after Malestroit. He had only a sensation of truncated, fleeting, somewhat alarming events, of passing from the bright dazzle of lights to a void of pitch-black shadows. He recalled having journeyed for a long while amid sounds of tinkling harnesses and rattling windowpanes, travelling in a carriage where very pale, sleepy faces jolted about in the dull gleam of a lantern. He thought he could still feel this motion in his body, the jolts, the buffeting. The tinkle of the harnesses still rang in his ears, but the sound was farther off now; the panes still rattled, but more dully now. He saw the steaming bony rumps of the skeletal horses, rising and falling in an aura of vaporous light. Then he saw the confused image of a town, half-glimpsed in the darkness, then a door, in front of which they stopped, a high façade topped by a cross, the arms of which glowed. Then there were long, white corridors, interminable stairs, the footsteps of a large group of people on echoing flagstones; and swift, fleeting soutanes, wan plaster saints, pallid madonnas, their stiff gestures casting shadows on the walls. Beds, more beds, then nothing. His skin burned, a pulse beat in his temples. It felt as though a band of red-hot steel was pressed round his forehead. Where was he? He half rose,

pulling aside the covers, and listened. There was a great silence. A great silence in which, little by little, he could make out the constant, hesitant rasp of people asleep and breathing, then suddenly a single terrified cry from within a dream, a hoarse cough, the dull thud of an elbow against the wooden partitions. He thought of his little room at home, his joyful awakening from sleep, of Madame Cébron, who would be in the kitchen every morning toasting bread to have with the coffee, and he sighed. It was all over. He would never see his room again, nor Madame Cébron, nor anything he had loved up till then. From time to time, against the whiteness of the curtains, filled briefly by a furtive breath of air, skulked the vigilant, distorted shadow of a soutane. The hours tolled at vast intervals.

It was eight o'clock before the bell went for the children to rise. A growing sound of pattering filled the dormitory; the footfalls of a multitude, the hum of a busy hive, above which could be discerned the sharper sound of curtains swishing aside, one by one, on their iron rings, and the splash of water into basins. Sébastien got up mechanically, his head heavy, his thoughts disjointed, feeling ill at ease. A miserly daylight, a prison daylight, replacing the glimmer of the now extinguished lamps, crept across the ceiling, bleaching the shadows in the cubicles. He got dressed hurriedly, awkwardly, not bothering to wash, fearful of being late, and, without quite knowing how, found himself in the middle of a long queue, pushed, jostled and flanked by two fellow pupils, like a criminal between two policemen. The queue set off. Again he saw the stairs, the plaster saints, the corridors pierced by broad windows through which he glimpsed rectangular courtyards and small, sickly gardens, square spaces like cloisters and quadrangles, uniformly enclosed by high buildings which conferred on them a chalky light, unconscionably harsh and gloomy. Distracted, yawning, the pupils heard mass in a dark, low, stuffy chapel, in a kind of gallery opening out laterally onto the public nave, which was high and vaulted, and of which one could see only a foreshortened view of part of the choirstalls and the magnificent altar. Next, they went to the

refectory, a vast, very bright, whitewashed hall, where, despite the cleanliness of the tables and the newly-decorated walls, there persisted a faint odour, the sickly sweet reek of past meals. Sébastien scarcely touched his breakfast, which was warm milk, served in enormous tin bowls. It was only out in the playground that he was able to regain a little self-possession, recover some notion of where he was, more or less recover his memory of what had happened, the elements of this violent, extraordinary episode in his life. Whatever he suffered at that moment, the pain of abandonment, exile, the trauma of being torn from his daily life, from his pleasures, his freedom to wander, his anguish at being immured from now on in this unfamiliar environment, he nevertheless took a deep, delicious breath of fresh morning air. He stayed there, motionless, watching the other pupils splitting into pairs and groups, watching the other yards, the school buildings coming to life, and marvelling that he could not see the theatre or the boat that they had talked of so much in the carriage, nor the sea, the sea which he so longed to look upon. It was drizzling; a sharp wind blew from the west, driving large, woolly clouds across the sky; and the damp, cool wind did him good, relaxed his tensed muscles and calmed his nerves.

All of a sudden, a young lad stood squarely in front of him.

'I am Guy de Kerdaniel,' he said. 'And you? What's your name?'

'Sébastien Roch.'

'Sorry?'

'Sébastien Roch.'

'Ah.'

Guy de Kerdaniel screwed up one eye, thought for a moment and, fists on his hips, shoulders thrown back, he demanded imperiously:

'Are you noble?'

At this unexpected question, Sébastien blushed instinct-ively, as if he had been guilty of some gross transgression. He did not know exactly what it meant to be noble, but, faced with the dominant manner of his small interrogator, he

suspected that not being noble constituted a grave fault, an impropriety, a dishonour.

'No,' he replied, humbly, almost beseechingly.

He touched his chest, his sides, his knees, just to check that he had not suddenly developed a hunched back or some other disgusting infirmity. Then he turned his gentle, terrified gaze on this bold fellow pupil, and his evident majesty dazzled him. His cap, perched at an angle right at the back of his head, so that it rested on his collar, his deliberate gestures, his insolent, pale, refined features, his supple, ambiguous grace, like that of a courtesan, and above all, his attractive, frivolous clothes, struck Sébastien as a revelation of something very grand, sacred, inaccessible, of which he had never dreamed until now. Sébastien was thoroughly overwhelmed by so much style and became, correspondingly, instantly convinced of his own worthlessness. Without a shadow of a doubt, he had before him one of those superior, august beings of whom his father had spoken with such respect and wonder. This little personage clearly was not at all like himself, constructed of vulgar flesh and crude bones, but was made of precious materials, more valuable than gold and silver. He said to himself: 'Perhaps he's a prince's son.' For a moment, he was stunned. Beneath his cast-off clothes, creased family hand-me-downs, summarily refitted and altered by Madame Cébron and weighing on his shoulders more heavily than sheets of lead, he felt himself to be so gauche, so feeble, fallen so low, that he wished he could disappear into a hole in the ground or evaporate into thin air, like smoke. However, with the vague intention of rehabilitating himself, he stammered, his lips working comically:

'I . . . I'm from Pervenchères . . . in the Orne . . . I'm from Pervenchères.'

He recalled his father's exhortations. In order to convince the troubling Guy de Kerdaniel that he too had a right to live alongside him, to breathe the same air, eat the same food, learn the same things as him, he tried to tell him about the church, the columns, his illustrious ancestor Jean Roch, the donkey, how the two of them had died in the street, beaten to death.

The words he needed would not come. He did not know where to start, with the donkey or with the church. He stammered all the more, and, hoping to sum up this magnificent history in a single cry, he reiterated:

'I'm from Pervenchères. So there!'

This laughable rebuff did not seem to impress Guy de Kerdaniel, who was, in turn, examining Sébastien scornfully from head to foot. Astonished, even scandalised to find himself in the presence of someone who, whilst not exactly a peasant, was not a noble either and had not even the tiniest scrap of nobility, the aristocratic lad did not even consider laughing. He had become as serious as a judge; his forehead was creased in a frown. This abnormality shocked him, just as it undermined his inherited ideas concerning the organisation of human hierarchies and the proper order of social contact. Should he shrug his shoulders and leave, or should he administer a couple of slaps to this minuscule insect who admitted to not being noble and who bore that barbaric name: Sébastien Roch, that cynical name: Sébastien Roch. Sébastien Roch? That alone deserved a slap. He hesitated for a few seconds, his hand raised. Finally, gripped by a lofty sense of disgust, more expressive of the inflexible antagonism between the classes than of any actual violence, he asked instead:

'Well, what are you doing here, then?'

'I don't know,' Sébastien groaned.

Guy grew impatient and starting tapping his foot.

'And your father, what does he do?'

'Papa?' murmured Sébastien.

But he paused, once more disconcerted.

After the initial shock of this interrogation, he had just distinctly heard the door to an entire world slamming in his face. A brutal shove had expelled him from a realm which was not to be his and where, as an anonymous, puny runt, he had no right to intrude. Now he had no doubt that lacking nobility was an unpardonable fault, the equivalent of committing some infamy, of which one could never be cleansed. He admired Guy de Kerdaniel as much as he envied and detested him. 'What does your father do?' The necessity of replying to

that question caused him insurmountable embarrassment, a sharper discomfort than any he had hitherto felt. Sébastien experienced a feeling towards his father and his own self that was horribly painful and which he had never known before. It was not anger; it was not pity either, but rather a kind of shame, the particular kind of shame, base and mean, associated with having some kind of physical deformity. In his mind's eye, with a precision in which every one of his social inferiorities was emphasised, he saw his father in shirtsleeves, the apronstrings of his grey cotton overall tied in the small of his back, rummaging about in a shop that was bursting with ugly, vulgar objects, his rust-stained, work-roughened hands arranging cast-iron pots, tying parcels of nails up with string. It now seemed repellent to him, inadmissible, and more irreparable than if he had been a hunchback or a cripple. Just as he had measured the distance that separated himself and Guy de Kerdaniel, so he measured that which separated his own father from the other boy's father. He was doubtless a handsome man, with a fine, vigorous beard and very white hands, proudly seated in a carriage driven by a coachman in gold braid down avenues of yellow sand and through lush countryside. In the dizzy second that his hesitation lasted, a thousand thoughts, memories, feelings, sights, forebodings, all raced before him in a jumble. People, objects and ideas took on new contours, new shapes and directions, but all shared the same implacable rigidity and disillusioning brutality. The walls of the courtyard and the shops projected their grimy shadow on his dearest and purest memories. His father, the neighbours, Madame Lecautel, Marguerite, the whole region where he had been born, his native sky and he himself, were all enveloped in this shadow, in a thick, suffocating veil of disgust. At that moment, his agate and coloured glass marbles, his fine compass box, his humming leather tops, of which he had been so proud with his friends at home and which embodied his highest ideal of happiness, luxury and rank, he would have sacrificed them all, immediately and joyfully and with no regrets, in order to have been born of noble, idle parents, in order to be able to shout it out in the face of all

57

the Kerdaniels of this world. In his injured pride, he first considered lying, denying himself, hoisting himself up onto vertiginous, heraldic heights. He could think of nothing plausible, nothing suitably amazing, having no idea what was the right thing to say. Besides, his too short trousers, his baggy jacket like a floating sentry-box, both of which spoke of the modesty of his background, discouraged him, and recalled him to the reality of his condition. Then he realised that it would be base to lie in this way and he remembered the words his father was always repeating: 'You must always be deferential and respectful towards persons more elevated than yourself, either by fortune or by birth.'

In a trembling voice, humble and tearful, he admitted in a murmur:

'My father? He's an ironmonger.'

There was an instant explosion of laughter and mockery which splashed his face like a jet of mud.

'An ironmonger! Ha! An ironmonger! Did you come here to mend the pots, then? Do tell! Will you sharpen my knife for me? What do you charge per day for cleaning lamps? An ironmonger! Hey, you lot over there! He's an ironmonger!'

The laughter died away, emphasised ironically by the sound of two departing feet. Sébastien looked up. Guy de Kerdaniel was no longer there. He had rejoined a group of pupils, to whom, with suitable gestures, he was already recounting the extraordinary and scandalous tale of an ironmonger who had stumbled amongst young nobles. Shouts of surprise, protest and indignation burst out. An ironmonger! What does an ironmonger eat? An ironmonger! He might be poisonous? Some suggested hounding out this unfamiliar, unclean beast. The laughter began again, reinforced this time by harsher laughter and more insulting jibes. They imitated the barking of dogs, the cracking of whips, the sound of the hunting horn, the gallop of a hunt through thickets.

'Go to it, bow-wows! Hee hee hee!'

The voices and stares weighed heavy on little Sébastien, inflicting the physical pain of a multitude of needles stuck into his skin. He wished he could launch himself on this band of

ferocious children and slap them or kick them, or else soothe them with his gentleness saying:

'You're mad to laugh at me like that when I've done you no harm, when I so want to be friends.'

If he had had his honey cake and his chocolate with him, he would have shared it out amongst them.

'Look, take it. You see, there's nothing nasty about me! And I will give you more.'

The priest in charge, who was reading his breviary a short distance away, came up and joined the group. The boy felt he was saved: 'He's going to make them shut up and punish them,' he thought. When the Jesuit had been told why everyone was laughing, he too began to laugh, but with a discreet, amused, patronising laugh, whilst his round belly trembled and shook, gaily swelling beneath his black soutane. So, in order not to hear the laughter and those painful voices, to escape those injurious stares, Sébastien bent his head and moved away in despair.

In the vast yard, surrounded by a high white fence and closed off from the gardens by a row four deep of spindly elms, children of his age ran about and played, some walked arm in arm, serious and talkative; others, seated on the steps of the real tennis court, recounted their holiday adventures. He knew no one amongst them. Not a single friendly face, not a single familiar step, not one hand ready to reach out to console his distress as a newcomer. With a heavy heart, he noted that the new pupils who had arrived like himself the day before and were homesick, lost and foolish, all sought one another out, approached one another, made tentative attempts at friendship, beneath the approving eye of the teachers. He alone stayed on the fringes, not daring to make any approaches, for fear of being rebuffed; he felt the void about him widen irremediably, he felt the unbreachable gulf, the inviolable universe which separated him from Guy de Kerdaniel and from the others, all the others, widen still more. Was it obvious, then, that his father was an ironmonger? Did he wear the visible stamp of that damned condition? Was he more disgusting than a dog with mange? And yet, people had

told him many times that he was an attractive boy; people admired his blond curls, his healthy pink cheeks, his eyes which were like his mother's. Had they lied then? Had they deceived him? Was he ugly, wearing an ugliness so overt that it excited laughter, disgust and hatred? What made him more convinced of this ugliness was that he attributed to all his schoolmates an aura of beauty, heart-breaking beauty, which was assuredly linked to their happy condition as nobles and to which the despicable son of a despicable ironmonger could never hope to aspire! Why, when he was so small, so weak, so ugly, so badly dressed, had they sent him so far away with no protection or defence? Why had they torn him so abruptly from the sweet peace and intimacy of his own home, the quiet, charming place he came from, where everything was familiar and fraternal, and where he was the most handsome, the richest, the most envied of all children, of all his school friends or playmates? Now, in this hour of suffering, every-thing made him yearn for his home, both the harshness of exile and the feeling of remorse at not having loved enough that land now lost, loved it with a love he only now felt and which engulfed him in bitter regret and savage affection. Here, the air seemed heavy to him; the wind, laden with strange smells, benumbed him; the gaunt trees, stripped of their fragile greenery, oozed grime; and the school buildings, far off in the distance, huge and grey, blotted out the sky with their four gloomy storeys, pierced by black, curtainless win-dows, windows full of spying eyes and invisible enemies lying in wait. So it was there that he was going to live from now on, in that cloistered chill, in that barrack servitude, in that stifling, prison atmosphere, alone in the midst of a swarming human-ity that would always be foreign and hostile to him. Some brushed close by him, indifferent to his mute supplication; others spat at him: 'Ironmonger! Hee hee hee!' and that 'Hee hee hee!' began to create a kind of hallucination. He thought he could hear that 'Hee hee hee!' buzzing in his ears like a dense swarm of insects, rumbling like the distant call of wild beasts. It poured inexorably forth from angry mouths and mocking eyes, it came out of the walls and the ground, fell

from the sky; it leaped over walls, circled the other courtyards, filling with spiteful gaiety the sleepy recreation hour of this first day back at school.

'Ironmonger! Hee hee hee!'

His head swimming, his limbs trembling, Sébastien leaned against a tree and wept. For a moment, his child's soul, which had met and understood life for the first time, took full measure of the boundlessness of pain, the limitlessness of man's loneliness.

For a long while, he stayed leaning up against the tree, his arms dangling, inert. In his distress, a strange idea, a child's stubborn idea, drifted to the surface; he wanted to see the sea. Why could it not be seen? Why could it not be heard? Had the Jesuits not bought a large boat? Where was this large boat? A flock of pigeons flew past, wheeling above the yard. He followed them with his eyes until they disappeared behind the school. Naturally, boats must sail on the sea just as pigeons float on the air; he recalled in a picture book a boat in full sail, the sails all white, like wings. His thoughts drifted from one object to another, attaching themselves mainly to things that float, to the clouds, dissipating mists, leaves carried off by the wind, flecks of foam caught on the drift of the current. But very soon, his reverie returned with a brutal crack of the whip to the implacable reality of his misery. One by one, he called to mind all the details of his journey, from the moment when he left his home. Each episode, exaggerated by his imagination, distorted by the nervous state brought on by his encounter with Guy de Kerdaniel, was a fresh source of despair. Exiled from Pervenchères, he had lost everything; rejected by his fellow pupils, despised by his teachers, condemned to abandonment, he had nowhere to fix his hopes. Oh, how delightful his father's tedious lectures would seem to his ears now! How he loved the room at the back of the shop, the stinking courtyard, the sweating walls, which now seemed to him to sparkle with gold and precious stones like the fairytale doors of dreams. Forgotten things, heart-rending, far-off, pitiful faces, came crowding in on him. He remembered François Pinchard, a sad neighbour, a little

hunchback shoemaker, with curly hair and skin darker than his leather hides. Every day on his way to school or in the park, Sébastien would see him bent over his work, hunched up on himself in a painful curve which accentuated the deformity of his torso. The other lads laughed at him, following him through the streets: 'Hey! Mr Punch!' And the little hunchback fled on his short legs, his hump rolling, his frizzy head half-hidden by his raised shoulders. Sébastien revelled in evoking the pitiful memory of François Pinchard, moved to discover analogies in their situation, similarities in their suffering, now that he too was an outcast. Poor hunchback! He was not at all unpleasant either! Quite the contrary. He was not spiteful as hunchbacks often were, he thought. So why that relentless assault on his miserable carcass? He was obliging towards everyone, skilled and courageous; he liked to help and please others. He was always ready to lend a hand whenever anyone needed it. People only had to call: 'Hey there, hunchback, come over here,' for him to hasten over, happy to offer his help and show himself to be useful and kind. Sébastien paused, filled by an immense pity, to consider François Pinchard's touching goodness; he exaggerated it, magnified it, sanctified it and, by an inevitable process of transferral based on natural human egotism, made it his own, just as he made his own all the sufferings of the little hunchback, to the point of confusing himself with him and feeling that he lived within him. The touching memories were set in motion again. So it was that one Sunday, Coudray, the carpenter, a sort of handsome giant, had hit the hunchback for no reason, for a laugh, to amuse the pretty girls, for they enjoyed cruel pranks that made him cry. He was so funny, his hump jolted so comically when he cried. 'Hey there, Mr Punch!' And the huge fist of the carpenter, used to sawing up huge oak trunks, landed several blows on the hunchback's hump. 'Damn you, Mr Punch!' Pinchard had shaken himself, like a dog punished by its master and, more astonished by the madness of this attack than indignant at the blows received, he had said, rubbing the painful spot:

'Why are you hitting me? You don't even know why you're hitting me. I suppose you think it's clever, do you?'

Then, one morning, he had been found hanged in his workshop. When Sébastien had asked why no one saw him around any more, why his house was silent and shut, he had been told that he was dead. In the inviolate innocence of his childish mind, death did not correspond to anything precise or terrible. His mother too was dead, which meant absent and happy. Sometimes, he had contemplated her photograph in the dining room. As he looked at her tranquil face, a little faded by time, her frail waist, her floral dress, her hair looped back, and behind her pretty figure, balustrades, faded visions of pools, woods and mountains, he had said: 'She is dead,' without any shock to the heart, without any regret at not having known her, he just felt it had to be thus. He was even happy to see her in such a calm, gentle setting, which was doubtless the paradise where the virtuous dead went. Living, dying: these were vague words, without material substance, enigmas upon which his childish intellect had not lingered, innocent of pain as it was. Now he understood. One hour of suffering in contact with real life had been enough to reveal death to him. Death was when there was no pleasure anywhere, when you were too unhappy, when no one loved you any more. Death was those peaceful open spaces, with pillars draped with fabric and decorated with roses. 'Hey, Mr Punch!' Another shout mingling with the cry of 'Ironmonger! Hee hee hee!' The two shouts melted together, uttered by the baying mob of the wicked. That was death. He envied François Pinchard, he envied his mother, he envied all the anonymous dead. Since all those dead people were dead, he could die too. And gently, without internal struggle or physical revolt, without any wrench to his little soul, the idea of death descended upon him, soporific and soothing.

Sébastien left the tree, walked the length of the fence, no longer concerned about the other pupils, who, taken up with other interests, seemed to have forgotten him completely. He was at peace. His muscles felt lighter and more supple, his brain clear, bathed with lapping waves and inebriating mists. Just as when on the brink of a deep sleep, after a tiring day, he felt something inexpressibly sweet, something like physical

dispersal, like the disappearance of his whole being, of his awareness of feeling and thinking. How should he kill himself? The idea of a brutal death, a horrible death, with blood, broken limbs, gaping flesh and spattered brains, did not occur to him. He thought of death as an airy flight towards the upper realms or like a slow descent, a pure, gyratory slide into abysses of light. The young priest, he remembered, had spoken of a lake. Where was it, this lake? He looked around and saw only noisy playgrounds. Opposite, the school launched darts of oblique, wild light at him, multiplied by its hateful eyes. To the right of the school building he could see a vast area, bounded by the summits of sombre firs, which stood out harshly like hills against the sky.

'Maybe it's there,' he said to himself, imagining already an immense pink surface, where pliant rushes, murmuring reeds marked out bright paths, resplendent avenues of celestial water; a motionless surface, dreamy, beautiful, like that of the pool at La Forge, where he had so often explored the grassy banks and breathed in the delicious, sour scent of the fermenting marsh.

Beneath the arches of the real tennis court, the teacher on duty strolled back and forth in leisurely fashion, his nose in his prayerbook. Sébastien quickened his step, thought of François Pinchard, of his mother, and left the yard without encountering any obstacle. Quite calm now, he walked on, his eyes trained on the empty space, not knowing whether it represented solid earth or moving water imbued with infinite mystery by the black circle of conifers.

'Perhaps it's the sea!' he said to himself, childishly obstinate.

A vision of the little cobbler preceded him, led him on.

'Hey! Mr Punch!'

The vision smiled and he smiled at the vision.

'Ironmonger! Hee hee hee!'

As he walked on, he was no longer aware of the earth beneath his feet. He walked as in a dream, as light as if he were being supported by something, borne along on two huge wings, skimming the ground. A monk crossed his path, wheeling a load of bread along in a small cart; he had a convict's face,

sly and begrimed. He did not notice him at all. Two other monks, thick-lipped, with the eyes of child-molesters, brushed by him. He did not see them either. He no longer noticed anything, just that space, which itself had become confused, fuzzy, transformed into floating white clouds. His entire sensory life was out of kilter and was concentrated solely in his sense of smell. Various odours assailed his nostrils, so strong he nearly fainted. The atmosphere, like in a closed room full of mouldering vegetation, seemed to him full of lingering, poisonous scents. He breathed in the ammoniac breath of leaf mould, the carbonic exhalation of dead leaves, the effervescent aromas of wet grasses, the fermenting bouquet of fruit, all increased tenfold by his morbidly nervous state. Sébastien suddenly had to stop, his throat tight; he was pale, close to fainting. He had gone past the school. To his left were occasional small, low buildings; gardens rose in terraces leading to parkland; to the right, a short avenue of chestnut trees came to an end at some outbuildings protected by a fence; beyond the outbuildings a meadow stretched out, flat, smooth, silvery green. In the middle of the meadow gleamed a great sheet of water, all white, reflecting no light. So Sébastien climbed over the fence, set off down the avenue and started to run. Suddenly, two priests out walking barred his way. He stopped, terrified, and let out a cry.

'Well, well, well. What's all this now? So we're playing truant are we?' said one of them harshly.

He was already grasping Sébastien's ears, when, struck by his odd expression, the unusual, mysterious, inebriate glow in his eyes, he spoke again, this time more gently, with reassuringly affectionate gestures.

'Come now, my dear boy, where were you off to like that?'

Sébastien was touched by the gentleness in this voice which had suddenly softened and become almost prayerful. However, he did not dare reply. The Jesuit persisted:

'Why did you leave the yard? Don't be afraid, I'm your friend. Tell me, child.'

Whilst he spoke, he stroked the child's cheek and looked at

65

him with an air of encouraging kindness. He repeated in a voice of tender pity:

'Why? Let's see now. You're sad, aren't you? You wanted to get away.'

These simple words finally defeated him, and Sébastien felt a dam break in his chest and a wave of tears flood through him. Choking, convulsed with wrenching sobs, he threw himself into the priest's arms and wept:

'They . . . they . . .'

He could not say any more. Like a drowning man who panics and blindly clings to the miraculous flotsam borne to him on a wave, he clung to the priest's robe. His whole body trembled, shaken by spasms, he stood on tiptoe and pressed himself against the priest's body, in a feverish love of life regained.

'They . . . they . . .'

When he had calmed down a little:

'Now then, don't cry any more,' the priest comforted him, 'there's nothing to worry about. Come and walk with me. Then I will take you to the classroom.'

But Sébastien, his head still hidden in the priest's soutane, groaned:

'No! No! I don't want that. I want to go back to Pervenchères. I'm from Pervenchères.'

CHAPTER III

Gradually Sébastien resigned himself to his new world and found himself caught up in the machinery of day-to-day existence. Life went on without too many serious setbacks, a life based on the monotonous regularity of timetables and a round of identical occupations and events. He forgot the traumatic journey, his painful entry into this grey prison of grey stone, the icy cold that had gripped his heart and made his flesh creep when he saw the long, bleak corridors and the little enclosed yards bathed in sepulchral daylight. He forgot the ferocious shouting, the gloomy lake in the distance, beneath a dismal sky, and the strange, unthinkable folly which, in a moment of madness, had driven him towards death, as if towards a refuge. Eventually, memories of his home blurred into a soft mist; his regrets became less painful and more distant. Far from his father, spared the boredom of his conversation, the emptiness of his advice, he pictured him as handsome, tall, heroic, sublime, and he loved him with a love all the stronger for his having previously blushed at the thought of him and almost denied him. His affection increased with all the insults endured on his behalf, became warmer as a result of his remorse at not having courageously defended him. In order not to worry him and out of a kind of pride, ashamed to detail complaints and recriminations in front of the teachers – because he knew that the Jesuits read both the pupils' letters and the parents' – he was determined not to confide any of his torments to his father. He limited his unburdening to naive, warm expressions of affection and repeated promises to behave well and work hard. He also tried his hand at little descriptions of the school, at accounts of walks, in which, despite the primitive literary form and the boy's as yet only partial awakening to sensation, there was nevertheless already evidence of a lively curiosity and a

67

vibrant imagination. He also felt the need to speak of his home and of his memories and, sometimes with forced cheerfulness, sometimes with anguish, he expressed his desperate longing for the pleasures of home, for familiar caresses, all of which indicated genuine moral distress. Anyone other than Monsieur Roch might have been alarmed by these signs of unusual agitation. Instead he saw it as mere chatter whose uselessness and lack of seriousness shocked him: 'I am not at all pleased with you,' he wrote, 'I see that you are wasting your time on childish business, futile pastimes, which I cannot encourage. I understand that in the early days you will have allowed your head to be turned by a change of environment which is both radical and seductive. But as a matter of urgency, you must now think about applying yourself seriously. The whole of Pervenchères is thinking about you. People are envious of me. I tell them: "My son will go far, he will reach great heights." Try not to make a liar of your father. Send me a list of your main classmates, particularly those who bear historic family names. What are your friends called? Who have you chosen to be your particular friends? Does the Reverend Father who accompanied you there speak of me?'

There was more harassment at school, but each episode grew progressively less violent so that, in the end, it became a kind of intermittent, jovial raillery which made the pain more bearable. However, he felt very keenly the bitterness of the social inequality in which he lived, acknowledged and persistent as it was. To be tolerated as a pauper and not accepted as an equal caused him great sorrow, a wound to his pride which did not heal, and he felt helpless to protect himself. The solitude in which the others left him made him more serious and thoughtful, almost old before his time. The roses in his cheeks faded and paled; his oval face grew thin, his eyes became shadowed, troubled, dull, always veiled by an expression of quiet sorrow and dazed introspection. Faced with the inextricable complications of his new life, every day he discovered something to surprise him. Every day revealed to him habits, names, a whole order of important things, a whole series of people, august and revered, who seemed familiar to

everyone else and whom he was mortified to be the only person not to know, and it angered him not to understand. This ignorance earned him frequent snubs. One afternoon, Guy de Kerdaniel asked him point-blank who he was 'for', 'the Count de Chambord or the Usurper'? Not knowing who these characters were, if they actually existed in real life, and how one could be 'for' or 'against' either, he had not replied. Everyone had laughed at his discomfiture. Sébastien realised that he had just supplied yet further proof of his inferiority. But what could he do? They laughed if he kept quiet and jeered if he spoke. 'Perhaps they are Jesuit surnames,' he said to himself. For a long time he felt a deep resentment towards the Count de Chambord and the Usurper for not being known to him, but, convinced that it had to be so and would always be so, he did not dare to find out, fearing a hoax. Besides, who could he have asked?

Schools are miniature universes. They encompass, on a child's scale, the same kind of domination and repression as the most despotically organised societies. A similar sort of injustice and comparable baseness preside over their choice of idols to elevate and martyrs to torment. Sébastien was completely ignorant of the fact that there are conflicts of interest, rival appetites, which are innate and which cause all human societies to fight amongst themselves, but by observing and making comparisons, he soon determined his precise position in that world, stimulated and motivated as it was by passions and concerns which, up until then, he had never even suspected. He found it deeply demoralising. His position was that of the underdog, a vanquished opponent who, to comfort himself in his defeat, does not harbour any memory of a struggle or hope of revenge. Struggle was hateful to him; vengeance he did not consider even for an instant. He understood that he must rely on himself alone, live a solitary, introverted life, act independently and seal himself off from any surrounding temptation. But he also understood that such a renunciation was beyond his powers. His generous, expansive, enthusiastic nature could not be confined within the narrow psychological limits which he would be obliged to impose on

himself. It needed air, warmth, light, a broad expanse of sky. While waiting for this light to shine, for this sky to open up, Sébastien continued to watch life pass him by against a background of blurred images and inexorable darkness.

In Vannes, each recreation yard was divided into distinct groups, each exclusive of the other, representing not a communion of sympathies or compatible personalities, but social categories, which, just as is the case in the real world outside, contained the privileged in one group and those who have only duties to perform in the other. Despite constant contact with one another, the jostling companionship enforced by studying together, being in class, in the chapel, in the refectory, where sharp edges are blunted and resentments fade, where the instinctual feeling of a common struggle against work and teachers momentarily unites the most disparate interests, no genuine mingling of spirit occurred between these groups. During recess, everyone returned to his official place, went back into the narrow compartments imposed by an aristocratic constitution whose strict functioning the priests, without severity and with an apparently benevolent and smiling impartiality, were careful to maintain, actively encouraging prejudices, intending thus to instil deep into the children's hearts the need for discipline at all levels and the cult of respect for hierarchy. Guy de Kerdaniel was the undisputed lord of the yard, and Sébastien was the scapegoat. The former's spoilt child's whims, fickle friendships and capricious hatreds were sovereign law. He knew his own power and abused it freely, particularly when it came to the weak. Pampered by the masters, because of his quasi-illustrious birth, adored by the pupils, because of the special attention and the evident preference given him by the masters, he epitomised for the others all that was most desired and most revered in life. People knew of his parents' considerable fortune, their prestigious chateau on the banks of the Rame, their magnificent, ostentatious lifestyle. Imaginations were fired by tales of hunts, receptions, of churches rebuilt, convents subsidised, of frequent meetings between the Marquis de Kerdaniel and the Count de Chambord, who had officially

appointed him his most intimate confidant, his most trusted friend. All these marvels, this elegance, this royal friendship, bestowed on the magnificent Guy an indestructible aura. Puny of body, unhealthy of complexion, his pallid, withered, already faded brow bore the marks of a species near exhaustion, but he had the self-assurance of a grown man, the brusque gestures, the imperious mouth, the insolent eyes beneath heavy, drooping eyelids. Despite looking like an anaemic groom, he was nonetheless the chosen centre and pivot of that community of children in which, by example and education, every form of servility and tyranny was taken for granted. The vanities, ambitions and aspirations, secret or avowed, of this small, divided people, with its jealous coteries, all focused on his frail, awe-inspiring person, or rather on what it evoked in terms of dazzling riches, revered luxury and people respectfully bending the knee. Sébastien did not attempt to gain his sympathy by cowardly submission, nor to impose himself on him by means of revolt. He disdained him and this disdain combined with pity for his friends back home, making him cherish them all the more, with their ill-kempt hair and ill-fitting clothes; and he loved, above all, those who were lost and poor, whose torn shirts and sad, patched trousers moved him to anguished tears. He decided to keep out of the way of the teachers and he tried neither to seek their approval nor arouse their sympathy. It seemed to him that the transient gentleness of their manner widened rather than narrowed the humiliating and ever greater distance created by the pupils between themselves and him. The priests' 'my child' uttered in an ingratiating tone rang false to him. By their side he felt no sense of protection. They ignored him in class, where his teachers made him recite his lessons mechanically, eventually interrupting with an abrupt 'fine', with never a word of encouragement or censure, never prompting him, whilst they applied themselves to awakening the intelligence of the others, guiding them along their preferred paths, arousing their interest by patient explanation; they left him to his own devices in the recreation yard, where no one invited him to take part in the pleasurable activities and noisy play led

by the priests who, eager, lithe, youthful, their soutanes hitched up, would instigate rumbustious games, and where he wandered, usually alone and bewildered, wounded by the others' joy, outraged by the roars of laughter exploding all around him as if to mock him all the more in his abandonment. In any case, he would have needed the equipment that everyone else had, a succession of very expensive toys which the Jesuits sold in a little hut called the *quaestura*. Oh, that little hut, full of such lovely things, like an unending Christmas, exhaling the delicious scents of pine and varnished wood, which recalled for him the magical, dazzling grocer's shop in Pervenchères in the beguiling days around Christmas and New Year. How his eyes devoured them. How he envied the rich as they emerged from there, arms laden, pockets filled, faces glowing. After long hesitation, he overcame his shyness and went into this tempting *quaestura* and bought a balloon, which was punctured the following day, two balls, which were stolen from him, and a pair of skates, which broke as soon as he tried them. The five francs his aunt had given him were used up; the regulation ten sous which were dished out to the pupils every Saturday in the yards by the Prefect of Studies went on loans which he dared not refuse. So, with a strength of will far superior to his age, he resolved to bury himself in work and in himself, and thus protect himself from future disappointments. Soon he achieved a kind of peace through work, and in the hours of silence and rest, in his mind, where a new world of thoughts and feelings was already beginning to stir, he achieved a kind of bitter satisfaction which grew as the days went by.

One Wednesday, before the walk, a pupil came up to Sébastien and asked:

'Would you like to walk with me? I'm Jean de Kerral. I think you know me.'

Before Sébastien had time to reply, he added:

'People tease you because you're an ironmonger, but I don't mind if you're an ironmonger, I like you anyway. You're nice and I like you.'

Jean de Kerral was short, stocky and very ugly, with a fish-like profile and a face sprinkled with freckles. Sébastien liked his bright, kindly eyes. He made small, somewhat feverish, jerky gestures, had a chirping, bird-like voice, and, like a bird, he hopped rather than walked. He had been given the scornful nickname, the Good Samaritan. In fact, Jean had an evangelical role in the yard: he protected the weak and consoled the sad. Whenever a pupil was ostracised for any reason, or beaten or teased, he went to him and showered him with noisy declarations of affection, deafened him with incoherent, effusive outbursts. He was kindly and talkative and so generous that he was easily stripped of all his belongings; but his parents, who knew of his mania, never gave him a thing. His enthusiasm would last about a week. After which, Jean would abandon his friend as abruptly as he had approached him and move on to another.

He spoke again:

'It saddens me to see you always so alone. Why do you go off whenever anyone gets close to you? Why do you never play?'

Another pupil came running up, out of breath, clothes flying.

'Ah, it's Bolorec,' explained Jean de Kerral, 'I invited him along for the walk too. He's very nice is Bolorec, I like him a lot.'

Bolorec took his place beside Sébastien. Plump, with rounded cheeks and frizzy hair growing low on his forehead, a long, shambling torso on legs that were too short and stocky, he, like Sébastien, was a target for his schoolmates' jokes. He was the son of a doctor, a profession not considered socially acceptable, and a fertile source of ragging. But the jokes fell harmlessly on his flabby flesh and his armour-plated self-esteem without leaving any trace of injury. He seemed not to feel or understand anything and he smiled all the time. Nothing affected this eternal smile, no amount of shoving or kicking, or even the most unpleasant of nicknames.

Bolorec buttoned his jacket, gathered up the string of his top, which was trailing on the floor out of a trouser pocket

stuffed with various bulky items, and gave Sébastien a fool-
ishly benevolent stare.

The children lined up and, at a signal from a bell, the little
band set off in silence, with one Jesuit at the head and the
other at the rear of the crocodile. Skipping happily along, Jean
leaned close to Sébastien and said very quietly:

'You're pleased to be with me, aren't you? Bolorec is too.
And I'm happy because I don't like it when people are cruel
to others.'

Once they were out in the open, they walked alongside the
port for about a hundred metres. It was low tide. Blackish
water slept in the narrow channel. On the mud, amid stranded
rowing boats, a schooner was perched on her side, keel up, her
mast crooked, as if about to topple into the void. Fishing
launches here and there revealed their timbers stained with
brine and their hulls the same colour as the mud in which
they were stuck. Further off, Jean pointed out the *St Francis
Xavier*, a white boat, a lovely, elegant cutter with a streamlined
keel, standing straight and proud between her supports, her
flag flying on top of the mast. The quays were almost deserted;
the landscape of brutally flat, hard, bare fields beneath a low
sky closed abruptly round them. Sébastien searched in vain for
the sea. He was disturbed by this immobility, these sleeping
objects, sad as flotsam, by these dead waters and the disgusting
mud, the stench from which made him feel queasy.

When they had left the port and walked along the town's
winding streets, they emerged into the countryside and Jean
de Kerral said to Sébastien:

'Do you live far from here?'

'Oh yes, far from here,' said Sébastien faintly, for cautious
and fearing a painful rebuff, he only dared reply in shy, almost
whispered monosyllables.

'I live very near here, at the Chateau de Kerral, on the road
to Elven. Do you know Elven? Where there's a large tower.
Sometimes we go there for a walk. Haven't you got a
chateau?'

'No.'

'Oh, that doesn't matter. Bolorec hasn't either.'

The crocodile of children had somewhat disintegrated. Now the piping of many voices accompanied the footsteps of the little band of walkers. He went on:

'I'm going to be a soldier. I'm going on to Saint-Cyr. What are you going to do? Are you going on to Saint-Cyr as well?'

'I don't know,' stammered Sébastien.

The Count de Chambord, the Usurper, Saint-Cyr: there were always so many things of which he had not the slightest inkling. How could he ever be the equal of the others when he knew nothing about all that apparently vital, indispensable information? He wished he could have asked Jean for explanations, but he did not dare. Jean chattered on:

'Papa says there is no place left now for nobles . . . either they must do nothing . . . or else go to Saint-Cyr. Papa doesn't do anything. He hunts. Have you got a drum?'

'No.'

'I have, a real one, made of leather. Papa gave it me. The farmer is teaching me to play it. He was the drummer in the regiment. He's very good at it. I am too now. I play the drum. And Papa has given me a red hussar's uniform too. When I go out for the whole day, I put on my hussar's uniform and I bang the drum. It's really good fun. That's how I'm learning to be an officer. Have you got a hussar's uniform?'

'No.'

'Well, what have you got then? What do you do for fun when you're at home? You should ask your father for these things.'

Sébastien felt his heart swell with some unnameable emotion; either regret at not owning a red hussar's uniform like Jean de Kerral, or joy at hearing for the first time since he left Pervenchères a voice that spoke gently to him, words which were neither mockery nor insults. All of a sudden he felt towards this person speaking to him a great tenderness, profound recognition, the irresistible surge of a soul giving itself to another soul. Moved, he took Jean's hand, squeezed it very hard in his own and, his eyes dim with tears, he said:

'I really like you.'

'And I like you too,' replied Jean de Kerral.

Bolorec said nothing at all and followed the crocodile, with his tiny steps and too short legs. Red-faced, the veins standing out on his neck, he kept puffing out his cheeks and then deflating them with a blow from his own fist, intrigued by the quiet explosion, the dubious put-putting noise that emerged from his lips. Between each operation, he smiled that neutral, troubling smile, which expressed nothing and was addressed to no one, that fixed smile, like the smile death sometimes brings to the frozen lips of its chosen victims.

They were walking down a broad road lined with tall chestnut trees whose bare branches touched and crossed, forming a filigree of twigs above their heads, a kind of open-work vault decorated with the sky's pearl-grey silks and pink lacework. On either side, drystone walls clothed in the gold embroidery of mosses, encrusted with the delicate jewellery of lichens and ferns, bordered grasslands, fields and little undulating meadows, each separated from the next by broad wooded slopes or, sometimes, by flashes of granite spikes, sharp and straight, driven into the earth. This was no longer the usual flat, boundless, gloomy moorland, infinite and dreary, spreading out the cankerous velvet of its sombre carpet over the barren soil, spangled with the pale silver of pools of water. Here, proliferating life germinated in the fields, shivering with the lively emerald green of the nascent rye and young corn. The softly beguiling sky was infused with a subtle, contained glow that was becoming filled with a translucent tissue of clouds, woven with threads of milky gold and washed with softest mother-of-pearl. Bathed in this tepid, infinitely diffuse, infinitely penetrating light, which bestowed celestial depths even on the trunks of trees and the fissures in the rocks, beneath this caressing light which left worlds of joy shining on each fragile ellipsoid of grass, every shape and every colour sang. What tune they sang Sébastien would have been incapable of describing or expressing, but he savoured the harmonious, almost divine music and admired the harmonious, almost divine beauty. It was like a miracle of resurrection taking place within him, a majestic ecstasy of love

which swelled his whole being, a kind of intoxication, a nuptial delight, to celebrate his heart's betrothal.

'Can we always go on these walks together?' Sébastien said imploringly.

Jean de Kerral replied:

'And we will always play together in the yard, with Bolorec too.'

'I really like you,' said Sébastien again.

'And I like you too.'

This was a magical moment for Sébastien. His worst days were over, he no longer dreaded any suffering or torment. His confidence was reborn, increased, fortified by the voluntary, spontaneous, eternal gift of his own heart, which he had just bestowed. He now walked more proudly, his limbs moved more fluidly, finding in everything things to admire or respect, promising himself to love Jean, to be devoted to him to the point of sacrifice. For the first time, he felt brave, longing to offer himself in battle. An unfamiliar strength coursed through his veins, making his pulse and heart beat faster. No obstacle seemed insurmountable to his courage. He could even have defied Guy de Kerdaniel.

They stopped in a pine forest. Between the avenue of trunks, the earth, strewn with dry needles, was all pink, and their feet sank softly into the moss. The smell of turpentine was everywhere, bitter, strong, mingling with vague scents of marine plants carried on the wind from the west. In fact, far away towards the west, striped by the dark bars of the pines, a strip of iridescent water could be seen, almost blending into the sky. Some of the pupils chased a squirrel. The boldest climbed into the branches of the tree, whilst the others barked like dogs and threw stones at the terrified creature. Sébastien and Jean sat down at the foot of a tree; Bolorec, standing leaning against the trunk, cut a rough boat shape from a piece of bark. All three, from time to time, watched the hunt and pointed up at the squirrel, which, confused by the noise, fled from tree to tree, leaping from branch to branch, its tail in the air.

'You'll never guess what I'm thinking,' said Jean. 'I'm

thinking I should ask my father's permission for us to go and stay at our place. I'd love you to come and stay for the holidays. Mother would like it too, and Papa, and the Reverend Fathers too. You will beat the drum and wear my uniform. Last year, Papa didn't want Bolorec to come, but you're different, because you're . . . well, because Bolorec is too scruffy.'

In a rambling, disjointed narrative, he described the Kerral chateau, his father, who had a huge blond moustache, his mother, who was very pretty, their large carriage and the six hunting dogs which chased foxes and tracked down hares.

Sébastien drank in Jean's words greedily. He already imagined himself as a pampered guest, caressed by a beautiful lady in a chateau, which he pictured resplendent, with broad moats, massive towers, crenellated walls, like the ramparts of Vannes. His heart was drowning in fathomless hope.

Jean went on:

'Do you know the story about Papa's six hunting dogs and the bailiff's clerk?'

'No,' replied Sébastien, annoyed at not knowing everything about his friend.

'What! You don't know it? But everyone at school knows it. Well, one day, my father was coming back from a hunt; he hadn't caught a thing and was not at all pleased. As he got nearer Elven, who should he see on the road but the bailiff's clerk. He's a nasty clerk, a very nasty clerk. He says bad things about priests, never goes to mass, and his family own a farm near the chateau, confiscated land bought cheap off us after the Revolution. Anyway, a really nasty piece of work. Papa says to himself: "Since my dogs haven't had a chance to hunt anything, I'm going to let them chase the bailiff's clerk." Funny, eh? He unleashes them, puts them on the scent and the dogs are off . . .'

Bolorec abandoned his piece of wood and listened with great interest to this tale of a human hunt and, all of a sudden, his eyes alight with laughter, he stamped his feet with joy and with all his might yelled:

'Bow wow!'

'You can imagine,' continued Jean, 'how the clerk bolted,

feeling the dogs at his heels. You can just imagine it, can't you? He leaps into the undergrowth, his hat flies off; he gets all tangled up in the reeds and the brambles, he rips his trousers, he falls over, gets back on the road, his face all bloody, and escapes as fast as his legs can carry him towards Elven. The dogs stick as close to him as if he was a hare.'

'Bow wow!' Bolorec started up again, his pleasure expressing itself in horrible grimaces.

'Apparently, it was really funny. No hat, hair all over the place, dogs right behind him snapping at his trousers. Luckily for the nasty bailiff's clerk, he was not far from Elven. He went into the church and barely had time to close the door behind him; he collapsed onto the flagstones and fainted away out of fear. Another second and he would have been caught and gobbled up by the dogs. They don't mess about, you know, those dogs . . .'

For the third time, Bolorec gave a lengthy bark, revealing his teeth between each yowl, teeth which seemed to worry cheerfully at the snatched prey.

'Bow wow!'

Jean de Kerral concluded:

'Well, the father of this nasty man took my Papa to court and Papa was ordered to pay this nasty man twenty-five thousand francs because, after this joke of a hunt, his son had fallen ill and had lost his mind. But Papa will get his revenge, because he's going to stand for election and bring back the King. When you come to our house, you'll see the dogs. They're very fine dogs.'

Sébastien listened to his friend's voice, that voice twittering like a bird singing a love song high up on a branch. He already loved those dogs; he loved Monsieur de Kerral, despite his large, blond moustache, which now held no fear for him; he loved the chateau; he loved everything except the nasty bailiff's clerk, whom he could not forgive for not allowing himself to be devoured by Monsieur de Kerral's fine dogs and for having cost the man so much money.

The clamouring in the woods stopped. The squirrel had been caught. Two boys carried it in triumph, hanging by its

tail from a stick, like a trophy. They set off back to school. The return route was delightful. However, in Sébastien's heart there was a shadow of doubt. Jean's tale troubled him a little, aroused a vague sense of remorse. Images came into his mind which were not at all reassuring, but brutally symbolic, where the inflexible and barbaric law of violence is affirmed. François Pinchard and the carpenter Coudray, Guy de Kerdaniel and himself, Bolorec, a martyr fiercer than his executioners, the squirrel, the bailiff's clerk, Monsieur de Kerral's dogs, all of them, in the depths of his consciousness, jostled together, linked by strange analogies, suddenly illuminated by fierce glimmers of light. Clenched fists, gaping maws, tearing hands, savage mobs, a dark and disturbing intimation of undying hatred, a confused and fleeting vision of universal violence: all this created in him a sense of unease which the walk and Jean's twittering voice soon dispelled. Bolorec had gone back to carving his boat; the crocodile of children had re-formed, and evening came, tinging the horizon with a dull orange gleam which bestowed on the firmament a mystic light like the effect of light through stained glass. Beneath the canopy of chestnut trees, a soothing, church-like shadow enveloped the columns of trunks and the network of branches; purplish clusters of lilacs sprang from stony escarpments and blazed against the greener background of the meadows. Within his heart, troubled only temporarily, happiness returned, clear and serene; remorse evaporated, hope reappeared, unsullied. A few farmworkers passed by on the road, sheathed in long, coarse, white shirts, some drunk, all vermin-infested and covered in mud. Sébastien watched them go by, and he saw in them supernatural beings, saints come down from the stained-glass windows in a church, angels flown from the chapel arches, accompanying him and watching over him. Everything was enlarged, embellished, ennobled by his imagination and took on the happy, exultant forms of tenderness and prayer.

As they walked back alongside the port, he saw more things to console him. Everything had come to life and was shining brightly. The tide was rising, slapping lightly against the walls

of the quay and the submerged hulks. Set upright again by the waves, the schooner bore her mast proudly, gilded by the last rays of sunlight; a few fishing launches were being rowed back in, sails furled, with a sound like rustling silk; and the seagulls skimmed the gleaming water in bold, playful flight. The air was impregnated by a salty smell mixed with powerful gusts of coal tar. The child breathed it in voluptuously, his soul filled by the enchantments of travel, the vast blue sea, the diffuse scattering of light. His imagination leaped the bounds of earth, which seem hard-edged and darker at this hour, blocking the horizon, and he reached up towards the concept of infinity.

In the little square near the school with its Gothic houses, two young girls of the same height, with the same graceful, delicate build, and wearing identical clothes, stood with their mother to watch the pupils go by.

'They're Le Toulic's sisters. He's in your class, you know the one who always comes top,' explained Jean. 'Mama always calls them "the two husbandless girls", because they would like to marry, but they can't find anyone. They have no money. Le Toulic's father used to be in charge of the wolf-hounds. He died. The girls are very pretty, though!'

They were indeed charming, clothed in shadow, their delicate twin silhouette against the backdrop of a shop whose lamps were just being lit. Beneath the veil through which he could just make out their faces, bathed by the errant beams of the evening light, Sébastien glimpsed the glow of a double sun, setting far off in the deep waters of their eyes, and he felt moved.

He did not work at his studies that evening, filled with indolence when faced with his books, overcome by weariness at the prospect of having to conjugate irregular verbs. His elbow resting on his dictionary, his penholder idle between his fingers, he sat daydreaming for a long time. His head was full of too many things, the day had been filled by such a tangled succession of events that he needed to try to coordinate them, savour them one by one and attempt to extract from them some new rule of conduct, some insight into a more appealing

future. However, he could not focus on any one of those mobile, turbulent images. Everything swarmed about inside his brain: landscapes, boats, idyllic gardens, chateaux decked out for parties and glimpsed at the far end of long, brightly-lit avenues, drums beating, dogs barking, squirrels leaping. He paused a moment to contemplate Le Toulic's profile. He was sitting not far away on the right, bent over his sheet of paper, barricaded in with books, swotting away at his homework, frowning, cheeks pink, fingers inky. He felt a strong urge to get to know him better, to talk to him about his two sisters, sweet as they were in the trembling indecision of evening. He suddenly felt for him a fierce friendship. Maybe Le Toulic would also invite him to visit his home, like Jean de Kerral. That would be an unforgettable time spent in the company of that mother and those two girls. Doubtless they would take walks together by the port, on the shore; he briefly saw a veil lifted on those privileged interiors, imagined entering on an equal footing into those unknown lives, which he had believed closed to him and whose captivating mystery was intensified by the odd word caught here and there. His dream changed direction, grew bolder and moved towards the impossible, venturing into the forbidden worlds where Guy de Kerdaniel ruled. He reined it in and went back to its point of departure, reality: Jean de Kerral with his gentle, seductive voice, to those unexpected promises, which had suddenly broken his bonds and set him free to live. At last, Sébastien fixed his stare on Jean's back; the boy was seated three rows in front of him. The whole of his new-found life was there, resurrected in that agile back, shifting, sometimes rigidly upright, sometimes bent, and seeming to glow with the glamorous tales of the afternoon. That back blazed like the sun. Joy sang out all around; joy sang out everywhere.

He felt an urgent desire to confide his happiness to someone, that is, to express it for himself, to render it in some way visible and tangible by material representation. He wrote to his father: a long letter full of feverish, incoherent enthusiasm, marvellous projects and childish foolishness. For the first time, he did not think to write an affectionate word, a message for

his friends at home, now forgotten, for Madame Lecautel, Marguerite or anyone else.

In the days that followed, Sébastien was totally happy. Most important of all, he was no longer alone and he knew himself to be protected from any possible return to unhappiness. He started playing again as he used to at home, taken by Jean de Kerral to play real tennis and other games, in groups where, thanks to Jean, the others put up with him almost affectionately. He found in himself ways to embellish his hours of rest and sleep. With this more intimate, rather than purely physical contact with his schoolmates, with their very different personalities, their dissimilar passions, his mind was constantly enriched with new discoveries, a thousand little insights into other people's thought processes, which constantly fed his appetite for knowledge and occasionally offered an explanation of his own feelings. His thoughts were now more active, more identifiable with his ego, and became his faithful, infinitely dear companions, vanquishing boredom. Often they carried him off beyond the brutalities of external appearances, into dazzling worlds, to the frontier between the real and the invisible where, by rendering shapes, sounds, scents and movement supernatural, they developed into a kind of unformed, precocious and initially unconscious awareness of the beauty of art and the essence of love. Initiated by his friend into the secret details of what was currently thought to be important, ignorance of which in the past had so distressed and trammelled him, he also became bolder in his relations with other people, and his self-confidence increased. However, he still did not dare to approach Le Toulic because of his over-serious manner and his overly pedantic ways. Le Toulic, an inveterate swot of slow intelligence, reluctant memory and obstinate Breton will, pretended to be interested only in his homework and even spent part of his break with his nose in a book. When he was not studying, he could always be seen clinging to the soutanes of the teachers and supervisors, whom he monopolised as soon as they made an appearance in the playground. Sébastien did not love him any the less, delighting in following his activities from afar, discerning in

his serious, grumpy manner some trace of the attractive charm of his two pretty sisters, who had aroused his young man's instincts when he saw them that evening.

However, as his intelligence broadened and pale glimmers of light pierced the vast field of his day-to-day observations, as the desire to learn developed in him, he grew ever more disgusted with schoolwork and this disgust grew to the point where the mere sight of his books caused him pain and irritation and almost made him ill. He had to force himself to open them and study them. Corporal punishment: dry bread, detentions, being banned from the walks, and moral punishment: the public shame of low positions in class, actually strengthened this frame of mind instead of reforming it. His reputation as an idle dunce was soon established and it hurt him, but it was something he could not help.

In children, who, by nature, are keen, passionate and curious, what is referred to as laziness is often merely an awakening of sensitivity, a psychological inability to submit to certain absurd duties, and a natural result of the distorted, unbalanced education given to them. This laziness, which leads to an insuperable reluctance to learn, is, contrary to appearances, sometimes proof of intellectual superiority and a condemnation of the teacher. Such was the case with Sébastien, though he did not realise it. What he was forced to learn bore no relation to any of his latent aspirations or the germ of understanding that was within him and awaited only a ray of sunshine to draw it out, as winged butterflies from their chrysalids. Once his homework was hurriedly despatched, his lessons recited, none of what remained in his memory made him think, interested him or seemed to concern him; consequently nothing, neither forms, ideas or rules, took root in his brain; and he was happy just to forget it all. He had the impression that his brain was just a succession of paralysing thuds, a cacophony of barbarous words, a senseless montage of Latin words, which he found repellent and whose uselessness oppressed him. There was never anything harmonious or pleasing which might tie in with his dreams, no clear explanation of the things that so tormented him. In the real world there were things which

beguiled him, astonished him; there was secret communication between his untutored soul and the things around him; he divined something of the inherent mystery in the world about him, delicious to unveil, of teeming, deliciously diverse life, but they were determined to shroud it all with the thickest and grimiest of shadows. He was torn away from nature, blazing with light, to be transported into an abominable darkness where his spontaneous dreams, his childish discoveries, his enthusiasms were taken and returned to him debased, subjected to ugly deformations, welded on to repellent lies. He was stuffed with distant dates, dead names, vulgar legends whose monotony and horror crushed him. He was escorted through the gloomy cemeteries of the past and obliged to bang his head against empty tombs. They were always talking about battles, savage hordes on the march towards destruction, blood and ruin; they showed him the fearful faces of drunken heroes, undaunted brutes, terrible conquerors, odious and bloody puppets, garbed in animal skins or armour-clad, who symbolised Duty, Honour, Glory, Country, Religion. And over this whole abject, mad hurlyburly of brutal assassins and homicidal gods, above these shadowy horizons, filled with the carnival red of massacres, there was always the image of the true God, an inexorable, colourless God, with a bristling beard, ever furious and thundering, a kind of maniacal, all-powerful bandit, whose greatest pleasure was to kill, and who, garbed in storms and crowned with lightning, travelled howling across space or else lay in ambush behind a planet brandishing his thunderbolt in one hand and his sword in the other. Sébastien refused to admit this bloodthirsty demon as his God and continued to love his own God, a charming God, a pale, blond Jesus, his arms full of flowers, his mouth wreathed in smiles, blessing children, his gaze constant in its boundless goodness and inexhaustible compassion.

However, he was not completely reassured by this consoling vision. Doubts plagued him and he was haunted by the image of the Jesuits' extravagant and sombre God. He would then go over all his sins, examine minutely his smallest misdemeanours, suddenly terrified that this pitiless God might

grab him by the throat and plunge him into hell, as he had done, so they said, to many badly behaved children who had not worked hard enough. In class and study periods and when expected to speak in lessons, his brain became heavy, his faculties dimmed, even his voice froze when it was his turn to say something. He tortured his little brain in vain: he could make nothing come out. Neither could he force into it the bizarre ideas contained in this teaching, which perpetuated a more serious version of whimsical stories about ogres and fairies, officially endorsed by the schoolmasters. Sometimes, on Saturdays, to amuse the pupils, the teacher would read out stories about the French Revolution, dramatised tales of the wars in Brittany and the Vendée. Sébastien recognised in them the same monstrous figures as appeared in the text books, the same band of sinister lunatics, the same clamorous warmongering and savage hatred. But this time the names of kings and conquerors were replaced by the terrifying names of Marat and Robespierre; the guillotine played a major role in these tales and was as red with blood as great men's spears and God's sword. He did not understand why he was obliged to hate one lot whilst being urged to venerate the others. He listened hard, hoping one day to hear references to Jean Roch, Pervenchères, the church and the donkey, but doubtless this was too small a massacre for it to have any chance of awakening children's imaginations, accustomed to hearing about so many human hecatombs. As soon as he could escape from those wretched classes, which weighed on him and filled him with horror, he would wander around the yard again and the dreary thoughts soon flew away; he took even more pleasure in his games, far more precious than all those talks. He even got used to being sent out of class and no longer felt any sense of boredom. Leaning against a tree, he enjoyed watching life humming and bustling around him and, occasionally, he threw pieces of bread for the birds, and the sparrows fought over them so prettily it filled him with delight. In this way he disassociated himself totally from work and soon, without any feelings of remorse, he gave up doing his homework and spent the long

hours set aside for study dreaming of gentler, pleasanter things; he conjured up shapes, sounds, visions, now sad, now joyous, according to his mood; he created in his mind a great multitude of poems, through which, naive and unaware though he was, he reached out towards the mysterious life of the Abstract. He also tried, instinctively, to reproduce objects which had caught his eye; he covered exercise books and textbooks with drawings of leaves, branches, birds, boats and the pale face of the teacher who, seated high up, enthroned behind a lamp, enveloped the silent schoolboys with his cold, vigilant stare.

At this time, of all the religious observances, confession was the one which upset him the most. Whenever he went to confession he felt very troubled, and his heart beat faster, as if he were about to commit a crime. The solemn, shadowy apparatus surrounding this obligatory act, the silence, the darkness out of which emerged a whispered voice terrified him. In that darkness he felt he was witness, accomplice to some unknown enormity, a murder perhaps. The feeling was so acute that he needed all his courage, all his common sense, not to shout out and call for help. Father Monsal was his confessor, a large priest with a red face, nodding head, thick lips and honeyed manner, who embarrassed him with his questions. He interrogated him on his family, his father's habits, the entire physical and moral setting of his childhood, ripping aside with a brutal hand the veil of intimacy protecting his home, forcing the innocent little creature to inform him of possible vices and probable sources of shame, sifting with a hideous slowness the muddy deposits left in the cleanest of homes, as in the most honest of hearts. Sébastien felt a strained, tense feeling of revulsion towards this man sitting there near him, such as one feels at the sight of certain soft, creeping creatures. He felt that the slow, moist words coming out of that invisible mouth condensed and stuck to his body like slime.

'And do you speak familiarly to your father, my child?'
'Yes, father.'
'Ah, that's very bad. One should never do that, it shows a

87

lack of respect. You will cease to do so from now on. And have you a sister, my child?'

'No, father.'

'No. Ah. A cousin, a girl?'

'No, father.'

'No cousin either. Good, good. That is very good my child. But you must be friendly with some little girl at home, hm?'

'Yes, father.'

'Ah! Good! That's very dangerous. What is she called?'

'Marguerite Lecautel.'

He was astonished to have uttered that name in the dismal darkness. It felt like a betrayal, a slander, something horribly vile and low. And Father Monsal's voice started again, muffled, escaping in little wheezes and gasps, mingling almost imperceptibly with the sound of his rustling surplice and the creaking wood:

'Marguerite? Ah! Now then, tell me my child, have you and she ever touched one another impurely? Tell me, when you are alone, do you sometimes kiss her? Does she sometimes, often, kiss you?'

'I don't know.'

'On the mouth? Ah, that's very serious, that is a very serious sin. Tell me also, do you not go a little further with her, for example, yes, you don't feel a desire to. . . . Well, I don't suppose you go a little further together to satisfy a certain need, eh?'

'No.'

'Well now, that's very good.'

He mumbled some Latin words; his hand crossed back and forth behind the grille, bestowing vague blessings. Then, very red, close to tears, his skin crawling with shame, Sébastien came out of the confessional, feeling that something of Marguerite's modesty and virginity had been left trapped between the violating hands of that man.

At this juncture, he experienced a great disappointment. On the very same day, he had received from his father a letter which was both angry and delighted. Monsieur Roch suffered

a great deal to see his son's bad marks and low position in class; he had hoped for better: 'I do understand, of course,' he wrote, 'that you cannot get a higher position than that, and I do not reproach you for that. It would not be natural that you should be placed ahead of so many wealthy, young people of noble birth. Hierarchy in society is essential and the sooner one inculcates that into children the better. If all Frenchmen were brought up by the Jesuits, we would never have to fear revolution again. The parish priest shares my opinion and says that hierarchy is essential. However, I am saddened, nay, mortified to learn from a letter I received from the Prefect of Studies – admirable, by the way, full of lofty ideas – that you are an idler, that you do nothing, that your teachers cannot get any serious work out of you. I do not ask that you should be top of the class, that cannot be; but I do demand that you work, for I am making huge sacrifices for you, I am being bled dry and I am denying myself everything in order to ensure a superior education for you. And yet look what is about to happen to you . . .'

Here Monsieur Roch's tone became exultant.

'Was I mistaken when I said that you were destined for a brilliant future? You see, you are about to enter an illustrious family. The Kerral family is very famous. The priest and I have searched for it in the annals of our glorious history. It is an historic family. It is mentioned by name everywhere in accounts of the revolution. There is a Count de Kerral who emigrated, was captured in Quiberon and shot in Vannes . . . in Vannes itself, my dear child! I am very proud of this connection for you. When you visit this great family, above all, behave properly, be very polite and respectful; watch your manners and your language; your clothes should be well-brushed so that I do not have to blush for you. You will offer this noble family my gratitude and sincere respects. So, let this be an encouragement for you.'

He added:

'Father Monsal is right. As far as paternal authority is concerned, and the development of the idea of family in present and future generations, it is best if children do not

speak familiarly to their parents. That is how it is in aristocratic homes. Furthermore, my child, remember this: everything that the Jesuits tell you is founded on reason, feeling and on a very proper desire to protect society. If they are masterly politicians it is because they are also masterly teachers.'

Monsieur Roch continued in this vein for two long pages of closely-written script, embellished with curlicues and flourishes. Sébastien was reading this letter when Jean de Kerral emerged from the parlour and came over to him.

'Now, you mustn't get cross with me, because I do still like you, but Papa has told me I can't take you to Kerral.'

Sébastien felt a sudden, terrible chill to the heart and, turning very pale, he dropped his letter.

'Just this moment . . .' he stammered, 'my father wrote . . . because . . .'

'Yes, well, you see,' interrupted Jean. 'Papa pulled my ears and said, "If we listened to this little rascal here, we would have the whole school round." So anyway, he didn't want me to, nor did Mama. They asked me who you were. I explained you were an ironmonger and that you get teased because of it, but that you're very nice all the same and that I had promised to show you my hussar's uniform. Well, then they forbade me to speak to you at all. They said that you're not the right sort of company for me, that I will learn bad habits off you, you know, and they started going on at me that I've got this mania for attaching myself to tramps. I replied that you're not a tramp, that you're not scruffy like Bolorec, but anyway, there you are!'

Jean looked worried, fidgeting and glancing nervously about him. He started again, jabbering:

'I'm not to mix with you, we mustn't be seen together. Father Dumont came over and promised Papa that he would keep an eye on me. But I'm still your friend anyway. I will speak to you sometimes when no one's looking, you know. And no one has forbidden Bolorec to spend time with you. You can be Bolorec's friend. He's very nice Bolorec is. I'm off now because that priest is watching us. He'll catch me if I

spend too long chatting with you. Ah, well. Oh, and you'll have to give me back the leather ball I gave you.'

Sébastien did not cry. The pain of the blow was so intense he thought he was going to faint. He wanted to shout out: 'Jean! Jean!' but could not. His throat was tight, his head buzzing and empty, his limbs cold. He tried to take a step and could not. The ground beneath his feet gave way, crevices opened up. Red lights danced before his eyes. Jean skipped lightly away.

The following day, the pupils went for a walk on the road to Elven. They stopped in the Kerral woods.

'Did he promise you he would bring you here too?' said Sébastien to Bolorec, who had not said a word since the start of the walk.

'Yes.'

'And then afterwards you weren't allowed?'

Bolorec shrugged his shoulders and, apparently not listening, picked up a sliver of wood which he started to examine attentively.

'And did you not feel hurt?' Sébastien persisted.

Bolorec shook his head.

'Why not?'

'Because I didn't . . .' explained Bolorec.

'So you didn't really care for Jean?'

'No.'

'And what about me? Do you care for me?'

'No.'

'So you don't care for anyone?'

'No.'

'Why?'

'Because I don't give a damn,' replied Bolorec who had pulled a knife out of his pocket and had started to carve the piece of wood.

And he added, calmly:

'Not for any of them!'

Sébastien then caught sight of the chateau, a large house flanked by turrets, sloping roofs, angular, disparate buildings, all lopsided and as sad as a ruin. Moss was eating away at the

rooftiles, the walls were all cracked and stained; on the bald, mangy façade large areas of roughcast had flaked off; the sand along the avenues had worn away and was fast becoming clogged with scruffy grass and dead leaves, trampled by cattle, chewed up by heavy carts. The huge, rusty iron gates were surmounted by an escutcheon with the seal broken off, and it creaked in the wind like a weather vane. Near the chateau, hidden behind a scrubby clump of holly and separated from it by a ditch full of blueish, stagnant water, a low, damp, filthy farmhouse crouched, creating a square yard, a sort of open sewer, in which pieces of cut turf lay rotting on a thick layer of ancient dung. It gave off a stench of manure, of putrefying vegetation, a whiff of putrid humanity, unbearable, pestilential. All of a sudden, Sébastien caught sight of Monsieur de Kerral, a small, stocky man, red-faced and with a drooping, blond moustache, his legs gaitered in tawny leather. He had a whip in his hand and was tapping the tree trunks, whistling a hunting song. He combined peasant and gentleman, soldier and vagabond. Monsieur de Kerral came up to the priests, with a skipping gait like his son's. He looked very like him in every way, but there was a harder look in his eyes. His clothes were both pretentious and unkempt; his black velvet jacket bore huge metal buttons depicting fleurs de lys in relief. Jean ran up, chattering, very proud to be seen by his friends in his own domain. The other pupils fell silent, a little embarrassed, and formed into small groups between the trees. They had been forbidden to chase squirrels or cut branches. Monsieur de Kerral, the priests and Jean made their way towards the house. High up on the stairway with its uneven steps, a woman wrapped in a red and green checked shawl stood waiting, her elbows resting on the wrought-iron railing. A shrill little voice could be heard:

'Good morning, Reverend Fathers. How delightful that you chose Kerral for your walk.'

More surprised than disappointed, Sébastien roamed through the wood, walked the length of the crumbling walls and the abandoned gardens, finding only the traces of what had been, the debris of things dead or fallen, buried beneath

the brambles. Through the gaps between the branches of the oaks and pines, he glimpsed views of the moorlands, an arid, desolate, black terrain, dotted here and there with meagre little fields, their soil full of roots and stones, only tamed with difficulty, then bald hillsides on which windmills turned. He remembered Jean's story of the bailiff's clerk and the six dogs. Every detail which had made him laugh so much then came back to him, precise and this time painful. His heart tightened. Ah, how distant was his dream now. How he repented of having so obstinately nurtured that dream, not because that longing for magnificence had eventually led to these ruins, to this squalid setting, to that man, hunter of poor wretches, but because a new emotion was penetrating his soul and overturning all his ideas: something strong and warm, like a draught of wine. He had just seen Monsieur de Kerral and he hated him. He hated him and those like him. To these men, living amongst other men, like beasts of prey amidst game, and of whom his father had spoken and told him several times that they were to be admired and respected, he compared those of his own kind, who toil to meet their daily needs, small existences eked out side by side, helping one another, working together to achieve tomorrow's hopes; and he felt proud to have been born amongst them, to represent their painful history, to reap the inheritance of their struggles. He found greater nobility in his father's overalls, the neighbours' smocks and tools, whose sound as they worked had been his lullaby as a child, than in the insolent gaiters, the whistling whip and the fleurs de lys of this Monsieur who had despised him, and along with him all the little people, all the humble folk, all the nameless ones, who have not killed and have not stolen. That comforted him. Faced with the image of inner decay evident in the chateau, which was collapsing stone by stone, and that soil, exhausted from having nourished men without pity or love, he felt true relief. He amused himself imagining behind those shaky walls, beneath those proud, toppling towers, which had never sheltered anything but wicked and barbarous opulence, a horribly sad life, more desperate than that of beggars, on whom, occasionally, the warm sun of charity smiles, a

life outside life, lost in the gloom, overshadowed by the irreparable, whose final fall and ultimate death agony was brought nearer with every minute that passed. And this created in him a profound sense of joy, quite wild and terrible, this thought of justice, in which he felt the intoxicating savour of revenge shivering within him, revenge for his own misery and for all the miseries of his own kind. Whatever blood of the people flowed in his veins, whatever proletarian ferment brooded there, whatever centuries-long suffering and endless revolt had been deposited there by a long succession of ancestors, with their calloused hands and their backs bent in subservience, all of this was roused from its atavistic slumber and burst forth in his child's soul, which, though ignorant and innocent, was large enough, even at that very second, to contain an immense love and immense hatred on behalf of all humankind.

Noticing that he had become separated from his companions, Sébastien rejoined them, grave-faced, haunted by the idea that, from now on, he had a mission to fulfil. Without defining it clearly, without disentangling the means and the end, he could glimpse it, a fine, courageous commitment. First of all, he no longer accepted that the other children should reject him; he would be the one to reject them. He made up his mind to make people respect his father, his memories, the things he was fond of, and anyone who dared so much as touch on them, had better watch out. He had had enough of the submissiveness that rendered him small, humble, suppliant and fearful. He would no longer put up with the cruel suggestions, the offensive remarks, the scorn that had swamped him hitherto, nor would he be the plaything of a capricious, hostile crowd, he would not watch himself being pursued by it, like the bailiff's clerk by Monsieur de Kerral's dogs.

'No, I'm not going to take it any more!' he said out loud, kicking up the dead leaves as anger mounted in his head. 'I'm not going to take it any more.'

Bolorec was still in the same place, whittling his piece of wood. Two pupils nearby were pestering him with jokes which were neither very insulting nor particularly nasty, but

Sébastien could no longer control his precipitate emotions. He yelled at them:

'Leave him be! I forbid you to annoy Bolorec! He hasn't done anything to you!'

One of them advanced, hands on hips, threatening.

'What are you wittering on about? Ironmonger, filthy ironmonger.'

Sébastien leaped on him in one bound, knocked him over and slapped him several times, saying:

'Every time you even think of insulting me, you will get the same . . . you and the others.'

The beaten child got up in a pitiful state.

'Yes, my father is an ironmonger,' confessed Sébastien. 'And I'm proud of him, mark you. He doesn't set dogs on poor unfortunates.'

Hearing the noise of the fight, a few pupils had come running. No one dared to reply and Sébastien was tugging at Bolorec to make him follow him, though he seemed not to have noticed anything.

However, on the way back, Bolorec proved more expressive than usual. He said:

'Next time, I'll carve you a nice root and I'll make you a whistle with a dog's head or something on it. Sometimes, in the holidays, Papa takes me with him in the carriage when he visits the sick. I carved the handle of his whip. It's two tibias, you know, bones, yes, two tibias with a skull at the end. I saw something like that in his study, on his desk and in his books too. His books are great, they've got people's hearts and things . . . they're like flowers. There's nothing in the books here, it's boring.'

Moving closer to Sébastien, he spoke very softly, having made sure that no one could hear.

'Listen, promise me you won't repeat what I'm going to tell you. You promise? Well, you know how it's the emperor who rules . . . well, he rules because he reinstituted religion. Did you know that? Well, the Jesuits want to overthrow him and bring back Henry V. I know for sure because Jean heard the Jesuits talking about it with his father. Well, I wrote to the

government about it and they're going to close the school. And then they'll kill the Jesuits. And then everyone else. See!'

'Are you sure?' asked Sébastien, terrified.

'Haven't I just said so!'

'And so we'll go back home?'

'Yes.'

'And never come back to school?'

'Never.'

The rest of the route back was completed in silence. They did not notice the moorland clasped by the two arms of the sea, crisscrossed by rivers of gold, scattered with Biblical lakes, the moor slipping away into the distance in the evening tides, a rosary of mysterious islands, shaped like huge fish or wrecked boats. They did not notice the town either, where the shops were beginning to light up, nor the two girls, so pretty, standing in their usual place near the school. Both were thinking. And their thoughts were the same. They were thinking of beloved things at home, of familiar faces, but the huge door creaking open before them put those smiling images to flight.

A few minutes later, Jean de Kerral came up to Sébastien in the yard, while they were getting back into line to go back into class. He asked him:

'Did you see the chateau? It's beautiful, isn't it?'

Sébastien did not reply and stared at Jean, his eyes hard. At the same time he thought of that man striking the trees with his whip, he thought of the dogs and the bailiff's clerk. The emotions he had experienced in the wood at the sight of those walls, those turrets, now returned with renewed violence. Hatred drove him, turned him against Jean. He wanted to cry out: 'Son of a murderer!'

'Why are you looking at me like that?' begged Jean. 'You're mean. It's not my fault, you know that. I'm very fond of you, it's Papa who didn't want you.'

'Your father, your chateau, you . . .' began Sébastien.

But he stopped, troubled and defeated. Jean stood before him, so sad, looking at him with such surprised, gentle eyes, that his anger suddenly melted away. He remembered how he

had come to him, kind, affectionate, when everyone else had turned away from him and scorned him; he remembered the vows they had exchanged. He said almost tenderly:

'No, don't say I'm mean. I'm fond of you too.'

Sébastien was fascinated by Bolorec. His impassive nature disconcerted him; his smile, a kind of grimace in that soft round face, was ambiguous. He did not know whether he should admire him or fear him. Did he like him? He found it difficult to say. He was worried by the fact that Bolorec had never addressed a single affectionate word to him. He never played and could spend entire days without saying a word, and it was impossible to penetrate his silence. He could always be found carving wood or small pieces of soft stone which he collected carefully when they were out on walks. He was very clever at constructing miniature works of art, difficult and complex, boxes fitting one inside the other, cases, boat-riggings; he was an extraordinarily gifted sculptor: dogs' heads, birds' nests, Zouave faces with long, flowing beards, like the ones you see on pipes. However, he was a mediocre student and did not attempt to hide his reluctance to learn. He had a good memory and keen intelligence, but his body was slow, flabby, verging on the misshapen and he could almost be mistaken for an idiot. Then, all of a sudden, for no plausible reason, as if he felt the need to break those heavy, accumulated silences, he would talk and talk. He spoke in short, disorganised, disconnected sentences about outrageous things, often crude and embarrassing, extravagant plans to burn the school down, resolutions to escape by night, breath-taking escapes along the roofs above the walls; sometimes too, he would tell folk tales, naive and charming legends of the Breton saints, which his mother had told him. Afterwards he would lapse into his usual silence. What seemed inexplicable to Sébastien was that Bolorec disdained all insults and jibes. When the others mocked him or struck him, he did not even turn round; he simply walked calmly away, never complaining, never rebelling. In the end, this laconic attitude had worn down the major bullies, such as Guy de Kerdaniel. Now hardly anyone bothered him, other than the bully's little lap-dogs, yapping

round his ankles, knowing that they were in no danger. Bolorec and Sébastien, always together, had reached the stage of never mentioning it to each other. They spent recess seated under the archways near the music rooms and they never tired of listening to the nasal scales played on the violin, the skipping gaiety of the piano and the savage, raucous, brassy explosions of the trumpets and bugles.

'I would love to learn music,' sighed Sébastien.

And Bolorec would sing the Breton words of an ancient dance tune, swaying his head to mark the rhythm.

Music was a deep and important source of pleasure to Sébastien. In the morning, he got up and, still half-asleep, attended the low mass, which was conducted in silence in the cold, bare, shadowy chapel, accompanied only by mumbling. The more bored he was by this and the more the multiplicity of religious observances that the pupils were obliged to pursue predisposed him to laziness, weakness, to disgust and an oppressive obsession with that sly, cruel God whom he hated, the more he looked forward to the high mass on Sundays. On that day, the chapel had a festive air, the altar decked with flowers, ablaze with lights reflected over and over in the gilt and marble, the officiants in their brocaded stoles and their lace albs, the great picture window opening out behind the blueish vapour of incense onto mystical paradises and, added to all that, the unearthly voice of the organ and the seraphic music of the choir, singing the beautiful refrains of Handel, Bach and Porpora: this was the triumph of his own God, his good, magnificent God, who was all beauty, all love, all harmony, all ecstasy. On Sundays, he truly felt close to God; he had a physical vision of him, touched his radiant flesh, his halo of hair, counted the beats of that redeeming heart from which forgiveness flows. Those melodies touched him physically, conquered him spiritually and awakened something in his soul which pre-dated his being, coeternal with the very substance of his God, the seamless continuum of immortal metempsychoses. Whilst that music flowed forth he actually witnessed the birth of exquisite forms, thoughts and prayers metamorphosed into real shapes, like saints or lilies, that

towered over him; he saw celestial landscapes made into paradises by a light that was at once mysterious and familiar, exploding into constellations of flowers, clusters of stars; he saw aerial architecture joining with the clouds, becoming a whirl of planets; a whole immaterial world blossomed, flowers bloomed and then disappeared in a rapturous exhalation of perfumes. Any tenderness or beauty he had experienced, all the stifled dreams and captive aspirations that had accumulated in his heart, everything was brought to life anew by that music; all this pure passion beat its wings, amplified, idealised, embellished by the purifying grace of love. Delicious, gentle tears flowed from his eyes; he was filled with a kind of sacred pain; his nerves were aflame with sensuality, a feeling so acute that sometimes he felt close to fainting or falling into a fit. When the terrible sound of the organ swelled, when the voices of the choir rose in exaltation, celebrating the miracle of the Eucharist, then he felt the same poignant emotion, the same overwhelming admiration he had felt once watching the sea in a storm. Then he had been left with an enduring sense of unearthly, sacred grandeur, his puny being was rendered supernatural and fused with the vast and the omnipotent, a feeling which returned there in the church, in even more powerful and austere form. He wished he could lose himself in those rolling waves of sound, allow himself to be lifted on that great tide of harmonies, where human brutishness vanished and even the weakest were treated gently, like the seagulls he had seen bobbing in the wake of a great ship, and he could let himself be embraced by the great musical swell. Stunned, exhausted, with the taste of incense lingering on his lips, the taste of the divine, Sébastien would return from the mass, as he had come back from that sight of the sea: weak, unsteady on his feet, retaining for many hours the heady, intense tang of salt on his lips.

From these heights where his soul had soared for an instant, he plunged more heavily than ever into the odious routine of his daily duties. His books horrified him all the more; he understood all the better how terrifyingly empty they were, how barbarously dishonest and depressingly alien. As soon as

he opened them there was instant darkness, a black, opaque night that enveloped him and where there lurked sticky grubs with priests' faces. Ah, how he wished he had a voice like the boys who sang in the church. How intoxicating to be able to draw from a wooden instrument or a sheet of metal those harmonies that pour forth ecstasy. How wonderful to be able to produce that magical, blessed language which expresses everything, even what remains inexplicable. He begged his father to allow him to learn music. But it would mean paying for extra lessons and Monsieur Roch was quite scandalised by such a request, which he felt was not what he expected from a 'serious, well-brought-up boy'. Monsieur Roch wrote back to him that music was a mere pastime, unworthy of a man and good only for women who have nothing to do, or the blind who have to beg for their bread. After all, he had never learned music. Did his son intend to become a tramp or an accordionist, like François Martin, whom everyone mocked? A band of German musicians had recently come to Perven-chères. They were dirty, ragged, with long hair and looked like rogues. They were strongly suspected of having set fire to the local grocer's shop. All the musicians he had ever known were just the same: ragamuffins! Drawing was the same. Should drawing be part of a masculine education? Did Napoleon draw? He won battles and drew up the Code Civil, that incomparable monument, that pillar of modern civilisation. No, no, a hundred times no! He expected his son to learn solid subjects and nothing but. He was not being bled dry so that his son – his only son, the last hope of the Roch family – might later end up tramping the roads, a clarinet under his arm. Music! Drawing! Had he made up his mind to be the despair of his family?

Sébastien resigned himself. Perhaps his father was right. There was no doubt that he was lazy, a bad child, and that he did misbehave. His distaste for homework, his desire for forbidden things were wrong, of course, but out of his control. He obeyed invincible forces against which he had no power. He realised that since his arrival in the school he had changed greatly. He lived in brief snatches, in a state of continual

anxiety, going from one decision to another, without keeping to any, going from enthusiasm to boredom, one day repelled by his situation, the next resigned, his head and heart full of contradictions, different aspirations, which seethed, unable to break free; what was he waiting for? For someone's encouraging, benevolent gaze to rest upon him? For a guiding hand to lead him through the cluttered avenues of his intellect? He did not know. Despite his father's letter, he continued to loiter near the music rooms, in the vague hope of discovering the secret of that wonderful, forbidden science, which seemed to him like a great doorway of light opening onto nature and mystery, which is to say, onto beauty and love.

'Sing me that pretty song,' Sébastien would ask Bolorec.

Without raising his eyes from the piece of wood he was carving with the tip of his knife, Bolorec would sing, sometimes interrupting himself to explain something.

'You see, it all takes place on the moorland there. All the women hold hands, and they set off and they turn and come back. Their headdresses are white and sway about. They have velvet on their red skirts. And Laumic sits on a barrel and plays the Breton bagpipes. It's lovely.'

But Father Dumont often chased them away.

'What are you two doing there again?' he would say sternly. 'It's not respectable for you to spend all your time together. Go out into the yard.'

So, reluctantly, they would leave, walk the length of the fences, stop at the fountain where they would play around, turning the tap on and off for a few minutes; and then they went back to the archways, as soon as the priest had moved away to read his breviary under the trees or play a game of real tennis with the privileged pupils.

'Why does he say it's not respectable for us to be together?' asked Sébastien, troubled by the priest's objection, which he did not understand at all.

'Because,' replied Bolorec, 'last year, in the middle school, they found two boys, Juste Durand and Emile Carade, doing dirty things in the music rooms.'

'What dirty things?'

'You know, dirty things . . .'

And with an grimace of disgust he added:

'Dirty things, like when you make children.'

Sébastien blushed, not attempting to go any deeper into what Bolorec said, though he guessed at culpable analogies and shameful correspondences with the questions with which Father Monsal assailed him at confession.

The weeks went by in this way until the Easter holidays, relieved only by the jolly carnival celebrations, which involved lavish meals, plays and lotteries, in which the losers won plates of gruel which they had to eat there and then while everyone else laughed and clapped. There was an academic joust, in which philosophy students argued eloquently about Descartes and came up with witty, spiteful taunts about Pascal. There were concerts, fencing matches, a whole series of entertainments in historical costume, in which Sébastien, despite the novelty of these spectacles, took meagre pleasure, a pleasure which consisted in enjoying the opportunity of being more alone with Bolorec and having discipline relax a little and classes interrupted. They acted out a play by Sophocles, translated into Latin verse by Father de Marel, with interjections by the chorus sung to the *William Tell* music, also adapted by the same Father de Marel, whose role in the house was to write poetry, in various languages and moods, sad or happy, sacred or profane, and adapt them to the ceremonies being celebrated. He was a plump fellow, round and pleasant-looking, always laughing, and much loved because he represented pure pleasure. He was only ever seen at feast times, when he was unstinting in inventing all sorts of amusing and exciting entertainments. The rest of the time, so it was said, he travelled.

For the three days that Carnival lasted at school, Father de Marel spent a great deal of time with the pupils and he had noticed how subdued Sébastien was, keeping apart from everyone else, and he recognised him as the little boy he had seen under the chestnut trees, near the meadow, on the day that school started, and who had clung to his soutane.

Sébastien had recognised the priest too. He wished he could speak to him, but he did not dare, since he now felt ashamed of his folly, and the Jesuit's presence only intensified his embarrassment. One day, Father de Marel approached him, followed by Father Dumont.

'Well, well, well,' he said in a friendly voice. 'Aren't you having fun? What are you doing moping over here, when there's a party going on? You should be laughing. This is the time for laughter.'

And turning towards Father Dumont:

'He's a fine boy, that child there. He has very intelligent eyes.'

Father Dumont shook his head.

'But so lazy, so lazy! He's thoughtless and incorrigible and very cruel to his fellows. But, above all, he's lazy!'

'Tut, tut, tut! And with eyes like that. It's because people don't know how to handle him. I know him, this little Sébastien Roch. I bet you he would work for me. Come along, Master Sébastien, let me hear your confession.'

His words were full of gentleness and gaiety. They were made to touch the heart and to make people laugh. Sébastien listened to them as if they were music. A great sense of peace entered him, just being there with this Jesuit who was not like the others and who refreshed his spirits gave him new confidence. Father de Marel questioned him with a tender, winning, perceptive benevolence, with an almost maternal skill that invited warmth and confidences, and Sébastien abandoned himself to the compelling joy of answering him, to the soothing balm of opening his savage, solitary heart. Gradually, in charming, childish phrases, at first slow and timid, then rushed and precipitate, he poured out his sorrows, his enthusiasms, his disappointments.

'Let's see now, let's see,' interrupted the priest, touched by the grave naivety of a passion expressed with such unusual force. 'Let's see. What would you like to the learn the most? Tell me.'

'Music! It's so beautiful. It's the most beautiful thing there is. It . . .'

He sought the words to express what he had felt, and not finding them, he indicated his heart:

'That's where I feel it. Sometimes not knowing makes me feel as if I were suffocating . . . because . . . but I would really work hard, because, when I hear music, then I understand things better, I . . .'

'In that case, I will teach you music myself,' promised the priest. 'I will teach you the cornet. It's a lovely instrument. Are you happy now?'

'I would like to sing in church too.'

'Well, you shall sing in church . . . and elsewhere. I shall make it my business. And now, my young friend, let's not think about all that any more. Today you must laugh, frolic, play the fool. Come on now, off with you.'

Sébastien stood there without moving, staring at him, his eyes full of a kind of grave intoxication.

'Come on now, off with you,' Father de Marel said again.

Sébastien said in an imploring voice:

'Father, don't be angry, don't tell me off, but I would like to embrace you, because, well, because no one has ever spoken to me like you . . . because . . .'

But the priest, half-smiling, half-sad, gave him a friendly tap on the cheek and moved away, stirred by a great sense of pity, saying to himself:

'Poor little devil. He's too affectionate, too intelligent, too everything. He will be very unhappy one day.'

The Easter holidays were an unexpected disappointment for Sébastien. He had dreamed of effusive greetings, endless embraces, inexpressible expectations of happiness. From his corner of the carriage that bore him homewards, he watched anxiously for familiar scenery to come into view. As the train approached the longed-for landmarks, emotion gripped his heart so tightly he thought it would break. Already he could recognise the sky he knew, a lighter colour, but more intense; he recognised the contours of the fields, the trees, the farms high up on the slopes, the river gleaming in the meadows, the winding roads along which he had run countless times. Nothing had changed. A bright

sun illuminated this charmingly resurrected vision. All of a sudden, between the crisscross pink of the poplars, there was Pervenchères, a pile of stacked-up houses clambering up a hill, and it had never before seemed so brilliant, so pretty, as it did at that moment, like gay scraps of silk and velvet shimmering in the air; and the church dominated everything, splashed with sun, with a great shadow falling upon it from the side, like a blue shawl. Beyond the wooden fencing alongside the track, he glimpsed Father Vincent in his garden; he wished he could shout out to him: 'It's me, Sébastien!' He was home; he was going to see again everything that he loved. His father was waiting for him at the station. Then it was all over.

'The omnibus will take your trunk. We are going back on foot,' said Monsieur Roch severely.

As soon as they were out of the station:

'Listen to me,' commanded the ironmonger. 'What I have to say to you is very serious. I hesitated a long time before agreeing to let you come home. My intention was to leave you at school, as a kind of punishment. Perhaps I should have done so. In the present circumstances, and for a mere ten days, it's not easy having to spend money on a journey like that, on top of all the money you're costing me already! I'm not a millionaire, for heaven's sake. The only reason you're here now is because I wanted to speak to you myself, to reason with you. I said to myself that doubtless I would have more authority over you than your teachers, and, after all, a father is a father. And furthermore, I flatter myself that I am not just any father.'

People passing by on the road recognised Sébastien.

'Ah! It's Monsieur Sébastien! Good morning, Monsieur Sébastien. How thin you've grown, how pale!'

'He hasn't got any thinner,' protested Monsieur Roch. 'On the contrary, he's fat, much too fat.'

His son get thinner with the Jesuits! He could not admit of such an idea: it would seem like an insult to that excellent order, an indirect reproach towards himself.

'It's just the journey,' he explained.

And rather brusquely tearing Sébastien from the compliments that are the returning hero's due, he again assumed his dignified voice, which trembled with an unusual note of irritation.

'I am outraged, outraged! You cause me nothing but trouble. You see, it is because you are lazy that Monsieur de Kerral did not want to have anything to do with you. He feared setting a bad example to his own son. Good grief, it's obvious. First of all, I forbid you to tell our friends about this misfortune, because I have been careful to tell everyone that you visit this great family regularly. That gave you a degree of prestige with people round here. Anyway, I cannot contradict myself now. If the priest asks you for details, you must give him some, lots. You must say that you saw dungeons in the chateau, you must speak of portraits of ancestors, suits of armour. In short, you will make sure that you do not make me look ridiculous, do you understand? After all, I do have some self-respect. And I am outraged, mortified, I tell you.'

And he shook the boy's arm roughly, to communicate his bitter feelings all the more forcefully and eloquently. Sébastien was stunned by this welcome. From the first words of this conversation, all the charm of his return home had vanished. He was overcome with weariness. As he made his way up the Rue de Paris, he realised how small Pervenchères was, how dirty and dismal, its inhabitants rough and vulgar. Scarcely had he returned the greetings offered him by everyone he met than he missed Vannes with its intriguing maze of streets, its houses with Gothic gables and overhanging storeys, the port, the schooner.

'Yes, I fear,' persisted Monsieur Roch, 'that you are to be the shame of my latter years. What sort of situation would I be in if the Jesuits decided they had had enough of you and wanted to send you back? Each morning I tremble to receive that catastrophic news. People ask: "How's Sébastien? Are you pleased with his progress? Is he doing well?" I don't want to look a fool, so I reply: "Yes." But what can you be thinking of? Why don't you say something? Are you listening? You're standing there like a lump of wood. You don't seem to under-

stand that you are a burden to me, a very heavy burden. Do you think I am rich? But you don't care about anything. If I didn't have you, this year I could have bought the Priory field, which was sold for a pittance, a pittance. See what you cost me. And I could have retired from the business. Instead I have to slave away for you, for a heartless child. I have been stupid. My God, I have been stupid. I should have kept you here and taught you the trade of an ironmonger. But a father is a father, I had ambitions and I have been thoroughly punished for it. And there's your Aunt Rosalie . . . she's not at all well. Her paralysis is getting worse. There's another inheritance we can't count on. And all this time, what have you been thinking of? Music! Here I am working myself to death, living in penury, and it's all your fault. And what do you do? Monsieur wishes to take up music. I am outraged, outraged, outraged!'

At that point, they had reached the shop. Sébastien noticed with astonishment, above the sign, a new banner in garish green and zinc. On the unfurling metallic folds was written in red, Gothic script, the Jesuits' motto: *Ad majorem Dei gloriam*.

'Look at that,' said Monsieur Roch, 'the paint is peeling. Is that right? Well, because of you I couldn't afford to have the shopfront painted for Easter. Music, I ask you! Right, in you go. Straight up to your room. I'll wait for the trunk. And try to put on a better face than that. We don't want the neigbours knowing all our dismal secrets.'

The ten days of holiday were unbearable. To Sébastien it felt like centuries. From the moment he got up to the moment he went to bed, he had to endure the same unending attacks made up of the same mad complaints and the same grotesque exhortations. He had to put up with the most unreasonable reproaches and the most extravagant accusations, whose rank injustice bordered on the farcical. Once launched along this path, there was no stopping Monsieur Roch. If anything happened to him that was annoying or out of the ordinary, he would blame his son. Bitterly, he flung in his face the plummeting price of iron, the recurrence of his rheumatism, a drop in sales, the bankruptcy of a local black-smith which meant a loss to him of fifty francs. Confined to

the house, immured in that room at the back of the shop, so cold and dark, looking out on the sweating walls and the morose spectacle of the yard, littered with rubbish, the child's only moments of respite were when visitors came. Even then he had to endure a no less cruel torture; he heard his father boasting of his academic successes, his aristocratic associations, going on and on about nobility, describing the magnificent Chateau de Kerral; he was obliged to rely on his extravagant imagination, encouraged to lie by his own father, whose base audacity and low effrontery filled him with disgust and made him blush with shame.

With great difficulty, he obtained permission to go and visit Madame Lecautel just twice. There, his pleasure at seeing Marguerite again was spoiled by the troubling memory of his confessions. The ugly, violating image of Father Monsal insinuated itself between his friend and himself. Marguerite had been ill and her illness had made her even prettier, strangely pretty; there was something disturbingly wild and morbid about her: the subjection of her entire body, the obedience of all her movements to an implacable and devouring sexuality. That passionate, ardent blood flowing in her little girl's veins was the legacy of her father's alcoholism, but it seemed also to have left in her overly-dilated eyes, with their green-flecked irises, and beneath her lids, already bruised with painful shadows, the marks of a precocious and melancholy decadence. Sébastien did not dare to look at her; he did not want her to kiss him as she had before. Every time she came near him, he recoiled, frightened: 'No, no, we mustn't.' At the same time, Father Monsal's words incited him to obscure temptations, despite himself; in his mind he undressed that supple, sickly body, as it brushed against him, looking for the place of impure mysteries, unveiling that forbidden and accursed flesh. Marguerite was astonished when he could only respond to her caresses with:

'No, no, we mustn't.'

When the holidays were over, he left with no regrets. On the contrary, it was a relief to find himself in the carriage again with Father Dumont and a few fellow pupils, carrying with

them the smell of school. He breathed in that smell almost gladly, the way a prisoner on release gulps down the air of the life restored to him. In the brief kiss which his father and he exchanged just before leaving, he had felt that something had been damaged, that something was now irretrievably lost. He was not upset by this and felt real pleasure at the prospect of seeing Bolorec again and thinking how he would probably have a new round to sing to him. He even recalled with satisfaction Bolorec's face as he said:

'It's all takes place on the moorland there . . . they set off and they turn and come back . . .'

He dreamed at length of landscapes alive with singing voices.

Springtime was delightful. Green leaves burst forth on the trees in the yard and the school garden was clothed in tender colours. Sébastien also experienced the effects in himself of the rising sap; he felt a surge of strength and confidence and all his ability for thought and action blossomed. He was less pre-occupied, more adept at small deceptions, adapting himself to the minor pains of his existence, and his distaste for work diminished. He even enjoyed moments of healthy gaiety and tried with his brio, though without success, to whip Bolorec out of his incorrigible indolence.

The Jesuits owned a sort of large villa, called Pen-Boc'h, on the gulf of Morbihan, a few kilometres from Vannes. In fine weather, the pupils went there twice a week. They bathed, ate a meal and then came back in high spirits through the pine woods and along by the sleeping waters of the estuaries. Sébastien took infinite pleasure in these outings. He never tired of admiring the spectacle of that little inland sea, enclosed on the right by the Arradon coast and on the left by the Arzon and Sarzeau hills, and which opens out into the ocean through a narrow gully, between the sharp point of Loqmariaquer and the square promontories of the Rhuis pen-insula. It is crisscrossed by breezes from all directions, which leave white trails, milky, translucent pathways on its blue sur-face; it is scattered with a multitude of islets, some cultivated like the Ile aux Moines, some wild like Gavrinis, where the

Druid temples stand, blocks of primitive granite. They all look different and strange; some are like fabulous fish, their dorsal fins showing above the waves; others look like huge crosses lying on their sides and drifting with the current; there are some which seem to be moving forwards like a troop of seals, in a boiling cauldron of foam; still others, rocks gleaming, now covered, now exposed by the tides, emerge from the slapping water and suddenly sprout clumps of firs in capricious black fan shapes against the radiant brightness of the water. Dark earth and bright waves alternate among an infinity of light blue lakes, mauve creeks, purplish rivers, pale maelstroms, cut off randomly by outcrops of rocky land or edged by orange beaches; through the meteoric confusion of reflections, flickering lights and flaring rainbow colours, pass flocks of boats with sails that glow blood-red in the sun and turn iridescent in the mist. But what Sébastien loved most, even more than the changing shapes and the shifting colours of this maritime setting, was the sound, the rhythmic music, the divine melody of the waves and the breezes. He grasped all the notes, felt all the vibrations, from the dull, plaintive, despairing rumble uttered by the broad, mysterious depths, to the soothing song of the rosy creeks and the gay, youthful, tripping harmonica note that rippled up from the water as it spread out on the shingled beach. He was amazed and charmed by that prodigious ensemble of voices, from near and far, sweet voices, harsh voices: he loved this incomparable accord of superhuman brass and celestial strings; compared to the scattered, molten harmonies of these airy orchestras and invisible choirs beneath the swirling waters, the music in the chapel on Sundays seemed to him the babblings of a child. He always returned from those trips as if slightly drunk, bumping into trees, colliding with rocks, his head thudding against the back of the pupil in front, his ears vibrating with the musical resonances of the sea. However, in that stunned state, greedily and as if to grow drunker still, he opened his nostrils as wide as possible to the wind laden with the iodine smell of the seaweed and the vanilla scent of the moorland in bloom. On those evenings, he went to bed with aching limbs, his head

throbbing with a pain that was sweeter to him than balm, softer than a caress.

Father de Marel kept his word. He came to collect him every Thursday in the evening study hour and taught him music. Sébastien showed immense keenness, impatient to get over the first hurdles of musical notation.

'When will I be able to sing in church?' he kept asking.

His teacher was obliged to calm him down. He was even cautious about the idea of revealing an art which might perhaps intensify the tendency to dreaminess in an already dreamy soul, and increase the sensitivity of nerves already far too easily excited.

'Heavens, my little friend,' he would say to him, shaking his head. 'I'd rather teach you gymnastics . . .you're much better suited to the trapeze.'

So he punctuated his lessons with cheerful chatter, funny stories, comic recitations, walks in the park, judging that such a temperament, predisposed as it was to deep melancholy, needed wholesome cheerfulness and physical exercise. However, the day came when, faced with certain worrying phenomena, he felt that it was too much of a responsibility. Besides, goodhearted though he was, he only really appreciated people of a cheerful disposition, prone to loud and healthy laughter. So, he started to make his lessons less frequent and shorter, and, taking advantage of the retreat to which all pupils preparing for their first communion were obliged to go, he eventually stopped them altogether.

Sébastien's first communion was marked by an episode which caused a great stir in the school and which is spoken of every year still, as a miracle of grace. The retreat had lasted nine days; nine days of prayer, examinations of conscience, religious instruction, all so terrifying that they had spoiled the mystical poetry of the sacrament and marred the sweetness of spending time with his fellow students when everyone was completely relaxed, and more sociable and affectionate as a result of meditation and piety. The act in which he was about to participate was described to him as something terrifying. There were plenty of dramatic examples of exalted happiness

and horrible punishments to back up the claims of the catechism. They quoted the story of the impious child eaten alive by dogs; another notorious example had smashed his skull falling from a cliff-top, dashed into the sea by the hand of divine vengeance. And how many others burned in hell! On the other hand, another had felt so intoxicated by happiness and holiness as he came out of the church, that he went to meet his parents in the parlour, presented them with a knife and begged them to kill him, saying: 'Kill me, kill me, I beg you, for I am sure to go straight to heaven.' This troubled Sébastien greatly. He lived in a trance-like state, obsessed by thoughts of the demons of hell toasting children's souls at the ends of their forks in flames that never died. Every day, following frantic examinations of conscience, everyone took confession, for which it was necessary to resort to special manuals which contained, in alphabetical order, a gloomy, terrifying list of sins, vices, crimes, such an extraordinary collection of infamies, of inexcusably shameful acts, that the panic-stricken children immediately felt that they had suddenly become sacrilegious lepers, filthy, mud-spattered animals, whom no pardon could ever purify or heal. Some would suddenly go completely white, shuddering with terror, beating their breast and shouting: 'I have sinned, I have sinned! My God, save me from damnation. My God, spare me your torments!' Some broke down and had to be carried out and put to bed and taken care of. Joseph Le Guadec died of an attack of meningitis.

It was in this particular state of heightened nervous tension that Sébastien approached the holy table. He was trembling; his throat was dry. His chin resting on the cloth, he waited, gripped by an almost deathly emotion, and out of the corner of his eye he watched the priest approaching, mumbling prayers and carrying the golden chalice, his long, white fingers lightly and rapidly placing the host into each waiting mouth. When Sébastien received the host, he was initially astonished. Instead of experiencing the essential heat and obligatory ecstasy he had been told about, he felt on his tongue an icy cold that spread to his mouth, his chest and through his whole body, making his limbs shake and his teeth chatter, as if in the

grip of fever. At the same time, this shock of surprise was compounded by acute embarrassment. He did not know how he could possibly swallow this host which was the flesh and the blood of God. His clumsy tongue disrespectfully shifted it from one corner of his palate to the other. One bit stuck to the roof of his mouth, the rest broke up and shrank to a sticky lump, but still he could not manage to force it past the narrow gorge of his throat. A cold sweat broke out on his forehead, dampening his hair, wetting his temples. He believed himself damned. God did not want him. God did not want to enter into him! 'My God, my God!' he prayed, 'Forgive me, forgive me!' A vain prayer. God remained hidden. A contraction of the throat pushed the host forward to his lips, that sacred host which was now no more than a small ball of paste soaked in bitter saliva. Then the certainty of sacrilege, the impossibility of avoiding punishment seemed to him so clear that he felt dazzled, dizzy. Everything around him was spinning: the chapel, the priests, the choirboys, the candles and the tabernacle, gaping before him like the red maw of a monster. And he saw darkness, a fearful, heavy, black night, where cliffs, precipices, furious dogs, huge, fierce devils, great devouring flames, performed a terrifying dance. However, he did not lose consciousness completely but staggered forward, grasping the pews with his hands, and was able to reach his stall, where he sank down, bent double, in a prostration of agony. All of a sudden, above the voices singing in the gallery, above the ecstatic joy of the violins and the triumphant sonorous chords of the organ, came a cry, immediately followed by a sob. The cry was so loud, the sob so anguished, that the disturbance nearly brought the service to a halt. At the altar, the priest, surprised in his genuflections, turned round, afraid; everyone craned their necks and looked in the direction of the cry. It was Sébastien who had uttered this cry and who was now sobbing his heart out, as he crouched over the prayer stool, his head hidden, lolling in his hands, his shoulder-blades shuddering as if shaken by a violent inner storm. A louder sob than all the others had shot the host out of his mouth in a jet of saliva and the unfortunate boy had been unable to retrieve it for a

113

few moments, his face wet with the saliva in which Jesus' body was dissolving. He sobbed like this throughout the rest of the service and during the sermon, given by the Rector. Whilst the strains of the *Te Deum* rose exultantly towards the vaulted ceiling, he could be seen crazily beating his breast. Prayers, ardent invocations, terrified supplications jostled on his lips. He was still sobbing on the way back to the priests' refectory where a banquet had been prepared for the first communicants. It seemed as if his tears would never dry. His lids pricked like raw wounds; he walked blindly, his legs so unsteady that, in order not to fall over, he had to lean against the walls. And he kept saying: 'My God, spare me. Don't let me die. I am a small child and it's not my fault. I promise to expiate my sins. I will work hard, I will love my schoolmates and my teachers, and I will wear hairshirts and I will beat my breast like the great saints who were once great sinners but are now in heaven.'

'Your first communion was very inspiring, my dear child,' the Rector told him in the refectory. 'We are very pleased with it. Later in life, it will be your safeguard, today it is your pardon.'

Uncomprehending, Sébastien looked at the priest; he had such pure features, such noble gestures, a face of such calm and marmoreal beauty; his voice was as soothing as balm, whilst his eyes behind their pale globes were somehow cold and impenetrable, slyer and more unpredictable than fate itself.

For a few weeks Sébastien displayed a wild, exemplary piety and a fierce dedication to work that was unusual in him. To his classmates he was a saint and a hero. Then, when he saw that not only did nothing disastrous happen to him after this terrifying adventure, but that on the contrary he derived from it unforeseen honours, flattering friendships and enthusiastic admiration, he began to reflect and doubt the host, the Rector, his fellow students and his own self. And, though still only in confused form, he had an inkling of life's irony, that enormous, all-powerful irony which rules everything, even human love, even God's justice. Unconsciously, he relaxed his pious

114

exercises and duties. He went back to sitting with Bolorec beneath the archways near the music rooms.

'When you made your first communion, what did you feel?' he asked him one day.

'Nothing,' replied Bolorec.

'I see. And the host? What exactly is the host?'

'I don't know. Papa gives it to the sick and it purges them . . .'

Sébastien sat thinking for a moment, then said abruptly:

'Sing me that pretty round of yours, you know, the one where you say "It all takes place on the moorland there . . . and they set off and they turn and come back."'

At the end of the year, he won two prizes and surprised everyone, including himself.

Two years went by.

Sébastien had progressed from the juniors' yard to the middle school yard, where life was more or less the same. Nothing of any importance had happened at school, except for the simultaneous expulsion of four pupils, attributed to improper behaviour about which there was much whispering behind hands, in low, scandalised voices. Then there was the sudden disappearance of the Le Toulic girls. Sébastien was slightly sad not to see them any more in the evening in the square with their mother, on the way back from walks. That twin presence had been a source of sweetness for him, giving tangible, charming substance to his still vague dreams and providing an emotional focus for his young flesh awakening to the chaste brightness of love. One, sadly, had died of a chest infection, the other had run away with an officer. These successive dramas gave rise to a great deal of gossip, and poor Le Toulic, shamed and distraught, kept his schoolmates at an even greater distance, his forehead more deeply furrowed, his fingers even inkier; the poor little wretch had grown almost hunchbacked from bending over his books. Some, cowardly and cruel, were jealous of his scholastic success and made fun of him. No one, apart from Sébastien, felt sorry for him, because he was not very rich, nor good at real tennis, nor much fun. Besides, everyone knew that the Jesuits had taken him on as a non-paying pupil. But he paid no attention to the cruelty and insults; silent and solitary, he merely intensified his fierce devotion to work.

Sébastien therefore transferred his habits, his interests and his dislikes from one yard to the other and that was that. He continued his singular friendship with Bolorec, whose skill as a carver was increasing and who still dreamed of setting fire to the school and slaughtering the Jesuits. There were the same

116

walks to the same places, along the shores, or beneath the crumbling rocks of the Roi Jean grotto, the same periodic feast days, the same oppressive, boring homework, to which he could never adjust.

However, in the three years spent living in this little world, he had been trained in intrigue and hypocrisy and had learned not to show his feelings and thoughts openly; he learned how to conceal both his pleasures and his suffering with a miserly, jealous prudery, and learned not to throw in everyone's face the bleeding pieces of his own heart. Without becoming suspicious or devious, he was more careful of his words and actions, particularly as far as his teachers were concerned, for the few moments of glorious release he had granted them had only afforded him momentary relief, and promises made to him were soon transformed into treachery. He resented Father de Marel for having half-opened the door to the dreamed-of Paradise and then, for no reason, shutting it brutally on his awakened hopes. Impossible as it now was for him to continue with his music lessons, and dominated and driven by an inner impulse to grasp, express and make material, so to speak, his vague, but also absolutely irresistible aspirations towards the ideal conquest of harmony and form, he discovered a source of nourishment for his ambitions in drawing and became passionately fond of art. On the sly, a day boy brought him examples from his own home: heads with clear, fine features, Spanish muleteers with bulging calves, profiles of mythological gods, laurel-crowned busts of emperors, virgins draped in veils with symmetrical folds, Biblical figures bearing amphoras, classically branching trees. Protected from the questioning gaze of the master on duty by a pile of books, a rampart of dictionaries, he made naive copies of the drawings, seduced largely by the most accessible forms of beauty, rather empty and pretty, regular and pleasant, preferring conventionally religious facial expressions, wide, round eyes, full of meaningless ecstasy, flat coils of hair, smooth contours, elongated ovals, stiff folds. Often his examples and clumsy sketches were confiscated. So he tried to reproduce them from memory, for he had a truly amazing

117

memory for shapes. This shortage of examples and the difficulty in getting new ones did not discourage him. He was ingenious at reproducing whatever had most struck him on his walks, preferably things evoking vigour and joy, not yet understanding the poetry of what is old, bent and frail, of what is half-hidden, veiled, nor the beauty of the sadness of stones or vast, bare spaces, or of the sallow, bony hollows carved by poverty in the faces of those who suffer. He did not experience the inspiring, lofty poignancy and sublime beauty of the ugly. At the same time, books of forbidden poetry and other proscribed books which he loved were circulating in the recreation yards. He learned by heart lines and phrases that intoxicated him and he recited them to Bolorec during recess and on walks. *Pour les Pauvres*, by Victor Hugo, seemed to him to be a song from heaven, divine music, a ray of pure charity, bursting from the very heart of Jesus; a few lines from Barbier's *Iambes* inflamed him with furious, suppressed battle fever. This was like the revelation of a new world for him, the dazzling world towards which his instincts had always led him and which he thought was a chimera, out of reach of the clumsy grasp of man. But it existed; that world really existed. The truth lay there alone; there alone could be found the sovereign life. His spirit basked in those flashes of light. What a difference between that warm, colourful, vibrant language, which left in the air resonances of harp music and trumpet fanfares, whose every word lived, breathed and sprouted beating wings, whose every idea corresponded to a human cry, a cry of love or a cry of hate, compared with the cold, creeping, grudging language of his school books, whose enslaved words and dull ideas seemed deliberately positioned in order to block his desire to know, to feel, to be inspired, like surly park-keepers, forbidding entry to a garden full of sound and blossom, full of splendid flowers and subtle birds, where the radiant sky can be glimpsed through swaying branches. This discovery, this sudden illumination of the Word, made his schoolwork even more painful for him. To forget it more easily and to help him to endure it, he copied out the poems and worked harder on his drawing, surprised sometimes to

118

discover mysterious analogies and similar laws between the order of the lines in art and the cadences of poetry. He was undeterred by repeated confiscations of his sketches and his notebooks, by detentions and a few days on bread and water; on the contrary, the stimulus of persecution added to his enjoyment. However, one day, something very surprising happened. As recess was finishing, Father de Kern, his director of studies, came to him and handed him back his notebooks. He was an attractive priest, with slanting, languorous eyes, a slow walk, and softly nonchalant, almost voluptuous gestures. He leaned over Sébastien, so that his breath caressed the young pupil's face, and said in a gentle voice:

'I'm going to give them back to you, but hide them properly so that I don't have to take them off you again.'

Then he considered Sébastien with troubled eyes, in which a flame flickered, only to be extinguished beneath the winking veil of his eyelids. This look embarrassed Sébastien and made him blush as if he had committed some secret sin, but he was unable to say why.

Sébastien had grown. His features had fined down to a rosy slenderness, his skin was the pale pink of a flower confined to the shadows. His face, in that moment of adolescent indecision, had a woman's grace and his fine eyes were still melancholy, velvety and profound.

In Pervenchères there had been many changes. Aunt Rosalie had died intestate. Sébastien learned this in a letter from his father and it caused him only a limited amount of pain. He did not really love his aunt, from whom he had only ever received insults. However, the last time he had seen her, he had been touched. The old spinster had been unrecognisable, lying in bed, motionless, her raised chin garnished with coarse white hairs, her eyes hidden beneath soft, puffy lids like blinkers. She could no longer speak and was unaware of anything going on around her. She could have been dead already, except for a gurgling sound, the regular exhalation of a death rattle which, from time to time, flared her nostrils in a mechanical, localised movement of life. By her bedside, old women leaned over her,

greedy and whining, horrible watchers over death. It was that, above all, that had impressed him.

As for Monsieur Roch, he had not counted on this inheritance and displayed a dignified sorrow, proportionate with the four thousand francs of income which had unexpectedly fallen from the heavens. He now judged the moment right to retire from commerce. He was fortunate enough to sell his ironmongery shop for a good profit and so had a house built in the gardens, which he adorned with artificial grottoes, a goldfish pond and, here and there, on grassy banks, balls of coloured glass. He lived a perfectly bourgeois life and was very bored. Now he was mayor of Pervenchères and a magistrate and nursed a quiet ambition to get himself elected onto the regional council. However, despite the multiplicity and novelty of these occupations, he was not happy in the new house, empty as it was and with no neighbours other than the dead in the graveyard. A residue of commercial habit drew him back to his old shop and, for two hours every day, he sat by the counter, legs apart, his two hands resting on the handle of his long cane. He took a kindly, bossy interest in the progress of the business, giving advice and tirelessly delivering long discourses on everything under the sun.

One day, he felt the need to create a personal world for himself, to make a life around him, that is to say, to find people to whom he could confide his secret desires, his ambitions and his projects for municipal reform. He thought seriously about remarrying. He liked Madame Lecautel very much. She had elegant manners, a refined education, and he could hope for no better hostess when, for example, he received a government inspector at his table. Also, it was no small achievement to take the place of a brigadier general in a woman's heart. He weighed up the pros and cons and decided to ask for the hand of his lovely tenant.

'I feel,' he said to her, 'that our respectability is absolutely above suspicion. You are a widow, I am a widower. Your first husband was a general, I am a mayor. So it would not be a step down for you. I have a certain fortune, honourably earned in the ironmongery trade, and as for my age,' he added gallantly,

'have no fear. I have lived all my life sheltered from the passions, though, of course, I am not a young man, oh dear no . . . but I have to say, well . . .well, you will see for yourself.'

In response to Madame Lecautel's polite refusals, which he interpreted as embarrassment and modesty, he said:

'It will be a great success, I can assure you. Goodness, I know, at our age, one does not think much about passion any more, but really! Really! A bit of a new lease of life now and again, that can only improve things. I will arrange for you to have a nice little allowance without harming my son's interests too much. Come now, give it some thought. May I call you Madame Mayoress?'

Madame Lecautel was obliged to put him off more sharply. He took offence and for several weeks was most annoyed with her.

'If she thinks she'll have them by the dozen, mayors like me . . .' he would mutter. 'A mayor! A mayor's a general too, a civilian general . . .'

To distract himself, he conceived a heroic, extravagant idea, suggested to him no doubt by the proximity of death. Right in the centre of the cemetery, on the path leading straight from the entrance gate, he bought a vast plot which he first enclosed with low, iron railings, featuring garlands of immortelles and roses. Then he had a deep hole excavated, with room for only one, for, he explained, 'What is the point in exhuming my wife? She is perfectly happy in her plot. And as for Sébastien, who knows when he will die?' When the hole was dug and lined with stones and slabs, he had a kind of funeral monument built, a square thing, in granite, in the shape of a great trunk, with a domed lid. He wanted no adornment, no mouldings, no symbolic additions. 'A glass tomb, like Socrates,' he said. 'Comfortable, but not luxurious.' On one of the sides, at the bottom, was fashioned an opening, like a large ventilation hole, intended for the insertion of the coffin. Monsieur Roch supervised the works, directed them with the imperturbable confidence of an architect and the untroubled serenity of a philosopher; sometimes he would pause in his technical advice to utter an aphorism on death,

such as: 'You see, death is all a question of habit.' One day, when Madame Lecautel had come to put flowers on a grave, he insisted on showing her the splendours of his monument.

'If only you had said yes,' he said to her, sighing regretfully.

He showed her the enclosure formed by the iron railings, the little contoured flowerbeds with curved edges, planted with young green trees. On the yellow sand, there were extraordinary hearts bordered with box, chrysanthemum crosses and geranium monstrances. Already, a willow drooped its sad, spindly branches over the empty stone vault.

'It's nice, isn't it? Very simple. And look at that, read that.'

Sombrely, he pointed out the inscription carved in red letters on the tombstone:

<div align="center">

HERE

LIES

THE BODY OF

MONSIEUR JOSEPH-HIPPOLYTE-ELPHEGE ROCH

MAYOR OF PERVENCHERES

MAGISTRATE ETC ETC

DECEASED IN HIS . . . YEAR, IN 18 . . .

PRAY FOR HIM!

</div>

'I wrote it myself,' he said. 'Now all they'll have to do is fill in the blanks.'

And coming back to his initial thought, he repeated in an elegiac tone:

'Ah, if only you had said yes. Then there would have been two names and two places.'

He looked sadly and disdainfully at the neglected tombs, at the little crooked wooden crosses, crumbling and rotting, at the faded flowers, and with a shrug of his shoulders, he murmured:

'Oh well, that wasn't what you wanted. As for me, I know that my descendants will ensure I have a decent funeral. And that's something, isn't it?'

Monsieur Roch himself built his coffin. He chose all the wood for it meticulously from numerous planks of fine oak,

very dry, very solid and very heavily grained. From time to time, he would try it out in front of the mayor's secretary and old Madame Cébron, who were summoned to give their opinions. His own view was that he felt both contained by it and yet able to move freely and easily. During this period of bizarre activity, Monsieur Roch was very cheerful, almost childishly so. As he planed his wood, he even sang and whistled tunes from his youth, though always careful to avoid macabre jokes or ones in bad taste. His good spirits never failed for a second. In his letters, he no longer lectured his son, but filled them with tales from the council chamber, news of his tomb, maxims about death and a stoical calm. However, when the job was finished, he was gripped by a different mood, which degenerated into genuine distress. The fear of death overtook him. He could not walk round his tomb now without being assailed by terrors. He came home very pale, interpreted the slightest tremor in his muscles as a sign of illness, sent for the doctor, woke up in the night bathed in a cold sweat, prey to terrifying feelings. He took refuge in his mayorship and, in order to stave off death, he bombarded Pervenchères with new decrees and additional taxes.

CHAPTER V

Sébastien had vowed never again to be deceived by the apparent but false benevolence of his teachers. His instinctively distrustful nature combined with this self-imposed rule had at first distanced him from Father de Kern, despite the priest's undoubted kindness, and despite the excessive freedom he gave him now. Unlike before, he no longer needed to protect himself with books and to immure himself behind dictionaries in order to indulge his growing passion for art and poetry. This passion, which had earned him many and various punishments, was now tolerated by Father de Kern and actively encouraged. Encouragement was what Sébastien had most wanted and he was happy to take advantage of it, but he did not enjoy it with the same sense of utter security and ingenuous pleasure as he might have done with Father de Marel. Instead he felt a permanent, irrational, vague sense of disquiet with regard to Father de Kern, a niggling, persistent feeling, not unlike guilt. But guilt about what? He would have had great difficulty in explaining.

During study periods, he could not look up from his desk without finding the priest's gaze resting on him, an extraordinary gaze, a sort of smiling languor, which sometimes made him feel very ill at ease. It was not just that gaze which embarrassed him, it was everything that went with it: the excessively white skin, the languid gestures, the feline body which, as it moved, seemed to rub against the corners of the rostrum or the back of the chair with the slowness of a cat. What exactly was that look? What did that troubling, searing look mean, a look filled with a dubious light that darted out from beneath slightly slanting eyelids surrounded by dark shadows? That look which passed indifferently over the other heads and backs bent over their homework to fix itself uniquely and obstinately on him alone. That look so unlike

any other and so charged with unspoken, secret, murky thoughts. Often he would turn his eyes away from that look because it would begin to fascinate him, weaken him, lull him into a heavy somnolence, replacing his own will with alien desires, insinuating troubling ideas into his mind and unfamiliar, almost painful, irritating fevers into his flesh, leaving his reason bewildered. Between this look and himself, he built up walls of textbooks and open notebooks, hoping to block out its magnetism, break its influence. But when he could no longer see it, he was even more aware of it, heavy, bold or flirtatious, prickling his skin with damp shivers, with exasperating ticklings, like those he had experienced when Marguerite touched him. Ah, those hands, with their network of veins and supple, tormenting fingers, casting their spell of ecstasy and torment, whose lacerating touch was fire and ice. He remembered too her ardent breath charged with a sour scent like that of a wild creature, her dark hair that gleamed with all the lure of the abyss, that hair that gave off wild perfumes, bitter poisons! Yes, the priest's look was like those hands; it evoked the same terrible, forbidden things. But why? It simultaneously frightened and attracted him. At those moments, incapable of concentrating on any piece of school-work or any drawing or verse or book, embarrassed by the idea that this obsessive look might envelop him in a special light which would point him out as a target for the spite of his schoolmates, he would ask to leave the room, thinking he might regain his calm outside. And, sure of his impunity, he sometimes prolonged those absences from study for a full quarter of an hour, wandering in a little neighbouring yard where a magnolia spread its pale petals.

Father de Kern would come out to look for him, he would flatter his opinions, encourage his enthusiasms and Sébastien was soon won over by the sweetness of that voice, its musical timbre and compelling softness. His reservations, which were, in fact, no more than a confused, indeterminate sense of fore-boding, dissolved, and despite his resolve to keep a watch on his heart, he gave himself over entirely to Father de Kern, just as he had abandoned himself to all those who had spoken to

him kindly in their clear, siren voices. There was not a thought, an action, a word, that Sébastien did not live passionately: the senses and the passions were so strong in him that he experienced them like an illness or a physical imbalance. Everything affected him much more than it did other people and had an impact on all his faculties. It was enough for one of his senses to be stimulated for all the others to participate in the sensation, quadrupling it, prolonging it, each with its own function. Thus it was that a sound could awaken in him not just the usual phenomena associated with sounds but also corresponding ideas of colour, smell, shape and touch, thus entering both his intellectual world and his emotional life. The human voice had a particular power over his intellect – indeed it was omnipotent – and from there it ruled imperiously over his will. Depending on whether he experienced agreeable or disagreeable sensations, he loved or hated, gave himself or withheld himself, a passive act to which his reason offered no counterbalance. So he gave himself to Father de Kern, whose voice had triumphed over his gaze. For a few weeks, he experienced a deep, intense joy, a joy he did not remember ever having felt before, so strong and fine was it. The priest set himself up as the boy's mentor in the areas he loved. He was full of knowledge, had all the qualities which make learning a delight and make one cling to learning with increased pleasure. He revealed to him the beauties of literature of which his books had only allowed imperfect glimpses and truncated images, and above all, he conferred on him the burning desire to know. Putting to one side the seventeenth-century authors with their icy pomp and controlled solemnity, he introduced him to Sophocles, Dante and Shakespeare and made him love them. With bright, exquisite, passionate charm, he told him the stories of their immortal works and explained them. He recited the poetry of Victor Hugo, Lamartine, Alfred de Vigny, Théophile Gautier, read out pages from Chateaubriand. In his mouth this poetry and prose had an oppressive music of their own, unimagined, unearthly, penetrating harmonies. As he listened, Sébastien felt himself rocked in strange hammocks, his brow fanned by cooling,

perfumed breezes, whilst, unfolding before him, reaching into infinity, lay misty, shimmering dream landscapes, vermilion forests haunted by female figures, provocative shadows, plaintive souls, exquisite flowers, vague, sorrowful, voluptuous images. Unlike Father de Marel, whose robust nature only responded to the brisk and jolly, to broad, side-splitting farce, Father de Kern was inclined to tender melancholy, the intoxication of remorse, airy embraces, tragic mysticism, where love and death were intertwined, where all things were at once immaterial and carnal, and this corresponded to everything in Sébastien's soul that was uncertain, generous, intense, but that fragile little soul was too delicate to withstand unscathed the electric shock of those visions, and their poisonous, corrupting emanations. The priest did not stop at this. Every day he gave his eager student some poetry to learn, some homework to write out, in which he had to summarise his impressions of everything he had read, explain why a certain thing had seemed beautiful to him. Sébastien abandoned himself to these daily tasks, carried away with a zeal that his teacher was often obliged to restrain; but, reading over those clumsy pages, those awkward sentences, amid the inevitable exaggerations, imitations and obscurities, lit here and there by strange glimmers of a spontaneous spirit which was both unusual and poetic, Father de Kern smiled an enigmatic, possessive smile.

Knowing how much Sébastien loved art, he spoke to him of the great painters too, excited him by telling of the miraculous lives of Leonardo da Vinci, of Raphael, of Correggio, their close friendships with rulers and popes, their divine triumphs. With every conversation, every chat, one more veil was lifted on some fascinating mystery, some new boldness perpetrated in penetrating further into the domain of forbidden things. Sébastien greedily drank in these stories of that rich, marvellous era, where art, heroism, piety and crime were all embellished with the adorable faces of women, where love dwelt everywhere, beneath the artist's doublet and beneath the Papal tiara, where one could die for a smile or be damned for a kiss.

'Why don't they teach us all this in school?' Sébastien asked, a little afraid. 'Is it a sin?'

'One can learn everything and do everything too when one loves God and the Holy Virgin,' replied Father de Kern evasively.

Caressing his pupil with his white hands and long, supple fingers, he added:

'If you're good, I'll teach you even lovelier things . . . '

These conversations took place in the yard, during recess or on walks, when they paused on the sunny shores or beneath the shade of the pine forests; and every evening, after the other pupils had gone to bed, in the archway of an open window in the dormitory where the two of them stayed until nightfall, the priest speaking in a low voice, Sébastien listening, enraptured. It was June. The evenings evaporated in the dusk, beguiling, dream-like; light scents drifted in from the gardens, the meadows, the woods, and behind the dark mass of the park, where night was slowly falling, the purple and sulphur flames of the sun would disappear, leaving behind only a few mauve clouds, shot through with gold, melting one by one into the immense space gradually filling with stars.

Then Sébastien would go back to his bed, somewhat unnerved by these tales, his head spinning in a tumult of feverish images and revelatory words. His brow burning, he stayed awake for a long while before sleeping, going over in his mind what he had heard and learned, forcing himself to recreate the triumphant glamour of those men who were more beautiful than gods, the inconceivable splendour of those things more splendid than dreams. His imagination, overstimulated by the racing of his pulse, took off towards distant lands, towards some undefined era, where he saw himself acclaimed by finely dressed, flower-bedecked crowds; or else perched high up on scaffolding in an echoing cathedral or in the hallway of a palace decorated for some feast day, he covered the walls with ecstatic madonnas, suffering Christ figures, beneath the gaze of lovely women offering him their bare arms and their lips, swooning with love.

One day, his teacher took him to the Jesuits' library. First of

all, he had him admire the glass cases full of books, antique folios bound in old hide, but that did not interest Sébastien, all those lined-up spines of volumes displaying repellent Latin titles. Also the strong smell of glue and old paper hanging in the air dulled his senses. He preferred to look at a Christ on the cross, a poor copy of an Alonso Cano, which occupied the wall at the back of the library between two canvases of the Spanish school, flaking and cracked, the original colours almost consumed by black. He was astonished to learn that these pictures were by Ribera, of whom the priest had spoken with such enthusiasm. A little monk, with sly eyes and a shaven head like a convict, who was sweeping the parquet at the other end of the library, had disappeared discreetly. They were alone, just the two of them, in the vast room. Father de Kern opened a cupboard and pulled out a folder from which he removed the contents and placed them on a table. It was a series of old prints, reproductions of famous Renaissance paintings: an Assumption of the Virgin, a prostrate Mary Magdalene kissing Christ's feet. The priest commented on each print. Little by little, he had come closer to Sébastien, so close that his breath mingled with the boy's breath.

'Look, you see this angel,' he said. 'He looks like you. He's beautiful, like you . . .'

His voice trembled. As he turned over the prints, his fingers moved jerkily and his face had grown paler still.

Sébastien felt ill at ease and, saying that the smell was making him unwell, asked to go outside. He had just seen again, with a shudder, the heavy gaze beneath those slanting lids, that gaze which had weighed so heavily on him for so long.

The following night, he woke up with a start in the middle of a horrible dream: devils were carrying him off in their hairy arms. As he opened his eyes, he saw a shadow bent over his bed, a huge, black shadow. The shadow was Father de Kern. The pale light of the dimmed lamps creeping over the ceiling, barely illuminated him; it cast only the blurred outline of his familiar shape on the partition. He recognised him, though, from that unforgettable look which now blazed in the

darkness. The rumpled blankets had been pushed back to the foot of the bed and his legs were bare. Sébastien was afraid and cried out and put his hands protectively in front of him as a shield against an unknown, imminent danger.

'Don't be afraid, my child,' said the priest, in a sweet murmur. 'It's only me. I heard you cry out and feared you were ill. So I came. Were you dreaming? Now then, settle down, see how agitated you are . . .'

He pulled the covers up over the boy's shoulders and tucked him in with a mother's care.

'Now then, my child, settle down and go back to sleep.'

These two episodes struck Sébastien forcefully and reawakened his dormant mistrust. Why did Father de Kern's presence cause him such violent embarrassment, a sort of strange, instinctive repugnance, a creeping of the skin, a nauseous fear, something abnormal, rather like the dizzying sensation he felt when he looked down into an abyss from the heights of a clifftop? Why had he come to his bedside at night? Why had he been leaning over him? The reason he gave for his visit did not seem natural to the boy; it rang false. He had come with some undeclared intention, to which perhaps he could not admit. But what? Sébastien had remained chaste, largely ignorant of the impurities of the human soul. Vice had scarcely touched him as it skimmed close by. What he knew, or rather what he guessed, he had acquired at confession, through Father Monsal's murky questioning, and in his mind, it had taken on an indefinite form, a worrying and dangerous shape, which alarmed him, innocent, virginal and naive as he was. He had heard, here and there, a few dirty words in conversations between pupils, but very rarely, though it was enough to excite his curiosity, which remained unsatisfied, for he did not dare ask anyone for information on this subject, not even Bolorec, fearing he might be doing something wrong and be denounced. Nevertheless, Bolorec's explanation on the subject of the expulsion of the two pupils had anchored itself in his memory: 'Dirty things, like when you make children.' He thought about it often, trying to understand and unable to connect this idea of children to

unknown relationships, to the secret, filthy actions of two young boys.

What he knew, out of simple instinct and merely guessing at the nature of sex, was that there existed between men and women mysterious and necessary connections, which were called love. Love, everlasting love: the poets sang of it, and with what divine fire in their words! Love came up ceaselessly, both doomed and blessed, in those verses which he learned and recited and which he loved as the most adorable of music. They were always mentioning kisses, embraces, tumbling hair, bare arms wrapped about swooning bodies; but those kisses only kissed air, the embraces only embraced disembodied images; that hair transformed itself into intangible rays of light, those arms enfolded only souls. Although the poetry did, in fact, evoke the triumph of happy flesh, in his mind, the idea of love was still at the stage of ethereal joy, cerebral inebriation, heavenly desire. It was the love that brought about the Assumption of the Virgin. Jesus died from that love and on the cross, bleeding and torn, he retained its eternal, incorruptible clarity.

Love was also that fascinating disquiet, that indescribable emotion which he had felt during Marguerite's caresses, purified by absence; he felt it at the fugitive vision of the Le Toulic sisters, and it existed in the waves of tenderness he felt for the dead chimeras of which Father de Kern spoke; it was in some sense the generous reaching out of all his faculties and all his sensibilities towards beauty and pain. He had no concept of its physical crudity; despite the ferment of his adolescent years, he knew nothing of the fierce and savage struggle that is sex.

So, why were his intimacies with Father de Kern mingled with vague fears about another love, an impossible, dirty love, since love was personified by woman? Why could he not in the calm of his heart give himself up to the priest entirely, without this fear of a terrible and definitive catastrophe which his ignorance could not define, but of which his instinct warned him? By what twist of the mind, what corrupt presentiment, had this idea of some unsuspected, yet inevitable

crime entered his imagination and found a foothold there to the extent that he had not the strength to drive it out? He reasoned with himself, told himself that he was the victim of a mistake, of some kind of madness. Nothing in the priest's behaviour justified such a fear. The man had taken an interest in him and shown affection; he directed his mind along routes of which he had long dreamed. Why should he therefore be resentful of him? The priest found him attractive, was worried if he thought he was ill. What crime was there in that? Was it in that case forbidden to show kindness? To reassure himself further, he remembered that Father de Kern had the reputation of being a pious priest, almost saintly. He wore a hair shirt, it was said, and scourged himself. That was why he was so pale sometimes and why his eyes often blazed with a strange mystical flame, circled by dark rings of pain.

Despite this line of reasoning, his ineradicable doubts endured. The day after the night when the priest had appeared at his bedside, he avoided him during recess and sought out Bolorec with childish, obvious ostentation. Bolorec did not speak. He was sculpting a lizard and nodding his head to the internal rhythms of a song. When Sébastien asked him questions, he merely replied in surly monosyllables and shrugs. In the evening, feigning sickness, Sébastien refused to join Father de Kern in the window arch. But, from behind his curtains he watched Father de Kern through a narrow peephole. The priest had taken up his usual place. Leaning his elbows on the window ledge, he was watching night gradually falling over the grounds, over the gardens, drowning the recreation yards in transparent shadow, that beautiful darkness normally filled by sweet words and engrossing stories. It seemed to Sébastien that he looked more serious and even cross, no, not cross exactly, but so very sad! His heart was touched. He accused himself of ingratitude and thought of going over to him and asking forgiveness. When darkness fell completely, the priest closed the window and walked slowly past the row of beds, his soutane swishing. Everyone was sleeping. Sébastien saw his shadow pass back and forth on the curtains; he heard the swish of his soutane and the rattle of his

rosary. Then he heard nothing more but the confused sounds of breathing; he saw nothing but the glimmer of the watchful lamps. And he too fell asleep.

Sébastien soon realised that Bolorec's company was no longer enough for him. The other pupils seemed boring and vulgar, they made fun of his poetic excesses. A void had suddenly opened up in his life. Something was missing, something essential, irreplaceable, like bread to a starving man. And sadness, a sadness all the more painful to bear because it was heavy with remorse, again overwhelmed him. He was in need of protection, intelligence, a voice that would pour the balm of bewitching, consoling words into his spirit and his heart. This protection, this intelligence and this voice, all of which he had summoned, had come to him, unhoped-for, to him, a person so long disdained by everyone, and see now how he rejected them, encouraged by foolish, guilty fears which were, in any case, very difficult to define. Now that he was in less intimate contact with Father de Kern, he was no longer afraid of him. On the contrary, Sébastien was astonished and touched to see that the priest's attitude towards him was the same. He could have avenged himself for this rude ingratitude, but he did not. Nothing had changed in the benevolent manner of that admirable, gentle priest. Not one of the special freedoms and gracious liberties which Sébastien enjoyed had been withdrawn by that saintly man; and in his eyes, whose gaze was returning to normal, there was neither severity nor anger; there was only sorrow, the glad, luminous sorrow that shines out from the emaciated faces of martyrs. Sébastien observed him, moved, repentant, his soul aching with remorse. Yes, he must be wearing a hair shirt, torturing himself with mortification, tearing at his body with the iron tips of the scourge. It was clear from the painful slowness of his gait, the painful bend of his back, the painful pallor of his skin. Everything that had worried Sébastien about the priest's manner, everything that had distanced him from him, he now recognised as nothing more than expressions of pain. In an excess of exalted, penitent gratitude for everything that the Jesuit had so generously given him of his knowledge and his affection,

for everything he had awakened in him that was fine, noble and ardent, he wished he could push back the folds of his soutane and dress the red marks on his chest and kiss the bleeding wounds. Finally, a selfish thought oppressed him. If Father de Kern refused to continue with his lessons, if he said to him: 'You did not trust me, you are unworthy of my favours', he would fall back into his former state of alienation, the same moral abandon in which he had vegetated, miserably oppressed by his teachers, vanquished by circumstance, prey to that stifling education which engendered such darkness in his brain. One day, whilst the priest was reading his prayerbook during the walk, standing apart from everyone else beneath the trees, Sébastien dared to approach him and, contrite, cheeks red, eyes lowered, he stammered:

'Forgive me, Father. I have been cruel. I won't do it again.'

The priest gave Sébastien a sharp stare which pierced him like a gimlet. Then he said simply, his voice sad and smooth as a sigh:

'How sorry I have been for you, my child, my dear child . . .'

After a silence, breathing hard, he said:

'But God heard me, because you have repented.'

He closed his prayerbook and started to walk slowly away, moving aside with a dainty gesture any overhanging branches that barred their way. Sébastien stayed by his side, timid, defeated, his head hanging, staring at the ground on which drops of sunlight trembled.

'Let's not speak of that any more shall we, my child?' said the priest. 'We must forgive trespasses, even love them, as Jesus loved them, since they make repentance more dear and pardon so sweet.'

He added in an ineffable tone, which shook Sébastien to the very marrow:

'Oh, little restless soul, which I can read so well!'

Sébastien did not dare raise his eyes to meet those of the priest. It seemed to him that as they walked, his feet did not touch the blades of grass and that as he moved through the

light, he was so tall, so big, so superhuman, that his forehead touched the skies.

The daily conversations and lessons resumed their interrupted course. Every evening the two of them met again in the window arch, and little Sébastien felt an even sharper pleasure at those customary meetings, to which the night lent a twofold mystery of religious feast and forbidden rendezvous.

Father de Kern deployed all his graceful inventiveness to make his lessons irrevocably attractive. With persuading, caressing words, with the evocative eloquence of an idea, he knew how to explain and fix in unforgettable images the most abstract of subjects and give the remotest characters of the past a personality of seductive contemporaneity, which made them seem more immediate, more visible, almost familiar. Sébastien was astonished to find himself passionately interested in details of the very history that had so bored him in class, because of its repellent dryness, but which in the priest's teaching wore the attractive garb of a tale, a beauty dressed in poetry. Everything came alive, everything was animated by his words, which had an incomparable power of suggestion. He was sweetness personified, his mercy was tender and universal. His precise, measured enthusiasms always allowed generous space to the unexpected dream. He was more dangerous for what he did not say and left to guesswork than by what he actually said. However, the words 'love' and 'sin' occurred again and again on his lips, with slow inflections, as if he liked to linger over them. The word 'sin' above all, by the way in which he pronounced it and circled around it, seemed like a strange flower which attracts by the very dangerousness of its scent; and though he expressed his horror of it, with specious disgust, that very horror seemed desirable and beguiling.

'You are now a little man,' he used to say to Sébastien. 'You must become accustomed to looking sin in the face. One can avoid it best if one knows it well.'

He stooped to personal confidences, spoke of a life which, for a long time, had delivered him up to sin. What remorse and expiation for a few wretched pleasures! Would there ever

be enough prayers to erase the traces of his former degradation?

'If I tell you these abominable things,' he murmured, grasping Sébastien's hands in a trembling grip, 'it is because I would like to preserve you from sin. Ah, if you knew how it offers itself to us, arms full of flowers, lips wreathed in smiles. If you knew how it clothes itself in beautiful flesh, intoxicating perfumes, to tempt us, to damn us, if you knew its seductive power. How many times have I trembled for you. When I see you with Kerral or any of your other friends, it torments me. I ask myself: "What are they saying to each other? What do they do together?" If you disappear from sight on the walk, I say to myself: "Where are they?" And I was worried I might surprise you, hidden behind a hedge, or huddled together in the shadow of a rock. How I watched over you in the night, dear child. Ah, the nights are so sad! They grieve me. Passion roams abroad then, sin is rampant. And I know so many little souls whose hearts are gangrenous, children who mutter feverish words that make the Holy Virgin blush and Jesus weep. Trust me, open your heart to me. Do not hide one evil thought from me, not one impure act. If you have committed the ultimate sin, do not be afraid to pour out your heart to me. It is so good to shout out one's sins. And Jesus is so compassionate and forgiving, he gladly pardons little souls like yours.'

He pressed him to admit to imaginary temptations, imaginary impurities, making specific questions which, hitherto, had remained tentative and vague. He too had been corrupted at school by a schoolfriend whom he cared for. Oh, what shame! And later . . . Blushing, in a display of modesty and embarrassment and blessed humility, he recounted the real truth about his family, revealed the intimate, poignant details. A mother who had died abroad, an adulteress, a debauched father, who installed his concubines in his own house, a married sister who received him at her home, half-naked, swathed in scented chiffon and lace and who initiated him into all the perversities of human love. The first thing she did was to compel him into the arms of a woman who completed the work of depravation begun when he was still a schoolboy.

136

Thus he had tumbled down through all the levels of vice, had rolled in the hellish filth of forbidden pleasures. Finally, God took pity on him. One evening, in the midst of an orgy, he had been miraculously touched by grace.

'And since then, my dear child, I live in love, true love, the immense love of Jesus. Ah, people are mad who go to other human creatures for brief intoxications, brief ecstasies, when those which the divine possession of the body of Jesus confers on us are infinite, inexpressible. Forgetting oneself in him, becoming one with him. Tracing the line of that adorable body with one's repentant lips, pressing one's mouth to the gaping wounds on that suffering flank, kissing the broken limbs, feeling against one's mortal flesh the searing heat of that celestial flesh. Where might one find comparable delights? Where might one dream of finding similar, limitless joys, which death itself cannot end?'

Gradually, Sébastien became engulfed by an enervating, sensual atmosphere in which, beneath the veil of divine love that masked all the carnal excitement, physical arousal and base depravity that rise from virgin sex organs to an already tainted mind, day by day, hour by hour, without him even realising or suspecting it, he was losing his moral equilibrium, his spiritual health, his instinctive honesty. He did not resist, he could not resist the corruption of his little soul, which had been skilfully saturated in poetry, chloroformed by ideas, overcome by the corrosive, emasculating morphine of ungraspable desires. For this secret, continual, invasive work, Father de Kern enlisted the aid of the sun, the mist, the sea, the languid evenings, the starry nights, the whole of nature, which submitted like an old whore to the monstrous concupiscence of one man. Neither nature nor priest addressed themselves directly to the child's lower organs, nor did they attempt to excite the vulgar appetites which lie deep in the purest of hearts. It was through his finest and most noble qualities, through the generosity of his intelligence, by gaining the confidence of his mind that they instilled in him, drop by drop, the mortal poison. They chose their moment

well for the rape of a delicate, passionate, excessively sensitive soul surrounded by tempting traps, attacked at the very roots of his intellectual life. Those obsessive conversations, those tormenting, corrupting dreams, provoked in Sébastien troubling, physical symptoms of an abnormal nature, like the symptoms of a serious illness. A surge of hot blood swelled and burned in his veins; his distended muscles stimulated his tormented flesh; he felt dizzy and had blackouts, nocturnal emissions, the erotic excretions by which, in precocious temperaments, the first upheavals of puberty announce themselves.

That evening, the pupils had all gone to confession. The following day, they were to take communion at daybreak and then set off immediately on a pilgrimage to Sainte-Anne-d'Auray; this was an annual pilgrimage looked forward to with great impatience as a pleasurable day out. The clock was striking nine when Sébastien and a few tardy companions came back from the chapel and went into the dormitory. Father de Kern was seated near the open window, one elbow casually resting on the sill, apparently deep in his own thoughts. The day had been scorching hot; storm-charged breezes stirred the stifling air. Huge clouds gathered, veiling the moon; the wind had got up, shaking the trees in the garden, eliciting dull groans, like the sound of a distant sea breaking on the shore. Father de Kern stopped Sébastien as he was about to take up his usual place.

'I was just thinking about you, my dear child,' he said, when the other pupils had gone to their beds. 'Are you taking communion tomorrow? It's such a wonderful occasion. I still remember your first communion. It was so moving. It was from that moment that I first began to take an interest in you, to love you. You are so different from all the others here. Every second I discover in you exceptional qualities which I strive to develop and direct. I talk to you as I would never talk to anyone else, because you understand, you feel things which not one of your fellows feels or understands. If I could be your sole teacher, I think I could make something of you,

something great, I have often thought about it. Ah, yes, I would like that . . .'

He sighed and looked out at the stormy night, the turbulent sky, across which rode enormous, gloomy waves lit by the moon that edged the clouds with a dazzling, metallic glow. After musing for a few minutes, he spoke again in a sad voice.

'The only problem is that you do not trust me. You look upon me as a teacher, when, my dear child, I am your friend, the friend of your heart, of your mind, the friend of all you dream of and of all that is in you, unknown to you, but known to me. Ah, how it torments me.'

He fell silent. The dormitory was quiet again. A sudden gust of wind, more violent than before, shook the roof above them. Dislodged slates flew and fell into the yard. Father de Kern closed the window.

'Come with me,' he said.

He walked past the row of cubicles, went out of the dormitory, down the stairs, along corridors dimly lit by the beam of a dying lamp, along dark corridors where the moonlight fell on the flagstones and traced in dingy white the rectangles of the windows and the shadows cast by the mullions. Sébastien followed him without thinking. Where were they going in this murky, flickering light, in this monastic gloom, so full of silence, in this solitude, where their steps could scarcely be heard? He did not think to ask himself.

'Walk more quietly!' hissed the priest, who, very cautiously, eyes darting, ears pricked, advanced on tiptoe, keeping close to the walls.

Sébastien tried to emulate the movements of his guide. He felt no doubt, no fear. He felt only surprise, a not unpleasant surprise, to be walking through entirely unfamiliar areas of the school at that hour of the night, down tortuous staircases, sharply twisting corridors, across lugubrious landings where the shadows were thickest, and where smoky lanterns glowed in the shifting, dissolute dark. At last, they stopped outside a door, which the priest opened soundlessly.

'Go in,' he said.

Sébastien, who was shivering a little now, hesitated, so Father de Kern took him by the hand, drew him into the darkness and closed the door, bolting it carefully behind him. Sébastien had felt that damp hand in his and it was trembling. He shuddered. At that moment, he felt fear – a terrible, racking fear – the fear of all those steps he had gone down, of all those corridors he had walked along, all those dim lights, all those unfamiliar shadows, and, above all, of the blackness where he stood alone with that man. At first, he could see nothing but a wan film of light, sinisterly projected onto the ceiling and the floor through the closed shutters of the window. It was a funereal light, it had an opaque pallor, the dead whiteness of linen. All around this pool of light, where the shadow of Father de Kern passed back and forth, was darkness, a nightmare darkness; it was not impenetrable, however, and as his eyes grew accustomed to the gloom, he could make out vague objects, the blurred outlines of furniture, incomplete shapes and, in the background, against what looked like a wall, something horizontal, rigid and long, like a tomb. Why was he there? What diabolical force had driven him to come there, to follow the priest, all unknowing, unquestioning, unsuspecting? Why, if the priest's intentions were honourable, had he been so obviously afraid of meeting anyone? Why had he behaved with all the care and caution of a burglar fearing apprehension or of a criminal on his way to commit a crime? What was he going to do that was so terrifying? Tragic tales of murders and throat-cuttings assailed him. He panicked. He thought he could make out terrifying, murderous faces, strangling hands, raised knives. On the floor, in the square of light, the shadow of the priest swayed like that of a hanged man. The wind had dropped. He could hear nothing now but a dull, distant sobbing, the indescribable sound of stifled moans. The priest did not speak. He came and went, barely visible. But his presence filled the night with a supernatural terror. His presence was revealed only by a series of thuds, bumps and rustlings, which left behind them strange echoes. Sébastien heard the click of locks, the chink of glass, a multitude of sounds the cause of which, in that place, terrified him. What

was he preparing? What torture? What torment? What death? He thought of walks at Pen-Boc'h, of the sea, of Bolorec; he clung desperately to calm, cheerful thoughts, to thoughts of all those who might care for and protect him: his father, Madame Lecautel, Marguerite. But these evocations quickly fled, disappeared one by one, like frightened birds that rise up from thick hedges and fly off, shrieking. He was suffocating. He broke out in a cold sweat; his legs buckled.

'Father! Father!' he begged.

'Quiet, my child. Someone might hear us.'

That voice, in the shadows, sounded so odd, so abrupt, so strained, that it only intensified Sébastien's terror. Someone might hear? But he wanted to be heard. Oh, if only someone would hear him! He cried out louder.

'Father! Please, I beg you, please take me back to the dormitory. Take me back . . .'

'Shut up, you little idiot. What are you afraid of?'

The priest was next to him, groping for his hand. He murmured:

'Calm down, my dear child, and don't be afraid. Why must you always be afraid of me? What have I done to deserve that? Come along now, come along . . .'

He drew him gently further into the room and sat him on the edge of the bed.

'You're trembling, poor thing. Come, drink a little of this. It will do you good.'

He pressed a glass full of some strong, scented beverage to the boy's lips and said again:

'You're trembling.'

When Sébastien had swallowed a few mouthfuls of the liqueur, the priest struck a match on his soutane and lit a cigarette. In the brief, bright glow, the boy glimpsed a light, clean, austere room, with white-wood furniture and, in the middle of the whitewashed wall facing him, a crucifix and, here and there, some holy pictures. The cleanliness of the room, simple as a monk's cell, the reassuring presence of religious objects, lessened his fears. But the cigarette, whose perfumed smoke filled the room, astonished him and replaced

all his terrors of a few moments ago with an almost amused, puzzled curiosity.

The priest sat down next to him and remained silent for a few moments. Feeling less worried now, Sébastien breathed in the smell of the tobacco, flaring his nostrils, and followed the glowing tip of the cigarette, which flitted through the renewed darkness, capricious as a lustrous fly.

'Have you calmed down now?' asked Father de Kern, in such a gentle whisper that it barely broke the silence in the room.

Sighing, he added in a tone of affectionate reproach:

'Why do you not trust me? Have I not shown to you a thousand times and in a thousand different ways that I love you? What is it that you're afraid of, my child? Tell me. Is it the darkness? Of course, it must have upset that sensitive imagination of yours. Dear little heart that I love so much, even in its weaknesses. But don't you, on the contrary, find this darkness quite delightful? And the words spoken in it, are they not more beautiful, murmured so low that they seem to come from far off, from the beyond . . . ? You will grow to love this retreat, so peaceful, so far from everyone else, so far from all noise . . . I will recite poetry to you, I will tell you beautiful tales from history. You will see how exquisite the night can be, in this chapel-like solitude, this untroubled, forest-like peace, where everything comes to life, where everything lives again, and takes on the glorious colours of mystery and dreams. How often, when I was sad and despairing, when it seemed to me that Jesus' heart was closed to me, how often have I taken refuge in this room. If you knew, my dear child, how I have prayed here, what happy tears I have shed here. It is here that Jesus appears most clearly to me, where I touch his real flesh, so beloved of pain and sorrow . . . here where the ecstasy of loving him is boundless. Oh, my dear child, if you only knew!'

He had come closer to Sébastien, his hand gripping the boy's hand. His voice had started to falter. His words were guttural explosions, broken by nervous tremors. He said again:

'Oh . . . yes . . . how I have . . . prayed here . . .'

142

Despite his fear, Sébastien could not help noting mischievously that such exalted piety, such ardent, religious ecstasies, accorded ill with the more worldly pleasures of smoking cigarettes and drinking glasses of liqueur. Nevertheless, he was troubled by the priest's unusual agitation, by his legs rubbing against his own legs, and, above all, by that hand. That hand was stroking his body, at first, light and timid, then impatient and bold. It was groping, clasping, gripping.

Now Sébastien was sitting, legs dangling, on the edge of the bed, half-clothed, exhausted, alone. Alone? Yes. He stretched out his hand and felt about him: nothing. He stretched out his hand and felt the rumpled blankets. He was alone. His limbs felt limp, his face burned painfully. His brain felt bruised and heavy, terribly heavy, so heavy that he felt he could not lift his head. In his recollection of events there was a gap, a gap filled by a brusque, violent, terrible caress. Was he dreaming? No, he wasn't dreaming. He wasn't dreaming because the priest was there too. He was there, ferreting about in the darkness. His silhouette walked back and forth, black, agile, infernal, in the rectangle of pale light that had lengthened obliquely across the floor until it divided the whole room in two with its swathe of grubby whiteness, like a shroud. He heard the same bumps and thuds, the same rustlings as when he had first come in . . . how long ago? In the far, far distance, muffled by the intervening walls, the wind groaned and moaned, sombre, monotonous.

'Drink a little of this my child, it will do you good.'

The sound of the priest's voice made him jump. However, he drank avidly from the glass offered him. He had a burning thirst, an unquenchable thirst. He drank a few mouthfuls.

'Thank you,' he said mechanically.

Then he heard the same clicking of locks, the same chinking of glass. Then he saw the room lit up in the glow of a match, he saw the priest lighting a cigarette, the little red brand burning and dancing in the shadows. He felt no hatred, because his head was empty of all thought. No moral impression remained in his mind of the abominable thing that had

just taken place, the crime – the most cowardly and hateful of all crimes – the murder of the soul of a child. He felt a great lassitude in his spine, a thirst that parched his throat, a general weariness in his limbs and all his flesh, which left no room for any other sensation, but he felt no mental pain. Noticing that he was partly undressed, he adjusted his clothing and then remained motionless. He would have liked a drink. The sound of water sang in his ears, fountains of clear water appeared in cool landscapes beneath hanging branches and flowering creepers; he breathed in the scent of damp grass, leaned over the edge of a well. He wished he could lie down on the bed as if on a bed of moss and sleep for a long time; he wished, above all, not to see the pale light of the moon cutting the room in two, but to stay in the shadows for ever. He was troubled by the idea of going back along those corridors, of climbing those stairs, of the murky light, of the dormitory.

The priest came and sat down next to him. Sébastien felt the weight of his body against his own. He did not pull away.

'Leave me alone, Father,' he said. 'Leave me alone.'

There was sadness in his voice, but no terror or disgust. The priest grew bolder.

'Leave me alone. Please, leave me alone.'

He dared to speak out because of the shadows enveloping them both, hiding that face, those eyes. He realised that, in the light, he would have been incapable of speech, that the sight of the man would henceforth be unbearable, that he would never again be able to meet his eye and that he would die of shame. He was weighed down by the thought of being haunted from then on by that continuous presence, by the tormenting, unremittingly vivid image of that stain, recalled at every moment, the certainty that he would never be able to escape that obsession, not during classes or during recess or on walks or in the dormitory, where the shadow of the priest on the curtains of the cell would come each evening to remind him of the indelible horror of that night. Oh, why had he not listened to his instinct! Why, despite his sense of foreboding, had he allowed himself to be ensnared by the man's soothing words, by his poisoned counsel, his poetry and his affection,

144

which all only masked the crime? And what annoyed him was that he felt no hatred towards this criminal. He was not angry with him; he was angry with himself for his own absurd, conniving trust.

'Now then, my child,' said the priest, 'You must go back.'

And cynically, groping with his hand to reassure himself that Sébastien's clothes were all in place, he asked:

'Have you done your trousers up?'

'No, no, leave me be. I don't want to go back. Don't touch me. Yes, I've done my trousers up.'

'We can't stay here any longer, it's already late.'

'No, no, leave me be.'

'Sébastien, my child, my dear child, please understand that it's impossible . . .'

'I know, I know! But I want to stay here. Let me be.'

There was a silence. The priest got up and paced the room, worried. He had not foreseen this stubborn, childish resistance, this implacable obstinacy that could be his undoing. He had a swift, clear vision of the problems, the disgust, the scandal which would be the inevitable consequence: disciplinary action, exile to some far-off place or else abandoning the priesthood altogether and being cast into the grubby margins of society. What could he do, though, if Sébastien refused to leave? Reason no longer reached this mind so shaken and concussed that the most resilient of human instincts, self-preservation had been shattered. Should he use force? That did not bear thinking about. The shouting and the struggle would have been even worse than this exasperating inertia. Then he reproached himself bitterly for this adventure in which he had failed to taste the promised pleasures. 'I thought he was better prepared,' he said to himself. 'I should have waited.' The future worried him too. 'I hope I can get him to go back. But what about tomorrow? The little fool is quite capable of giving me away by giving himself away.' He had lured many others into that room and they had come, some already corrupt, others still innocent, but none had made these deplorable scenes. For a moment, in the obscene darkness, where, transfixed and gripped by shame, Sébastien sat on

the sullied bed, the priest savoured the memory of the procession of little martyrs, little deflowered creatures, his startled prey, docile or anguished, either instantly overcome by fear or made submissive by pleasure. But what if the morning found them both there, cutting off their retreat. He thought how sweet murder would be, if it were not impossible in the circumstances and in that place, and what a relief he would feel if he no longer had to take account of this miserable, obscure, little existence, this human larva in which the flower of the vice he loved refused to bloom.

Father de Kern approached Sébastien. He said simply, in an imperious tone, like that of a teacher reminding a pupil of some forgotten task:

'You know you're taking communion tomorrow.'

The effect of this sentence was electric. Sébastien leaped up, trembling. It was true. He had to take communion the following morning, in a few hours' time. Now he would no longer be able to do so. All the others would go, grave and pious, their hands clasped on their chests, all the others would partake at the holy table. He alone, like one of the damned, would stay in his seat, pointed out for universal opprobrium, his face bearing the ineradicable imprint of his infamy, his whole body exuding the stink of hell. Again, he fell face down on the bed and, his eyes filling with tears, he murmured:

'But I can't now!'

'And who will stop you?' snapped the priest.

'After what you . . . After what I . . . After this sin . . .'

'Well, my dear child, am I not here? Can I not hear your confession?'

'You!' cried Sébastien with a surge of horror. 'You!'

The priest's voice once more became caressing and slow, humble and sorrowful.

'Yes, I. I am a priest. I have the power to absolve you . . . however unworthy, culpable and criminal I might be. I have not lost the sacred character which allows me, miserable wretch that I am, to give you back peace of conscience and proud purity of body, the candour of your little angelic soul. I, who have fallen deep into hell, can restore you to paradise.

Listen, I don't know what took hold of me just now . . . was I obeying some mad instinct? I don't know. As God is my witness, my intentions were honourable. They're frightening, these sudden resurgences of passions which one believed had been extinguished and vanquished by years of prayer and penance . . .'

He knelt down, rested his forehead on Sébastien's knees and continued:

'I don't want to deny my responsibilities, to diminish my crime. No. I am a monster. But have some pity on me, as I kneel at your feet begging your forgiveness. Nothing has touched you or soiled you because you are a child, but I . . . To redeem my soul, to erase this sin – and can I ever redeem this soul and erase this sin – what lengthy penances I must do! This flesh I have soiled, this flesh in which sin still sleeps, despite fasting, prayer and chastisement; it will have to be torn out, rooted out, fibre by fibre, with my nails, with . . .'

Sébastien saw the instruments of torture, the horror of pincered flesh, broken bones, streaming blood and, seized by dread and pity, he cried out:

'Father! No! No, I don't want you to do that on my account. I don't want that. I don't want that.'

'I have no choice, my dear child,' replied Father de Kern, with a resigned air. 'And that torment will be sweet to me, I will bless my sufferings, if you have forgiven me and allowed me, by absolving your sins, which, alas, are my sins, to give your soul back its purity and peace. All I ask is that tomorrow, at communion, you will pray for me.'

Sébastien stood up, resolved. He felt no pain now. He felt an intoxication in his heart, a strength in his limbs, and he would have liked dazzling lights and church fires suddenly to set the room ablaze with their forgiving glow. In his turn, he knelt down fervently at the priest's feet and, bathed in tears, beating his breast, certain that he would thus redeem a soul and appease God's anger, he made his confession.

'Father, I confess to committing the sin of impurity; I confess to having taken guilty pleasure. I confess . . .'

And as the priest spread his hands in blessing, those hideous,

profanatory hands which, a moment before, in the darkness, had soiled for ever the soul of a child, he murmured: '*Absolvo te*' and thought:

'At least now he won't go blabbing to Father Monsal.'

CHAPTER VI

The road from Vannes to Sainte-Anne is long and dreary. It is how one imagines Biblical landscapes of old, the desolate plains of Asia Minor. It is as if ancient suns, now extinct, have desiccated, sterilised and charred its soil, a soil made of solidified ash and pulverised iron, where only sombre, puny plants manage to grow, where even the water burns the sparse grass like acid, where only the rusty flowers of harsh reeds and heather bloom, faintly pink in the gloom. Instinctively, one expects to see the footprints of the prophets in the dead dust and the tracks of the long paths followed by pilgrims. It must have been in similar landscapes that St John howled out his pain.

As a setting for their mysteries, religions have always selected wretched and hateful places; they have never wanted joyous nature to burst forth near their birthplace and discomfit the gods. They require shadow, terrifying rocks, distressingly barren lands, sunless skies, skies the colour of sleep, where the drifting clouds perpetuate a dream of future homelands and ethereal resting-places.

As one leaves the meadows and outlying fields, the road crosses deserted moorland, pinewoods, silent gorges where rocks tumble down the arid slopes. These rocks are so sad, these gloomy expanses so inexpressibly melancholy, for there it is as if the very fount of life had dried up. There everything is smaller, punier, more stunted than elsewhere. It is as if men, animals and plants had had their growth arrested. The trees, weary of growing, knot themselves up in low, scrawny humps, and old people look like withered children. It touches the heart and troubles the imagination, and one can well understand that for this miserable humanity, welded by centuries of dire poverty to this infertile soil, the consoling legends and the prayers which open the mystical door to hope are more

149

necessary than bread itself. Sometimes, like graceful flowers lost in the midst of the harsh moorland plants, one encounters on the road young peasant girls of an ancient beauty, who have the liturgical pallor of figures in stained-glass windows. With their winged headdresses, their coloured scarves revealing bare, supple necks, with their homespun dresses falling in heavy, statuesque folds, they walk slowly along, like Gothic visions, evoking other times, the times when Van Eyck painted his Virgins with their peaceful faces, their straight backs, their long hands joined in prayer.

Sébastien followed the boys in front, dazed, not knowing what drove him on nor where he was going. After a few hours of leaden sleep, he had got up, his mind and limbs heavy, with a sense of oppression that left him only a distant awareness of some earlier pain. Still stunned, he had mechanically taken communion, without devoting any more attention to this religious act, which normally he found so troubling, than he had to his morning ablutions. It had rained in the night; the storm had broken in a furious downpour; a light mist wrapped about the drenched leaves and the darker greens of the moor broken, here and there, by the white gleam of puddles. The morning air dissipated the heavy stupor clouding his brain, and the walk loosened his stiffened joints and recalled him to an awareness of reality and life. One by one, his memories came into focus: the corridors, the dark stairs, the room and the sinister square of light from the window. It was a moment of fearful anguish, a horrible moment, in which he relived all the torment of that irreparable night with redoubled pain and shame, physical shame and moral pain. Ten paces ahead of him, Father de Kern walked alongside the boys, his prayerbook under his arm, his posture relaxed and elegant, his face very pale, his eyes cheerful and devoid of remorse. Devoid of remorse! It seemed inconceivable to Sébastien. He expected him to feel as weighed down as he did, his eyelids red from weeping, his shoulders sagging beneath the burden of guilt. He might have been able to love him then; he certainly would have pitied him. But not like this. His whole body displayed an ease and freedom of movement, an

indifference which was deeply painful to the boy. If the priest had approached him, saddened, contrite, begging forgiveness, Sébastien might well have rejected him, he might well have said to him, 'No, leave me alone.' But he would have been pleased nonetheless. In fact, the priest had not glanced at him for a second, had not given him a moment's thought; instead, with visible, impenitent joy, as if nothing had happened, as if no crime had taken place, he was taking deep breaths of the morning air and of the fresh scents rising from the earth. Sébastien could no longer bear the sight of that priest, so cruel and hateful. To avoid him he briefly considered feigning a sudden illness and staying there alone on a hillock while the others went on ahead. Instead, for the whole of the rest of the walk, he lowered his head and, silent and stupefied, kept his gaze fixed on the backs of the boys walking in front of him.

As they proceeded, the way became thronged with pilgrims. They were coming from across the moors, in groups, from far distant locations, emerging from gorges, streaming along every path. At the crossroads, there were carriages filled to overflowing, joyful cartloads of people, dallying outside the taverns, mingling glasses of cassis with hymns, already drunk on gin and holy water. If Sébastien's mind had been clearer he would have enjoyed looking at the costumes the men were wearing and at the women's headdresses. Brittany's picturesque history paraded before him in little scraps of cambric, muslin and tulle. Wearing tall bonnets, impish fanchons, imposing diadems and Jewish tiaras, wild Tcherkesse headdresses and sweet little caps, the girls from Saint-Pol, Paimpol and Fouesnant passed by, as did the Bigoudenne girls from Pont-l'Abbé, whose strange, phallic headdresses glitter with tinsel and garish embroidery, along with the pale virgins of Quimperlé, so slim, dainty and nun-like, and the bold housewives of Trégunc and Concarneau, made for love; and the sardine girls from Douarnenez, always quick with saucy repartee, their poor widow's shawls pulled tight across their narrow shoulders; and the wrack-gatherers from Plogoff, with their strong backs and fecund loins. The moor was bright with flying ribbons, with this procession of living flowers, these

snowy flights of migratory birds, shattering the bleak isolation of the plains, the grey solitude of the sky, the stubborn silence of the solitary stones. The breeze blowing across the clumps of reeds brought with it snatches of plaintive melodies and a lingering scent of vanilla, which embellished and softened the austere countryside. But Sébastien felt nothing, heard nothing, saw nothing. Bolorec walked by his side, his face radiant, his eyes shining, his lips busy with songs from home. Amongst the girls passing by he recognised those from his region by their flat headdresses perched high on their heads, the edges flapping in the wind like wings. He kept exclaiming and pinching Sébastien's arm:

'Hey, look! They're from home. They're the ones who dance on the moorland and who sing, you know, the ones who sing:

> When I'm fourteen
> I'll have fun all night long
> With all my gallant lovers.
> And all day too
> I'll spend making love.
> When I'm fourteen
> With my gallants
> And my lovers
> All handsome as gulls.

But Sébastien was not listening to Bolorec, who added:

'Look at those big fellows with their white jackets and green ears of corn stuck in their great hats. They're from my region as well, those men are.'

And he started up again, nodding his head to the music:

'When I'm fourteen . . .'

As they neared Sainte-Anne, they had to slow down and close ranks. The crowd was getting bigger by the minute, waiting in front of the shops where holy medals, scapulars, sacred hearts in flames and small miraculous images of St Anne and the Virgin were on sale. Near the shops, housewives were grilling sardines over peat fires and selling unidentifiable

cold cuts to passers-by. The smell of cider and cheap alcohol was bitter in air already heavy with the stench of humans. Covered in teeming vermin and dried mud, carefully applied for pilgrimages, unlikely-looking beggars swarmed amongst the crowds begging for alms whilst, in the background, could be heard people singing hymns. On both sides of the road, along the verges, cripples and monsters, spewed forth from the mortuary or disinterred from the grave, paraded their festering flesh, nightmare deformities and indescribable mutilations. Crouching in the grass or in the mud of the ditch, some proffered horrible stumps, swollen and bleeding; others proudly displayed a nose cut back to the bone and lips devoured by blackened abcesses. There were some who lacked both arms and legs and dragged themselves along on their stomachs, trying to create some kind of comic effect out of their absent members, incredible, hideous parodies of Nature's creation. Women with shrivelled, dried-up breasts gave suck to hydrocephalic babies, whilst a kind of terrifying gnome, with dead eyes and a shock of ginger hair hopped along on feet enclosed in enormous fetlocks of soft, sore-encrusted flesh. At one point, the line of schoolchildren stopped and Sébastien saw to his right, propped against a milestone, a section of naked torso, a chest with gaping wounds, breastplated with gleaming pus like armour, a monstrous dropsical belly where there stirred, lifted by the effort of breathing, sticky scales, multifaceted scabs, a mass of putrifying, multicoloured meat so horrible that he turned his head away, his face white, vomit rising to his lips.

'And yet,' thought Sébastien, 'I am as disgusting as these wretches. I too am an object of horror now. Every part of my body is now stained with filth that can never be washed away.'

Addressing Bolorec in a frightened, pleading tone, he said:

'Do I disgust you, tell me, do I disgust you?'

Bolorec was not listening. He had cast a cursory glance in the direction of the monsters displayed on the verges and was now searching the crowd for people from his village, happy if he recognised someone and could breathe a little of the scent of his own moorlands, rediscover corners of his favourite

landscape, reminding him of freedom, of familiar, cosy nooks and trees where he had gouged out the bark and carved a design on the knots. The foolish look of serenity and joy on his friend's face and the way he turned calmly towards innocent memories were a real torture to Sébastien. He would never again feel that particular delicious pleasure, he would never again see anything in the same light, never again have innocent dreams, never experience past, present or future without the accursed shadow, the defiling, devouring image of his perdition.

'Tell me if I disgust you,' he repeated.

Bolorec was not listening. His imagination had taken flight towards the familiar plains, and he was murmuring:

'When I'm fourteen . . .'

At that time, there was no garish, ugly basilica, which today stands on that sterile piece of land, impoverished still further by the brutal opulence of the monument, with its mass of carved stone and its giant tower, overshadowed by the colossal statue of St Anne. Near the holy field of Bocenno there was a little village chapel, as humble and poor as the unfortunates who came to worship there. It was a low building made of dark roughcast and scarcely distinguishable from the houses surrounding it. Beneath its primitive ceiling, with its warped, exposed beams, there was no gold, marble or bronze, no proud columns or insolent, decorated altars, like courtesans' beds. Its only luxury, its only wealth, were the naive votive offerings covering the bare walls, the boats suspended in the naves by sailors rescued from shipwrecks and the white altar where, amid constantly renewed flowers and the eternal flames of candles, the saint – a saint of gilded plaster – dispensed to the faithful the cherished illusion of her miracles and her benevolence.

Sébastien could not pray. In the same row as him, in the main nave, between the pews, Father de Kern was kneeling at a prie-dieu. He could not see him, but he felt his presence, and that presence froze any religious impulse and poisoned his ardour. Any prayer he began remained unfinished; it immediately slipped away from him, dissipated, ungraspable as smoke.

Then it seemed to him that the saint turned her painted but knowing gaze away from him. So he spent the whole service with his eyes fixed on the model of a frigate, a frigate hanging above him in the air on a thin chain. This boat, with its masts and hoisted sails, small as a child's toy, spoke to him of distant voyages. He wished he could set out, carried away by those gentle sails, over unknown waves, simply sail far, far away and put seas, continents, impassable mountains between him and that man who dared to pray, who could pray, that man whom he could not bear to look at and whose image was everywhere, filled everything, his thoughts, his prayers, the light in the sky, the mystery of the woods, the wild soul of the moors and the shadows of the night, even the plaster eyes of good St Anne. For a long while too, he was able to forget himself perusing the simple votive offerings recalling extraordinary and consoling adventures: pacified lions, resuscitated corpses, sinners illuminated by grace. As he came out of the chapel, jostling with the others beneath the portal, Sébastien brushed against Father de Kern and it made his skin crawl.

After lunch, which was served in the gardens of the charterhouse at Auray, the noisy rejoicing and the excitement all around him only aggravated Sébastien's distress and he felt the need for solitude. Even Bolorec's company weighed on him and upset him. Alone, he hoped to regain his composure. He withdrew quite a distance from his schoolmates, high up on a slope, and sat on the grass, his back against an oaktree that sheltered him with its shade. From there he watched the other pupils. Some, tired by the long walk, stretched out on the ground and slept, others began to play. Nothing he had seen since the morning had remained in his thoughts. Any images of reality, which normally remained so strongly imprinted on his memory, faded away without leaving the slightest trace. He had already forgotten the chapel, the miraculous fountains, surrounded by the colourful, trusting crowd; he had forgotten the gorges of the Loch and the river humming over the pebbles below; and the road with its steep slopes dominated by enormous sphinx-headed rocks; he had forgotten the Martyrs' field, with its grim horizons and marshy vegetation, which the

briny waters burned and bleached; he had forgotten the calm avenues of the charterhouse, its quiet cloisters enclosing little square rose gardens; he had forgotten the ossuary with its white marble tomb and gaping hole, at the bottom of which the trembling glimmer of a lantern lit up the gathered bones of those shot in Vannes and Quiberon. And he was already forgetting, or, rather, did not even notice, the multiple sensations of the present moment, the softness of the sky, the gentle sun, bright, restful, magical nature, the dreaminess of this forest atmosphere, so devout, so musical, this seemingly underwater atmosphere, in which gentle flowers and sprightly, capricious insects wandered, wavered, zigzagged, shivered and concealed themselves, and where graceful, solitary leaves from time to time detached themselves from the trees, whirling as they fell with a rustle like the brush of wings. He remained entirely untouched by this perfumed peace, these shifting shapes, this constant vanishing of beings and things, in a sort of glaucous transparency and submarine sonority. He who loved so much to set one shape, sound or scent next to another and endow them with identical life and similar significance and breathe the life of his soul into them, remained impervious to the sight, sound and smell of the harmony about him. His senses had been annihilated, his mind had sunk into something black, darker than the ossuary in the charterhouse, and his thoughts were like the bones of those ancient dead, like the dust lodged in the cavities of those empty skulls.

As he stood there, motionless, he suddenly glimpsed between the leaves Father de Kern walking with Jean de Kerral. Jean looked happy and the priest was talking and gesticulating, the smooth, graceful gestures he affected when he was reciting poetry or telling stories, and which Sébastien knew so well that he could have recited the verses just from the gestures marking their rhythm. Both walked slowly the length of the avenue. Jean hopped along, very small, his face lifted towards the priest; the priest with his slim torso and strong hips, outlined by the soutane. Occasionally, the thickness of the foliage hid them from view, then they reappeared a moment later in a gap, haloed in greenery. Sébastien then

remembered that he had often seen them together; he also recalled that Guy de Kerdaniel, Le Toulic and many others liked to follow the priest, listen to him and cling jealously to the folds of his soutane. And he suddenly saw what the priest wanted from them. Yes, it really was that. From so far away, he could not hear what the priest was saying to Jean de Kerral, but he knew by heart that florid, intoxicating language, to which he had succumbed and which had led him to that room where Jean would go, where he had perhaps already been. 'Oh, little restless soul which I can read so well!' Doubtless he repeated the same things in the same soft voice, speaking all the time of his soul. All at once, Sébastien experienced a strange, intense feeling of pain and pity for those little victims, but mingled with that feeling was, to his astonishment, jealousy and also hateful admiration for that attractive, accursed priest. What could he be jealous of? What was there to admire? He did not know. Sébastien searched deep in his memory to find the precise, particular, unmistakable circumstances that could change his still hesitant suspicions into absolute certainties. A multitude of forgotten details, a quantity of tiny facts not understood at the time came back to him, details and facts to which, being ignorant of such things, he had paid little attention up till then.

Yes, that had been what lay behind it all! It explained undercurrents of behaviour, special favours suddenly withdrawn, constantly changing preferences and protections. He remembered how one night he had felt ill and, obliged to get up, he had seen as he came back to the dormitory a shadow coming out of Jean's cubicle, next to his own. That person, worried no doubt at being seen by someone walking down the corridor, had immediately slipped back into the cubicle. Was it Jean's cubicle? Yes, because as he approached, he had noticed that the curtains enclosing it were still moving slightly. Was that shadow Father de Kern? Yes. Although the episode happened several months ago and despite the furtive nature of the apparition, he recognised it immediately from the shadow it cast on the illumined background of the dormitory wall. He should have waited and spied on the shadow from behind his

curtains, pressed his ear to the partition. However, not believing in wickedness, he had thought nothing of it and had said to himself that his eyes had deceived him and that the shadow was merely a shadow, not even the shadow of a man, the shadow of some fixed object, possibly set in motion by a gust of air fanning the flame of the lamp. Yes, that was what lay behind it all! That was why during swimming lessons, Father de Kern always took Jean aside, in order to teach him to swim, taking obvious guilty pleasure in holding him from beneath the water. The memories came flooding back, crowding in, tearing away, one by one, each hypocritical veil, ripping off each lying mask. Each action, each word, each gesture of the priest could be linked to some intended act of lust. His kindness and indulgence were all besmirched by ignoble intentions and impurities. Sébastien's imagination, prey to the obsession of sin, engulfed all his schoolmates in a common martyrdom. Did not all of them, wretches like himself, bear the frightful stigmata of this priestly kiss, the stamp of that monstrous embrace? The pale faces, sickly appearance, limp gait, large, mournful eyes beneath bruised lids, did they not speak of the infamy of this devourer of little souls, the crimes of this child-murderer? Gripped by a need to justify himself by universalising his shame, driven by the urge to conjure up firm evidence of sins and tangible filth, he made his doubts real, dramatised his hypotheses with evocations of lubricious scenes and images, with which his corrupting obsession bombarded him.

Suddenly, the wood all around him became enclosed in thick walls, day turned to dark night. He recognised the terrible room, the low, white bed at the end, like a sepulchre, and the livid brightness of the window, where the awful shadow crossed and re-crossed. He saw Jean, Guy, Le Toulic, all the pupils, one after the other, enter, struggle, surrender, already vanquished, to prepubescent vice; he heard their sobs, their shouts, deadened by gags and furious fists; their cries, their laughter, the thuds, stifled in crumpled pillows; and what he saw was a horrible tangle of little naked bodies, little gasping throats, the sound of battered flesh, broken

limbs, something dull, hoarse, criminal, murderous. The hallucination went on. Other faces invaded the room, people singing. Dishevelled, drunk, stinking of alcohol, they danced obscene dances, surrounding him with diabolical laughter, impudent grimaces, brushing against him with touches that burned like flame: 'It's us, don't you recognise us! We are the years of your youth, your years of ignorance and purity. If only you knew how you bored us. And how ugly we were. Look how nice we are now that Father de Kern has shown us what pleasure is. We don't want you any more. He's waiting for us. Goodbye!' Other figures appeared. They were half-clothed with chests bared and they blew cigarette smoke in his face. 'We are your prayers, your poetry, your ecstasies. Oh dear. We've had enough of souls and we're off to a rendezvous with Father de Kern. Goodbye!' They made masturbatory gestures and displayed engorged genitals: 'And me? Why did you run away from me? Why do you reject my kisses?' It was Marguerite. 'Come, come with me. I know a place where the flowers intoxicate like the breath from my lips, where the fruits are more delicious than the flesh of my body. There I will teach you things you do not know, lovely things which Father de Kern taught me and which will make your teeth chatter with pleasure. Look at me. Am I not beautiful like this?' She raised her skirt, proffered her body for him to kiss, a body already prostituted and soiled. 'And then in the evening we will go into the woods; we will hide in a dark clearing; I will make you a soft, smooth bed and I will lie on top of you. Wouldn't you like that?' She beckoned to him, yielding, her hands bold, breathing hard, her eyes rolling back beneath fluttering lids: 'I will give you all the pleasures lust can offer and you will die beneath my caresses. No? All right, then, I will go back to Father de Kern. Goodbye!'

Sébastien was gasping for breath. He reached out to stop Marguerite fleeing from him; but his hands closed on emptiness. The void became peopled again with chaste images and calm brightness. He looked all around. It was a beautiful day; the wood disappeared into the distance, drowning in its

own peaceful, mysterious depths. At his feet a foxglove was growing in the grass, its frail stem laden with purple bells. Everywhere, amid the leaves, schoolchildren were running about, chasing one another, climbing trees. Had he been asleep? Had he dreamed all that in a waking nightmare? He rubbed his eyes. Flashes of his dream briefly sullied that calm resurrection of an untainted nature. Nevertheless, the dream had barely vanished and its impudent images scarcely faded, than Sébastien was overcome with a strange feeling of painfully intense sensuality: fire coursed through his veins; there was unbearable heat in his chest; he felt his muscles engorge, engendered by he knew not what inner turmoil; he felt he was waiting for something undefined, both desired and feared, the complete surrender of his entire being. He longed to soak his body in a bath of icy water, to roll about amongst cool things. He angrily tore up a clump of fresh moss and rubbed his face with it, breathed in its bitter scent of musk and damp earth.

'Why are you all alone here like this, my dear child?'

At the sound of this familiar voice, Sébastien turned round brusquely, his hands flat on the ground, ready to spring up and flee. Father de Kern was standing to his left, leaning against the trunk of an oak tree, his eyes boring into him. He was chewing a blade of grass.

'Did you fall asleep? Are you tired? Are you sick?' he asked tenderly.

At first, Sébastien did not reply. Then, all of a sudden, his cheeks aflame, his throat tight with fury, he yelled:

'Go away! Don't speak to me, never speak to me again, or else I'll tell, yes, I'll tell on you! Go away!'

'Come along now, my dear child, calm down. You have been absolved and you have forgiven me. I am so very unhappy about it all . . .'

These words, interspersed with silences, fell on Sébastien's skin like drops of boiling oil.

'No, no, don't speak to me . . . ever again!'

He leaped up and ran nimbly away into the undergrowth, beneath the branches, like a young deer.

The time had come to set off back to school. They took shortcuts. Behind Sébastien and Bolorec, who were walking along in silence, Jean de Kerral was chatting to a companion.

'Did you know there was a miracle at Sainte-Anne this morning?' he was saying. 'A very great miracle. Father de Kern told me about it. Three days ago, a Belgian came to Sainte-Anne to stay in a tavern. Even though he was ill, he had walked all the way. As he entered the tavern he died. The innkeeper sent for a priest and a doctor. The Belgian was good and dead. So the priest said a prayer to St Anne and left. The next morning, just as they were going to put him in the coffin, the Belgian sat up straight and said: "I was dead, but now I am alive." And he asked for something to eat. What had happened was, while the Belgian was dead, a thief, a heathen, had come into his room and searched through his clothes and taken the dead man's wallet and replaced the money it contained with a little medal of St Anne. He thought he was playing a good trick, this heathen, you see. Well, at the very moment that the Belgian came back to life, the thief died. What's even more peculiar is that the money stolen from the Belgian turned first to silver then to gold. So now the Belgian's really rich as well.'

'I know something even better,' replied his companion. 'Last year, a Persian came to Sainte-Anne, all the way from Persia. Naturally, he didn't speak French or Breton and no one knew what he wanted. Well, someone had the idea of placing on his tongue a medal of St Anne, blessed by the Archbishop of Rennes, and all of a sudden this Persian started to speak Breton. I saw it myself. Now he's the porter at the seminary. What did you ask St Anne for?'

'Well, I asked our mother St Anne to bring Henry V back,' replied Kerral, 'because then Papa would get his twenty-five thousand francs back and the bailiff's clerk would be thrown in prison and his father would have to give back the farm that was confiscated from us . . . what about you?'

'I asked our mother St Anne to let me win the gymnastics prize.'

Their conversation continued in this vein, with talk about

St Tugen who cures rabies and St Yves who resuscitates sailors.

At the top of the hill at Ponsal, on the left, towards Vannes, the view opens out. It is a sombre landscape, with undulating hills sliced by deep ravines and clad in wild woods that seem to be lying in ambush. The fields are enclosed by steep, fortress-like banks. On the right, the black moorland descends towards the estuaries of the rivers Baden and d'Auray, furrowed with natural trenches in the flat parts, defended by escarpments that rise up menacingly, like citadels.

Abruptly changing the subject, Jean pointed at the country-side and said:

'This would be a great place for sniping at them . . .'

'Who?'

'The revolutionaries of course. Oh I'd love it if I was an officer and they came back. I'd kill loads of them.'

Passing swiftly on to another idea, he demanded of Bolorec who was walking peaceably along in front, steps ponderous and legs bowed.

'What did you say to our good mother St Anne, eh?'

Bolorec shrugged his shoulders, disdaining to turn round.

'I said "shit",' he said, 'that's what I said.'

Jean let out a sad groan:

'That's very bad, you know. That's a sacrilege. I like you a lot, but you deserve to be reported to Father de Kern for that.'

They fell silent. Along the whole length of the crocodile of children, the lively chatter gradually died away. It had been a tiring day. Now feet trailed along the ground, steps grew heavier, shoulders hunched forward, bodies ached with walking. The return was completed in silence.

Sébastien had been unable to recover his equanimity, nor extinguish the ardent passions burning in his body. The poison was in him, having travelled through his whole flesh, insinuating itself deep into his marrow, ravaging his soul, leaving him no physical respite, nor a moment of mental peace, in which he might be able to cling on to the scraps of reason that seemed to be fast abandoning him. He was pursued by hallucinations; he would slip suddenly into terrifying dizzy spells.

He resisted in vain, trying to reawaken his defeated conscience and intermittently summoning up all his courage, but he could not stem that inner invasion of fire nor defend himself against the progressive numbing effect of that poison, and with every second that passed, his body grew more troubled, his willpower further weakened. He tried to take an interest in what he saw happening around him, but everything merely reflected impure images back at him. He shut his eyes, but in the darkness the images multiplied and became more clearly defined. They passed before him from left to right, cynical, solitary or in obscene troupes; they disappeared, then renewed themselves ceaselessly, more numerous and more insistent. He tried to pray, to beg for the help of Jesus, the Virgin and St Anne, whose smile begets miracles, but Jesus, the Virgin and St Anne only showed themselves to him in provocatively naked forms, as abominable temptations that came and squatted upon him, delved into his skull and sank sharp, tearing talons into his skin.

If at least he had been able to pour out his heart to a true friend, to void himself of the frightful secret suffocating and devouring him. The secret was often there on his lips, like vomit. Often he was on the point of confessing it, of shouting it out to Bolorec. Shame held him back; his friend's disconcerting nonchalance and coarse sarcasm dissuaded him. Haunted by the belief that Bolorec perhaps already knew something and in the hope of making him admit to something first, he merely asked him over and over:

'Do I disgust you? Tell me if I disgust you.'

'You get on my nerves!' replied Bolorec, whose mood had darkened now that he could no longer see the white head-dresses of the women from his region flitting past him.

Sébastien made an effort to try and distract himself from this environment that reminded him all too forcibly of his mistake, that was too directly involved in his sin; he tried to recall the tranquil sensations and calm faces of before. He thought of Pervenchères, of the peaceful, strong, cheerful child he had been then: of the beloved paths he once ran along, of the forest he had so often visited, of his river brimming

with shrimps. He recalled his father and his comical eloquence and the solemn buffoonery of his mannerisms, and his hat with its worn silk, each year more threadbare and which, when he put it on, made him look like an old-fashioned caricature; he thought of François Pinchard again and his dismal workshop, Aunt Rosalie and her corpse-like stiffness as she lay on the big white bed surrounded by the watchful old harpies. But happy or sad, joyous or funereal, all memories evaded him. One image and one image alone dominated, swallowed up all others: Marguerite. Not even the real Marguerite from home, who was quite troubling and mysterious enough in her pleated smock and short little girl's dress, but the Marguerite of his woodland dream, the Marguerite of Father de Kern, unclothed, violated, violating, the shameless, swooning monster with lips that exuded vice and hands that brought damnation. Then, despairing of putting these obstinate images to flight, he unconsciously abandoned himself to them. His shame at seeing them, remorse at listening to them, terror at feeling their ardent caresses and at breathing in their erotic exhalations, all vanished; then he reproached himself for having rejected Father de Kern so harshly, he missed the priest's room and started to hope to return there and savour the violent lusts that boiled in his body. He took pleasure in imagining an audacious rendezvous with Marguerite, future caresses and embraces, the unknown contours of her sexual organs.

'Do you know what women look like?' he asked Bolorec.

Bolorec, replied in thick, surly tones, though unsurprised by this unexpected question:

'Like everyone else. Except they have hair under their arms.'

'Really? Have you ever . . . ?'

He did not finish the sentence. And he longed for night to come so that he could be alone, enclosed by the silent partitions, alone with his imaginings.

The following day, after the morning bell, Sébastien's curtains remained closed. No sound came from his cubicle. When

making his rounds, Father de Kern noticed this, drew them aside and saw the child in his nightgown, kneeling by his bed, sound asleep. He must have been surprised by sleep in mid-prayer for his joined hands were still clasped. His cheek rested on the blankets which were damp with fresh tears.

'Poor little mite!' thought the priest, with a stab of remorse.

He did not want to wake him, so that Sébastien would not open his eyes and find the face he loathed before him. Gently he closed the curtains again. A monk was passing.

'Put that child back to bed,' he commanded. 'He's not well. And tell him to have a good sleep.'

CHAPTER VII

A little attic room under the eaves. There is deep silence; the movement and life of the school, contained by walls, yards and tall buildings, does not penetrate this far. A narrow iron bedstead, with white curtains; between the two windows, against the wall, a kind of writing-desk, with paper, an inkpot and two volumes of Father Huc's *Travels in Tibet*; on the mantelpiece, a plaster statue of the Virgin. Such is the room where Sébastien lies, separated from his schoolmates barely an hour ago, led there by a little, sallow, bony monk, jangling the keys in his hand like a jailer. He examines this furniture in astonishment and listens fearfully to the silence. A moment ago, another little monk, this one fat and paunchy, brought him his dinner. Sébastien attempted to question him, but in vain. The little monk made a few mysterious gestures and left without speaking, bolting the door. It is half-past twelve, the time when the pupils leave the refectory and go out to play. The little prisoner opens one of the windows and tries to get his bearings. The horizon is enclosed on all sides by rooftops, bristling with chimneys and black pipes. Above, the sky is a milky white punctured with pale azure; beneath, against a grey façade, there are descending lines of windows and, below them, a yard, sadder, damper, darker than a well, a cold yard crossed by tradesmen, with black caps on their heads and dirty overalls flapping round their legs. All of a sudden, to his left, he hears a confused sound like a distant buzzing. It is the schoolboys playing in the yards. With a lump in his throat, he lets out a long sigh. At that moment, he is thinking of Bolorec whom the same monk, the sallow, bony one, came to find and lead off somewhere too. But where? Where could he be? Would he be able to see him? He scans the windows opposite. But the windows are dark; they reveal nothing of what is going on behind their opaque eyes. Baffled, he sits at the table, puts his

head in his hands and thinks. He cannot understand what is happening to him. Why is he in this room? Vaguely, he guesses that Father de Kern is not uninvolved in this new turn of events. But how? Whilst he is thinking, he notices words carved with a penknife into the wood of the table and blacked in with ink. They are prayers, invocations, some half-effaced by subsequent rubbing. Sébastien reads: 'My God, have pity on me and give me the strength to endure your justice.' Also: 'My God I have sinned, I must be punished. But spare my parents. Oh, dear sweet father, oh, dear sweet mother, oh, dear sweet sisters, forgive me for causing you so much pain!' And: *'Mea culpa, mea culpa, mea maxima culpa!'* All these prayers are signed in large, deeply-scored letters: 'Juste Durand.' Sébastien recalls that Juste Durand was expelled from the school. He goes pale; a sharp pain twists his entrails. He too is going to be expelled. But why? He sits there going over the story of his life since the day of the Sainte-Anne pilgrimage. Four days have passed since then, four days of feeling lethargic and stunned, during which his spirit has been able to rest a little. Father de Kern has not spoken to him again; it is obvious he is avoiding him. Even in study periods he does not meet his eye. Is he really repentant? In any case, he has submitted to the boy's will, for Sébastien slipped a letter into his cell on the sly, in which he forbade him, begged him never to address another word to him. And the priest has done as he was asked. Freed from that gaze, that voice, that incessant pursuit, he intended to devote himself to his work and to follow the lessons attentively. But he is ceaselessly distracted by painful thoughts. His sin is still too recent; he cannot forget it. Even in his extreme depression, he suffers from shuddering, jolting, lacerating moments of anguish. Of course, he is calmer now; but not sufficiently calm for the images not to reappear from time to time, stoking the fire in his veins, precipitating the poison in his flesh. He has been able to pray and that has relieved him. During recess, he has stayed by Bolorec's side. Despite everything, Bolorec offers him some kind of refuge because Sébastien finds him interesting; because sometimes too he makes him laugh with the fierce spontaneity of his

questions, the unexpectedness of his responses and his meaningful silences. Both have gone back to their old habit of sitting under the arches near the music rooms. Bolorec carves and often sings. Sébastien watches him carve and listens to him singing. It soothes him, tears him away from his consuming obsessions. Yesterday, whilst he was sculpting and singing, Bolorec suddenly stopped and said:

'I'm so bored here. I'm bored! Are you?'

'Yes, I'm bored too,' Sébastien replied.

'It's no good, I'm bored – bored, bored, bored!'

After a pause, Bolorec started again:

'Well, I've just thought of something. This time, we've got to leave.'

Those words, like a friendly breeze, brought to Sébastien's nostrils the scent of fields and the freshness of spring water; those words, like a cheery light, brought to his eyes a vision of open spaces. But his enthusiasm soon evaporated.

'Leave? And go where?'

Then Bolorec, very serious, traced a broad gesture in the air with his short arms, as if embracing the whole universe.

'Where? Just go, anywhere. Listen, on Wednesday, during the walk, we can hide. Then, when they've all gone, we can wait for nightfall and skedaddle.'

Sébastien remained deep in thought.

'Yes, but the police will catch us, and anyway we'll need money.'

'Well, we'll steal it. Haven't you ever stolen anything? I have. Once I stole a rabbit off an old woman.'

'It's wrong to steal. We shouldn't steal.'

'Not steal?' replied Bolorec, shrugging his shoulders. 'Well, why should she have a rabbit? Why has Kerdaniel got his pockets full of money and a gold watch, while we have no money and no gold watches, or anything, even though we're at the same school? I'll steal some money off Kerdaniel and we can go.'

'But where?' Sébastien persisted.

'I don't know. To my house.'

'Then our parents will send us to another school.'

168

'So what? At least it won't be this one.'

Sébastien groaned.

'But then we won't be together any more. What will become of me without you?'

'You'll manage, you'll manage. So, you don't want to go then? You prefer to be shouted at all the time and for me to be hit, because my father's a doctor and yours is an ironmonger? I don't say anything because they're stronger than me, but I'm waiting. I have a great-uncle who was a leader in the Revolution. He killed aristocrats! Papa is a royalist and calls him a brigand. But I love my great-uncle . . .'

'He killed aristocrats!' echoed Sébastien, terrified by the look of hatred on Bolorec's face as he spoke.

'Yes, he killed aristocrats. He killed over five hundred. I love him, my great-uncle, I think of him all the time. If there's another Revolution, I'll kill some too. And I'll kill some Jesuits as well.'

Bolorec went on talking about his great-uncle and there was no more mention of leaving.

Sébastien recalls this conversation, whose every word returns to him, accompanied by Bolorec's wild grimaces. Perhaps they had been overheard. However, he is sure that there was no one near them and that they had spoken quietly. Each time a pupil passed by under the arches and entered the music rooms or came out, they had stopped talking, not trusting anyone. Everyone else was playing in the yard far away; and the priests were walking about, along the fences, beneath the elms. He is sure no one heard them. With meticulous precision, he thinks back to when he was sitting on the steps, he sees Bolorec next to him, with his red face and fiery glare; he sees the yard, he sees everything, right down to a flock of sparrows pecking at the sand, cocky and quarrelsome. He then remembers that, at one point, one of the music rooms was left open. There is no one in the room. On a chair, in front of a desk, lies a violin. Bolorec says nothing; but Sébastien stares at the violin. This violin attracts him, fascinates him; he wishes he could hold it in his hands, feel it vibrate, throb, complain and cry. Why should he not enter that room? Why not take

the violin? No prying eye is watching him; that corner of the yard is deserted, quite deserted.

'Come with me,' he says to Bolorec. 'We're going to play the violin.'

Looking as inconspicuous as possible, they slip into the room and half-close the door. Sébastien seizes the violin, turns it over and over, astonished at how light it is; he touches the pegs, plucks at the four strings, which emit shrill, discordant sounds. Then he stands foolishly before this violin, which, in his hands, is no more than an inert, jangling instrument, and he feels an infinite sadness at knowing that a soul lives in it, that a magnificent dream of love and suffering sleeps in its lined box, but that he will never be able to breathe life into that soul nor awaken that dream. An inner voice says to him: 'Are you not like that violin? Like that violin, have you not a soul, and do not dreams inhabit the void in your little brain? Who knows about that? Who cares? Those who ought to make your soul resonate and your dreams take wing, have they not left you in a corner all alone like that violin abandoned on a chair, at the mercy of the first curious, ignorant or delinquent passer-by who, in order to amuse himself for a moment, takes hold of it and breaks for ever the fragile wood which was made for eternal song?' Discouraged, Sébastien puts the violin back where he found it and goes out, followed by Bolorec, who watches him with an ironical air. But at the very moment when both are coming out of the doorway, Father de Kern passes, almost brushing them with his soutane, but without stopping, without turning his head. Instinctively, they fling themselves backwards into the room. His eyes on his breviary, the priest continues his slow stroll right to the end of the arches which he then leaves, continuing at the same slow pace towards the other end of the yard. Taken aback, Sébastien asks:

'Do you think he saw us?'

'So what if he did? What does it matter?'

It was true, what did it matter? They had done nothing wrong. All day he thought of the violin, so sad, on the chair. In the evening, troubled by that sudden encounter with the

priest, he tried, slyly, to read his eyes, to see if he could detect in his manner whether anything had changed, whether there was something more severe which implied: 'I saw you!' His attitude was the same though; his eyes, indifferent and peaceable, roamed over the vast room filled with the sounds of schoolwork: crumpled paper, books leafed through, squeaking pens. They did not rest upon Sébastien even for one instant.

Then one morning, a little monk, the little, sallow, bony monk, interrupted the study period and took Bolorec away. Then a quarter of an hour later, he came back and took Sébastien. Sébastien, very red, crossed the room between the raised heads and intrigued faces. He even heard insulting, vicious hissings as he passed: 'Kiss, kiss, kiss!' From beneath his desk, Guy de Kerdaniel stuck out a foot to trip him up and said through gritted teeth: 'Pig!' Father de Kern sat high up on his chair, his body turned sideways, his face calm, a book open before him. As the murmuring grew around Sébastien, Father de Kern rang his bell and firmly called for silence. Just as on that fateful night, Sébastien climbed stairs, crossed corridors, dark landings and squalid corners. Where was he going? He had no idea. The monk would not reply to his questions, retaining amidst the vile folds of his ill-shaven cheeks the insidious smile of the corrupt priest. Sébastien found this monk irritating and repulsive. His long, grimy coat exhaled a combined odour of latrine and church: his trousers hung in dirt-encrusted folds over wretchedly poor boots with holes in the toes; his back was bent in a servile manner; his ambiguous gaze, both cowardly and cunning, lay in ambush at the corners of his eyelids; there was in that man an odious mixture of jailer, domestic, sacristan and criminal. Sébastien felt a real sense of relief at his departure.

Now he is in that room, in that prison, alone, locked in. He guesses that something irreparable is about to take place there. But what? Not knowing exasperates him. Why did those monks refuse to answer his questions? Why did they leave him in this cruel anxiety between freezing walls? He listens. The buzzing coming from the yards has stopped. Above the

motionless roofs and impenetrable windows, clouds pass, the only moving, living things around; behind the bolted door there is silence, only troubled from time to time by steps shuffling along the flagstones of the corridor. Never has he been more conscious of the crushing weight of the school, its suffocating walls, its oppressive discipline, the viscous cold of this darkness pressing down on his skull, his shoulders, his back, his whole body and his whole soul. Of the thousand little lives being lived out there, of all that is thought, dreamed, breathed there, not one whisper reaches him, not one sound, nothing, nothing but the hostile step of a guard creeping along close to the walls and listening at doors, a hideous watchman. He looks again at the inscriptions on the desk, Juste Durand's naive and heartbreaking prayers: 'Oh blessed mother, St Anne, grant me this miracle; spare my dear sweet father, my dear sweet mother, my dear sweet sisters, the shame of my expulsion from school. Oh good mother St Anne, and you, Holy Virgin Mary, mother of Jesus, I implore you.' His heart goes out with inexpressible tenderness to this Juste Durand whom he never knew and whom he loves because of his suffering, the twin of his own. Where is he now? Have his parents sent him away; perhaps they had him shut up in a reform school. Perhaps he died. Whilst he sits there feeling sorry for Juste Durand and all those who have passed through this room and not left their names carved into the wood of the desk, the door opens. It is the little, fat, paunchy monk coming in with a broad smile on his lips.

'I am ordered to take you to the Very Reverend Father Rector. But your hair is all untidy. You must comb it a bit. Apart from that, here are your things, Monsieur Sébastien Roch.'

The monk places a parcel on the table and Sébastien recognises his toilet things, his comb, his brushes, his sponge.

'There. And soon you will have a basin and a pitcher of water. Sort yourself out, Monsieur Sébastien Roch.'

'Do you know how long I have to stay here?' asks Sébastien.

'I don't know anything, Monsieur Sébastien Roch,'

demurs the monk with a humble gesture. 'I do not need to know anything. I am forbidden to know anything.'

'And Juste Durand? Did he stay here long? Did you meet him?'

'Ah, that dear child. I used to bring him his food and take him for walks. A truly edifying young man. His tears could have broken your heart.'

'And Bolorec, where is he?'

'I don't know. Right, now you're nice and clean, come with me.'

Sébastien follows the monk, full of anguish, his legs like jelly.

The Rector's study was a large, austere room, with three windows overlooking the older children's recreation yard. The stiff, neat furnishings comprised various square objects: a broad mahogany desk cluttered with papers, a tall filing cabinet, a small bookcase bearing a few books on open shelving, two armchairs either side of the hearth and, arranged on the walls, a portrait of the Pope, the revered image of St Ignatius and various holy objects. When Sébastien came in, the Rector was sitting with his back to the light, his legs crossed beneath his soutane, examining a sheaf of papers. Without looking up, he pointed to a chair, on which Sébastien sat or rather collapsed, and for a few seconds, he continued his reading. His biretta rested on one corner of the desk; he was bare-headed, his face almost completely obscured by blueish shadows, his clear, elegant, strong body silhouetted against the white light of the window.

The Rector did not give generously of himself to the pupils, amongst whom, however, he enjoyed considerable prestige. When he appeared in class, in study periods or at a ceremony, his presence was an event and caused a sensation. He was always very gentle and yet had an air of majesty, addressing each pupil by name, congratulating one, encouraging another, reprimanding yet another, his remarks always relevant and to the point, in a tone in which fatherly indulgence never quite relinquished teacherly authority. His keen

eye, exceptional memory and profound knowledge of every-
one's faults and qualities, were just some of the things that
astonished the schoolboys and made them venerate and fear
him. They actually took him for someone superhuman.
Added to this, he was extraordinarily handsome, with a truly
regal bearing; and, beneath the worldly, grave and dis-
enchanted asceticism of his face, there bloomed a lively and
beguiling sense of irony, whose melancholy gleam tempered
any apparent dryness and impenetrability. Always perfectly
groomed, he was adept at using some discreet detail of dress, a
white collar or good shoes, to relieve the monotony of
ecclesiastical wear. Without knowing why, people loved him,
and this deep affection was transmitted almost adminis-
tratively, like a legacy, from the older pupils to the younger
ones. On his birthday, celebrated with great pomp by the
whole school, former pupils came from far and wide, thus
perpetuating the enthusiasm for a love whose origin no one
could explain, except that it seemed part of their education,
like learning Latin. No other Jesuit establishment could boast
of having at its head a Rector like him. Impressive stories were
told about him, embroidered each year with further admirable
and mysterious feats. People said he could have become head
of a province a long time ago, but that he preferred to stay
amongst his dear pupils, whom, however, he saw as little as
possible. He spent every holiday in Rome, where he had fre-
quent audiences with the Holy Father, who held his character
and his exceptional intelligence in particular esteem.

Sébastien realised the gravity of the situation and believed
that he was lost and condemned. He felt small, wretched and
crushed before this solemn, powerful Jesuit, who held so many
destinies in his hands, whose unbearable gaze had plunged
deep into so many souls, into so many things, and, regardless of
what might happen, he immediately gave up any thought of
defence or resistance. He had no reason to hope for pity from
this man, nothing could move that marble brow, those incor-
ruptible lips, those pale eyes. And ignorant as he was of the
history of the Society of Jesus, he had a confused, irrational
sense of the priest's formidable, inexorable powers. What

174

possible importance could the life of a child have in his concept of justice, his secret schemes? He resigned himself to the worst sufferings, and, sitting hunched on the chair, his shoulders bent, he waited, almost fainting, for what the Rector was about to tell him.

The Rector placed a piece of paper on the desk, leaned his elbows on the armrests of his armchair and clasped his hands.

'My dear child,' he said, 'I have to make a sad announcement to you, sad for you, sad, above all, for us, whose hearts are broken, believe me. We cannot keep you here at school any longer . . .'

Sébastien made a gesture as if to say something and the Father added quickly, with an expression whose falsity grated on the child's nerves like a finger sliding over wet glass:

'Do not ask for mercy, do not beg. That would cause me unnecessary pain. Our decision is irrevocable. We have responsibility for the souls of children. The pious families who entrust their pure children to us demand that we return them to them still pure. We must be pitiless with the black sheep and drive them from the flock.'

He shook his head and sighed sadly.

'After your first communion, which touched us all, who would have expected such a scandal?'

Sébastien had no idea what the Rector meant. He understood that he was being expelled, that was all. But why was he being expelled? Was it because of his conversation with Bolorec? Was it because of the violin? He was as confused as ever. He searched in vain for meaning and could find nothing plausible. In his innocence, too ignorant of evil to suspect such darkness, it did not occur to him that Father de Kern might be behind this crisis, denouncing Sébastien in order to rid himself of the embarrassment of his over-excited state, his over-zealous repentance. He was being expelled, that was the only clear thing. Since the Rector had started speaking, he felt relieved, not happy, but genuinely relieved, able to breathe freely and move about on his chair. He was being expelled. So, in a way, his and Bolorec's wish was coming true. He was going to leave the school, the stifling walls, the hostility and

175

indifference and Father de Kern. The reason didn't matter. What did the future matter either? Wherever he was sent, he could never be as unhappy as he had been there, he could never feel more abandoned, more despised, more defiled. That was why it did not even occur to him to protest against the summary fate befalling him, or even to ask for an explanation.

The Rector started to speak again.

'Now, my dear child, think carefully about this. All sins are redeemable for anyone who sincerely wishes to repent and live according to the Lord's commandments. Despite your sin, we feel love for you and will pray for you every day. We will follow your progress in your new life from afar, for however culpable they may be, we never abandon the sons we have raised, who have grown up with our protection and love. If later on, you are unhappy and you remember your childhood days spent in the peace of this house, come and knock at our door. It will open wide to you, and you will find loving hearts, familiar with suffering, with whom you may weep. For one day, you will weep. Now, off you go, my child.'

Sébastien was scarcely listening to this voice, whose false affection and forced emotion he could sense; he was looking out of the window, through the gap in the curtains at a corner of the yard and at the spindly elms in whose shade he had sobbed so many times. He stood up without saying a word and took a few steps towards the door. The Rector called him back.

'Your father cannot come for another four days. Have you any particular devotions you would like to carry out? Is there anything you would like to ask me?'

Sébastien suddenly thought of Bolorec, who was also all alone in a locked room, and he overcame his timidity.

'I would like to see Bolorec before leaving and say goodbye to him.'

'That is not possible,' said the Rector in a sharper tone. 'And if you wish to retain a little of our sympathy, I suggest you forget that name.'

'I would like to see Bolorec,' insisted Sébastien. 'He is the only person who has been kind to me; when I was unhappy

and people were cruel, he never rejected me. I want to say goodbye to him, because I will never see him again.'

But the Rector had returned to his desk and was not listening any more. Sébastien went out. The monk was waiting for him at the door, mumbling his rosary. He led him back to his room and ferreted about, checking if everything was in place.

'Do you require anything, Monsieur Sébastien Roch?' he asked as he was shutting the door. 'Would you like some books? *The Life of St Francis Xavier*, our holy patron saint? It's very interesting. If you wish, I can take you to confession.'

'No, father.'

'You are wrong, Monsieur Sébastien Roch. Mark my words, there is nothing more revitalising than a good confession. Monsieur Juste Durand confessed at least six times in four days. Oh, the dear child. And when I used to come in here, he was always on his knees, beating his breast. But what consolation he found too!'

'But he was expelled all the same.'

'Yes, but what consolation he found!'

Left alone, Sébastien lay down on his bed. He was calmer, astonished not to feel pain, accepting almost as a deliverance the public shame of being expelled from school. Only one thing tormented him, and that was not to see Bolorec again, not even to know where he had been banished to. For a long while, he thought affectionately of Bolorec's songs, his carvings, his short legs which always ached during the walks, that strange muteness which he could maintain for several days sometimes and which would end with a crisis of rebellion during which cruel laughter alternated with fierce anger. Of those three years, so long, so heavy, Sébastien would take only one sweet memory away with him, that of a few hours spent with this bizarre companion, who was still a puzzle to him. Of all the faces, only one would remain dear and faithful, Bolorec's face, so plain, soft and round, that grimacing face, terrified and terrifying, with eyes that never betrayed what was really happening in his heart, and which could light up suddenly with a mysterious gleam. He also thought with compassion of poor Le Toulic, endlessly swotting, trying to

gain forgiveness for having won a free place by dint of hard work, heroically enduring his schoolmates' cruelty, understanding that he needed to regain for his inconsolable mother some of her wrecked hopes, a little of her lost happiness; and Sébastien smiled at the lovely, vanished vision of the two sisters down there in the square. But those sweet memories and those dear faces were rendered still sweeter and dearer by the many hateful memories and hated faces he had known there! Cruel, frivolous schoolfellows, indifferent, deceitful teachers! Deceit made master! Deceitful expressions of affection, deceitful lessons and prayers. Deceit everywhere, wearing a biretta and a black soutane. No, little children like him, poor, humble wretches, the anonymous ones with no position and no fortune, had nothing to hope for from those young, pitiless boys, corrupted from birth by all the prejudices of a hateful education; nothing to expect from those loveless, servile teachers either, kneeling before wealth as before a god. What had he learned? He had learned pain, and that was all. He had arrived, ignorant and pure; they were expelling him, ignorant and defiled. He had arrived full of naive faith; they were driving him out full of troubling doubts. The peace of mind and bodily tranquillity he had possessed on entering that accursed house were now replaced by a horrible, devouring void, a burden of remorse, disgust and constant anguish. And that had all been accomplished in the name of Jesus! They were twisting and suffocating the souls of children in the name of the one who had said: 'Suffer the little children to come unto me'; of the one who cherished the unfortunate, the abandoned, the sinners, the one whose every word expressed love, justice and forgiveness. Oh, he knew all about their kind of love, justice and forgiveness! To earn it, you had to be rich and noble. When a person was neither rich nor noble, there was no love, no justice, no forgiveness. You were expelled and no one told you why!

As Sébastien moved in his mind from the general to the particular, he encountered only images of pettiness around him, pettiness of feeling and of intellect, which now he could not help but smile at. He remembered once how he had been

punished with eight days' worth of detentions for having written in an essay the phrase: 'the child emerging from her lacerated loins'. Oh, the blushing astonishment of the pupils and the indignation of the teacher when he read the phrase out loud: 'the child emerging from her lacerated loins'! What a scandal in class! His neighbour had shrunk away from him; a murmur went up and down the rows of seats. He was asked: 'Where did you learn such indecencies, such filth? It is shameful! You describe things of which you should know nothing. I enjoin you to keep yourself under stricter control.' He had imagined something! So it was a crime to imagine things? He had sought beautiful, expressive, living words. Was that forbidden, then? Besides which, that was the only occasion on which his teacher had ever addressed him directly. The rest of the time he took no notice of him, leaving him hunched at the end of the table, and reserving his benevolence and patience for the others. He had been judged a dangerous, rebellious spirit from whom no good would come. Father Dumont would say, using an abundance of bold metaphors: 'He is a little serpent we are warming in our bosoms. He is only a grass snake at the moment, but just you wait and see.' Whenever there was some favour to be bestowed, he was excluded. He had never been allowed to be part of any special society or favoured group. Even at mealtimes things were organised so that he was served last and so only ate what the others had rejected. 'And their lottery?' he thought. 'I never win anything. Guy de Kerdaniel always wins the large prizes.' He considered all these minor resentments, these little deceits and vexations and exaggerated them, enlarged them, whipping up his own jealousy towards other pupils and hatred towards the teachers, so as to give himself courage. But he did not succeed. As the minutes flew by, his uncertainties were reborn; apprehension regarding the future reared up, pregnant with menace and difficulty. The interview with his father, the journey home, his entombment in the house in Pervenchères, the shame that awaited him there, the shame that he would leave behind him here, all of this undermined his false sense of security, overcame his rancour. Besides, it was all very well

179

telling himself that it would be impossible to live here from now on in this hostile environment, where everything would remind him of his mistake, but he felt powerfully rooted there, he felt the attachment that animals feel for the place where they have suffered. He was only counting the pain; but had he not tasted joys as well, precious joys which he could not regret? Would he ever find the equal of the sea, the walks back from Pen-Boc'h, the music in the chapel, Bolorec, and even, though he hated to admit it to himself, the delicious evenings at the dormitory window, when Father de Kern would recite poetry and speak to him of immortal works of art.

He carried on thinking like this until evening, feeling sometimes resigned, sometimes rebellious; one moment determined to demand an explanation from the Rector, the next, saying to himself: 'What's the point? It's best that I go. There are just eight bad days to get through and I will probably be very happy far from here.' When the monk came to bring him his food, he found Sébastien lying on his bed, his eyes vague, lost in a distant dream.

'Now, now, Monsieur Sébastien Roch!' he exclaimed. 'And there was I hoping to surprise you at prayer. Oh, you wouldn't have caught Monsieur Juste Durand, the dear child, just lying on his bed. And I bet you don't even have a rosary.'

'No, Father, I don't.'

'No rosary! No rosary! And here I am bringing you a pear, Monsieur Sébastien Roch, a pear culled from the tree of the Reverend Fathers. No rosary. Oh, blessed St Labre! How do you expect to have a peaceful heart? I'm going to lend you mine. I have twelve of them.'

'Thank you, Father, but couldn't you just tell me where Bolorec is?'

'Monsieur Bolorec? I don't know! Monsieur Bolorec is where he is, you are where you are, I am where I am, and the good Lord is everywhere. That's about all I know, Monsieur Sébastien Roch.'

Sébastien leaped up from his bed and asked sharply:

'Now then, Father, tell me why I am being expelled.'

'Why?' cried the monk, putting his hands together. 'Oh,

great St Francis Xavier! I don't know whether they are going to expel you! I don't know anything! How do you expect a monk, that is to say, a creature of less importance than a rat, than a maggot, than a slug, to know anything? Monsieur Juste Durand, the dear child, would never have asked me such questions.'

Imprisoned in that silence, amid such ugliness, Sébastien found the next four days very painful. In the morning, he heard mass alone in a small chapel. In the afternoon, at the time when classes were held, he had an hour's walk in the garden or the grounds, led by the monk, who was kindly and talkative, but unbending in his mission. Sébastien did not attempt to question him any further, realising it was pointless, and instead remained silent, walking beside that fat fellow who soon got out of breath and had to stop every hundred paces to gather his strength.

'Look, Monsieur Sébastien Roch,' he might say. 'Look at this lovely pear tree and what fine pears! This year no one has any fruit . . . only here . . . The good Lord protects our trees. God is good, ah, God is good.'

In the grounds, in front of the statues of the Virgin, the rustic altars or the grottoes decorated with pious images, the monk, gasping, would command:

'Stop here! A little prayer, I think, Monsieur Sébastien Roch . . .'

And they would kneel down, the monk making broad signs of the cross, Sébastien, his gaze lost in the distance, breathing in the scent of the foliage and listening to the sounds. Between the trunks, between the leaves, beyond the terraces, in the distance, he could just make out the school façade, mute and grey, with its treacherous cross on top. They never met another living soul. If they so much as glimpsed a priest as they turned a corner, they immediately retraced their steps or changed direction. Once, Sébastien thought he recognised Father de Marel; another time he imagined he saw Bolorec passing by, accompanied, like himself, by a monk.

'No, no, it's not him,' protested the monk. 'It's nothing at all. What are you thinking of, Monsieur Sébastien Roch?'

The rest of the day, locked in his room, he spent the interminable hours daydreaming or worrying; or watching the clouds scudding by above the rooftops. Too anxious and troubled to immerse himself in some quiet task, he read none of the books brought to him and did not attempt to distract himself with any work. At recreation times, he leaned on his elbows at the open window and listened to the distant noises coming from the yards, a familiar, confused buzzing which alone proved to him that there was life and movement somewhere nearby. His spirit returned there. Through the walls he saw once more the yards bright with a thousand games and with animated faces, the supple movements of his schoolfellows, the priests under the elms, the fights, the laughter. There was Le Toulic, leaning against the fence, with his bent back and his consumptive pallor, his forehead already lined like an old man's, learning his lessons, stubborn, dogged, struggling with all his will against the slowness of his intelligence and his obstinate memory. There was Guy de Kerdaniel, insolent and cruel, surrounded by his gang; there was Kerral, skipping about, in search of someone unhappy to console. There was also the now empty place, their place, his and Bolorec's, on the steps of the cloisters, where the sparrows fretted not to see them any more and not to hear their songs; all those things, all those faces were about to fade and disappear for ever. What did they think of him? What were they saying about him and this sudden, unforeseen separation? Probably nothing. A child arrives: everyone throws stones at him and insults him. A child leaves, and it's all over. On to the next. What astonished him was that Father de Kern had never come to visit him. It seemed to him that he ought to have done, or at least to have enquired about his state of mind, to prove to him that not all compassion was dead in his heart.

'Has Father de Kern not spoken to you about me?' he asked the monk every time he came into the room.

'And why should the Reverend Father speak to me about you? I am nothing. A lion, Monsieur Sébastien Roch, does not speak to an earthworm.'

This caused Sébastien real pain, mingled with frustration,

frustration that he meant nothing in the life of that man, not even a moment's remorse.

Left to his own devices for most of the time, seated or lying on his bed, his body inactive, he was also scarcely able to defend himself against the temptations which assailed him, more numerous and more precise each day, against the unbridled madness of the impure images inflaming his brain, scourging his flesh, driving him to shameful relapses, immediately followed by self-disgust and bouts of prostration during which his soul sank down as if into death. Afterwards, he would fall into an agitated, painful sleep, interspersed with nightmares and a feeling of suffocation; his dreams were terrible, as if he were emerging from the heavy, terrifying darkness of a would-be suicide.

On the morning of the fourth day, he said to the monk as he accompanied him back from mass:

'Do you know whether my father has arrived yet?'

'Do you really expect me to know, Monsieur Sébastien Roch?'

He was quite right. Sébastien should have foreseen that reply. However, he was beginning to feel angry. He had had enough of this uncertainty, this loneliness, this terror of hearing the door open at any moment and seeing his father suddenly appear, angry and threatening. He wanted to have someone near him, to speak to someone. He thought of Father de Marel, the least severe, most amiable of all the priests and he said abruptly:

'I wish to speak to Father de Marel. Go and inform Father de Marel that I wish to speak to him, immediately!'

'But that is not the way it's done, Monsieur Sébastien Roch. Speak to him! Immediately! Oh, great St Ignatius! First, you must submit a request with reasons, using me as intermediary, to the Very Reverend Father Rector. The Very Reverend Father Rector, in his wisdom, will give a ruling on your request, and . . .'

Sébastien interrupted him, furious, stamping his foot.

'I insist!'

The monk did not allow himself to become flustered and

slowly prepared a sheet of paper; then very humbly, very formally, he dictated to the child a request which he took immediately to the Rector. One hour later, Father de Marel came into Sébastien's quarters.

'Oh, unhappy child,' he sighed. 'Unhappy child.'

His face was sad but not severe. Beneath the mask of sorrow, there was still extreme benevolence. He said again:

'Unhappy child.'

Then he fell silent and sat down, uttering a groan.

Sébastien did not know what to say any more. He had wanted to see the priest and unload onto him everything in his heart that was too heavy for him to bear alone, but he could not find the words. His mouth frozen and foolish, he bowed his head. The priest groaned again, brushing a few grains of dust from the table:

'Can it be possible?' and then was quiet again.

After an embarrassing silence, he asked:

'It was Bolorec, wasn't it?'

As Sébastien said nothing:

'It was Bolorec,' he reiterated. 'Bolorec led you on and corrupted you. It was so obvious.'

The child started to deny it, and Father de Marel immediately burst out:

'Don't defend him! Bolorec is a monster.'

Then, the idea of defending Bolorec gave Sébastien back something of his courage. He stammered:

'I swear to you, Father, I swear before God, that it was not Bolorec. Bolorec was kind to me. We never did anything, never. I swear to you.'

'Why tell lies?' said the priest sadly and reproachfully.

'I am not lying, I swear to you! I am telling the truth.'

'Now, now. You cannot deny that you were seen, that you were caught together. Come along now, child, you were caught!'

All of a sudden, light dawned in Sébastien's mind. In the blazing clarity of that light he understood everything. He realised that Father de Kern had invented a horrible story, that he had denounced both Bolorec and him, a cowardly act, because

184

he feared Sébastien, dreaded that one day he might speak out about his sin. It was not enough to have dishonoured Sébastien; he wanted to implicate Bolorec too. It was not enough to have defiled Sébastien in the darkness; now he wanted to defile him in broad daylight! At first, he could not utter a word. His throat felt so tight that he could only make hoarse gasps, then, little by little, by dint of forcing the muscles of his face, by sheer willpower, his eyes wide with horror, almost mad with fury, he shouted:

'It was Father de Kern who . . . Yes, it was him, in the night, in his room! It was him! He forced me, he took me by force!'

'Be quiet now, you little wretch!' ordered Father de Marel, suddenly very pale. He leaped up from his chair and shook Sébastien roughly by the shoulders. 'Be quiet now!'

'It was him, it was him! And I will tell! I will tell everyone!'

In short, jerky, staccato phrases, with a sincerity that no longer minced its words, needing to free himself once and for all of this heavy, suffocating secret, he described the seduction, the conversations in the dormitory, the incidents at night, the room . . . He recounted his fear, his remorse, his torments, his visions; he recounted the Sainte-Anne pilgrimage, the discussion with Bolorec, his lonely relapses, the music room. Father de Marel was appalled. Faced with this confession he could harbour no doubts; now he strode up and down the room, making incoherent gestures, uttering incoherent exclamations.

When Sébastien had got as far as the violin episode:

'So it's that devilish music!' he exclaimed. 'That devilish music. Without the violin nothing would have happened, nothing!'

Sébastien had finished his story and kept repeating:

'I'll tell. I'll tell. I'll tell my friends and I'll tell the Rector.'

Grasping the gravity of this unexpected and irrefutable revelation and having recovered from the first shock, the priest did not take long to recover his wits. He let Sébastien give full vent to his tumultuous emotions in shouts and threats, knowing that exhaustion would quickly follow this crisis, which was too violent to last, and that he would then be

185

able to influence him in his own way and get all he wanted from him by making a specious appeal to the boy's finer feelings. Although, in normal circumstances, he was a good man, he had only one thought at that moment: to prevent this terrible secret from getting out, even if that meant a flagrant injustice or the sacrifice of an innocent, unhappy boy. However unimportant the child, however unimportant the accusations of an expelled pupil in the eyes of the world, even if they managed to rewrite the story in their own favour, there would always be a lingering doubt, damaging the proud reputation of the Order. It was vital to avoid that, particularly now, since public spite had recently been aroused by a scandalous episode in which one of their number had been caught in flagrante in a train carriage with the mother of a pupil. This compelling need, this *force majeur* stifled all feeling in him, all compassion and made him virtually the accomplice of Father de Kern. He realised this but did not reproach himself. He consciously assumed the role of cunning Jesuit, implacable priest, sacrificing his natural generosity to the greater interests of the Order, sacrificing to shadowy politics a poor child, the victim of an odious assault which he, chaste as he was, hated and condemned. At that moment, he even felt for this child, the possessor of such a secret, the hatred that he should have felt for Father de Kern alone, and which instead he did not feel at all.

Soon Sébastien's fury abated and he calmed down, tears came and with tears the nervous release which, little by little, left him slumped like an inert object on his chair, without strength, without resistance, his brain bruised, his limbs heavy. Father de Marel sat down next to him, drew him gently towards him, almost onto his lap, and lavished on him loving, soothing, childish words. After a few moments, seeing that Sébastien was quiet again, dazed, he said:

'Now then, my child, are you calmer now? Can I talk sense to you? Listen. I am your friend, you know that. I have proved it to you. Remember how you ran away the day you arrived here. Remember our music lessons, our walks. Well now . . .'

In fatherly fashion, he wiped away the tears filling the boy's eyes and dabbed his face with his own handkerchief.

'Well now, assuming that this crime really did take place . . .'

When he felt Sébastien flinch, he hastened to add, as a kind of parenthesis:

'Which, of course, it did, it did . . .'

Then he continued:

'Assuming that it did happen, which, of course, it did, were you not in some way an accomplice? I mean, could you not have prevented it? In any case, my poor child, you will have to be punished. Believe me, Father de Kern will be punished too, oh yes, severely punished. I will take it upon myself to inform the Rector, who is justice itself. He will be driven away from this house and sent to a distant mission. But what about you? Think. Do you really believe that you can stay here? For your own sake and for us who love you so dearly, no, you cannot. It would be like deliberately irritating a wound which needs to heal and to heal fast. You say you are going to reveal this crime to everyone, to shout it from the rooftops. What would you gain by that base action, except even more shame? To this crime, which should remain secret though not unpunished, you will have added a scandal without any benefit to yourself. You will have given solace to the enemies of religion, made pious souls despair, compromised a holy cause and dishonoured yourself completely. No, no, I know your character and you will not do this. Of course, I feel very sorry for you. Oh, I pity you with all my heart. But I also say to you this: "Accept with courage the trial which God has sent you . . . "'

Sébastien tried to disengage himself and said in a voice still trembling with tears:

'God! You still talk to me about God! What has he done for me?'

The priest grew solemn, almost prophetic:

'God has sent you this suffering, my child,' he pronounced in a grave, deep voice. 'It means he has plans for you which we cannot understand; it means perhaps that you have been chosen for some great task. Oh, never doubt, not even in the

midst of the most atrocious suffering, never doubt the infinite and mysterious goodness of God. Do not question it; submit. Whatever tears you shed, whatever bitter chalice you accept, raise your soul to God and say . . .'

He pointed to the heavens, his finger raised, and recited in the tones of religious inspiration:

'In te, Domine, speravi, non confundar in aeternum.'

The priest stood like that for a few seconds, finger pointing heavenwards, eyes fixed on Sébastien's eyes; then, all of a sudden, he grasped the boy's hands and, moved, sincere, almost tearful, he begged:

'Promise me you will leave this house with no hatred in your heart. Promise me you will make this sacrifice with nobility. Promise me to keep this terrible thing a secret for ever.'

Sébastien had never felt deceit weigh so heavily on him. But he was too broken by the moral upheaval, too annihilated by a succession of violent emotions to feel indignation. He felt nothing but disgust for this priest now, even though he was the only one in whom, before, he thought he might find a little goodness; he was sickened by these grave words which accorded so ill with that plump face where, despite everything, beneath the changing mask of sadness, emotion and enthusiasm, there lingered a trace of easy good humour and comic joviality which, ultimately, was prepared to connive at infamy. He replied:

'I promise.'

'Swear, my child, my dear child.'

Sébastien's lips were twisted in a bitter expression. However, he spoke again, resigned:

'I swear.'

The priest was delighted.

'That is excellent, excellent. There now, I knew you were a good boy.'

His face beaming again, he asked:

'Now then, have you anything to ask me?'

'No, Father, nothing.'

'Let me at least kiss you, my child.'

'If you wish.'

Sébastien felt on his forehead the slimy touch of those lips still smeared with deceit. Disgusted, he tore himself away from that embrace, which was as hateful to him as that of Father de Kern, and he said:

'Now leave me, Father, I beg you. I wish to be left alone.'

When the door had closed behind the priest, Sébastien breathed more freely and he exclaimed out loud, outraged and disgusted:

'Oh yes, I'm leaving! Let me leave now!'

In the evening, he was taken to see the Rector again. As he entered his study, he saw his father standing there, a pale, gesticulating figure. He was wearing his dress coat, holding in his hands his familiar, ancient hat. Sébastien noticed that his black trousers were dusty at the knee: he must have been grovelling at the feet of the impassive Rector, begging him, imploring. The sight of him neither surprised nor moved him. For four days he had been preparing himself for this meeting with his father and was ready to endure his reproaches. Calmly he stepped towards him to kiss him, but Monsieur Roch pushed him roughly away.

'Wretch!' he cried. 'How dare you, you miserable wretch? Do not come near me. You are not my son any more.'

His fury was boundless: his grey hair and beard bristled with anger. He stammered. Then Sébastien looked at the Rector, who remained calm and dignified, his handsome face just barely shadowed with the emotion of the moment. 'Did he know?' the boy wondered. He tried to read his pale eyes, where no reflection of his thoughts seemed to show. Monsieur Roch had started to speak again, his jaw jutting and heavy. He was stammering:

'One last time, Reverend Father, one last time, I dare to implore you . . . not on behalf of this wretch, he is not worthy of any pity, no . . . but for me! I am the only person this affects! And I am innocent! I have a position! I enjoy the respect of everyone! I am the mayor, for heaven's sake! What do you think will happen to me? So near to the holidays, what am I to say?'

189

'I beg of you, Monsieur,' replied the Rector. 'Do not insist. It gives me great pain to refuse you . . .'

'In the name of Jean Roch, my illustrious ancestor!' begged the former ironmonger. 'In the name of that martyr who died for the holy cause.'

'You are breaking my heart, Monsieur. I beg you, do not insist.'

'Well, I will make you a proposition. I do not ask you to keep Sébastien for good. Who would want such a miserable wretch? But keep him just until the holidays. Keep him in a cell, on bread and water if you want, I don't care. At least like that, in our village, it won't look so . . . you understand? My situation won't suffer by it. I will not be obliged to blush in front of everyone! You see, Reverend Father, I am prepared to make the greatest sacrifices, even though this wretch has already cost me thousands and thousands of sacrifices. Listen, I'll pay double the fees.'

As the Jesuit made a gesture of protest, he added swiftly:

'I will pay whatever you ask, here!'

He was already pulling his leather purse out of his pocket and, kneeling, he offered it to the Jesuit in a frenetic gesture of supplication.

'Whatever you ask, eh? Whatever you ask!'

The priest drew Monsieur Roch to his feet, and, visibly shocked by this scene, said curtly:

'Some restraint, Monsieur, I beg you. Let us cut short this interview which is causing pain to all three of us.'

Then Monsieur Roch turned the full force of his anger on his son. He threatened him with a clenched fist:

'Wretch! Rogue!' he yelled. 'What am I to do with you? Bled dry and this is my reward. You miserable wretch!'

He slammed his fist down on the desk. A few sheets of paper floated to the floor.

'Anyway, who taught you this filth? Who? Tell me, who? Even animals don't do that! A dog wouldn't do what you did! You're worse than a dog!'

The Rector had trouble calming him down.

His father's attitude pained Sébastien deeply. That vulgar

selfishness, crudeness of feeling, that baring of a soul stripped of its façade of majestic, comic eloquence, caused him invincible disgust. What remained of any respect, what survived of filial affection, disappeared at that very moment, engulfed in shame. He realised that he would never be able to love him and that he was all alone in life.

'Your pain is understandable, Monsieur,' the Rector said to Monsieur Roch, leading him to the door, 'and I also understand your anger. But, believe me, this child should be treated with care. A moment's thoughtlessness need not compromise a whole life. He repents.'

'About time too,' sighed Monsieur Roch. 'And do you think his repentance will sort out my affairs and that, after a scandal like this, I will be able to stand for election for the local council? Oh, never mind.'

His tone became bitter, he pulled himself up.

'Never mind. I would have thought that people on the same side . . . that honest folk . . . I would have thought they would rally round.'

They left Vannes the following day, early in the morning. During the journey, Monsieur Roch remained silent, angry, his head full of terrible plans for exemplary punishments. Sébastien looked at the fields, the woods, the sky. One thought preoccupied him:

Did the Rector know? What had happened to Father de Kern? Then he thought of Bolorec too. Where was he? What was he doing at that moment? He would have liked to have got to know his region, Ploërmel, so as to picture his friend properly and relive the time with the only friend of his days of sorrow, the only person he missed. He imagined the moorlands, the moors like those at Sainte-Anne, moors where the girls danced and sang:

'When I'm fourteen . . .'

They arrived in Pervenchères at night, which was some consolation to Monsieur Roch. 'I just hope there's no one else at the station. What will people think of me?' he kept saying on the journey. There was no one. The streets were deserted. They were able to get home without being seen.

At first, confined to his room and only coming out at meal times, Sébastien could not get used to not being at school any more. He thought he heard the buzzing of the yard, the whispering, the rustling along walls. When Madame Cébron came in, he jumped. However, the horizon was no longer bounded by walls, roofs and chimneys; he really could see before him his beloved landscape, the slopes of Saint-Jacques, distant and powdered with ash-blue, the river, invisible in the greenery of the meadow, but whose pretty meanderings could be glimpsed through the undulating line of poplars and alders; the road along which people he recognised walked, the carts and animals of his home town. But all his senses were still stunned by his experiences at school, just as after a journey at sea, one still hears the sound of the wind and feels the rolling motion of the boat. Thus for three days, three numb days, he lived without pain, joy or thoughts of any kind.

On the fourth day, in the morning, Madame Cébron came into his room. She had just come from the market, out of breath and red-faced, and had not yet had time to put down her basket of vegetables in the kitchen.

'Oh, Monsieur Sébastien, Monsieur Sébastien! I really do think your father is mad. He's off his head, I'm sure. You should have heard him. He was there in the square, drawing a crowd and angry . . . so angry! He was saying: "I'll bring him to heel, the wretch! But can I bring him to heel?" We're really not used to seeing gentlemen in that state. And bless me, but it's frightening . . . He was saying: "When I break his bones for him, then he'll have to do what I say, won't he?" And he told such horrible tales about you! Horrible! No, it's not right. I really think he's mad. Got to be careful though, Monsieur Sébastien, because you never know with mad people. Is it true, Monsieur Sébastien, that you were caught with a little lad like yourself . . . doing . . . well, you know what?'

'No, Madame Cébron, it's not true.'

'I knew it. I'm telling you, Monsieur, he's mad.'

Then she added, shrugging her shoulders:

'I mean, even if it was true, it's hardly something to go shouting about! Oh, by the way, I also met Mademoiselle

Marguerite. She's really grown this last five months, in fact, last Sunday, she started wearing long dresses for the first time. She's a lovely child. She asked after you . . . Oh, really, you should have heard her: she asked if you were shaving yet! Can you credit it! No. Now where do little girls like that get such ideas? But to get back to Monsieur, I really think . . . no, I know he's mad.'

At lunch, Sébastien did indeed think that his father seemed more overexcited than usual. He ate with a kind of suppressed rage; his movements were so clumsy that he smashed a glass and cracked two plates, which only made him all the more exasperated. All of a sudden, he said:

'So, I suppose you think I'm going to keep you here doing nothing, and feed you while you do nothing? Do you really imagine such an absurd thing is likely? You must think I'm an idiot?'

Sébastien did not reply.

'Well, my lad, you're wrong. Tomorrow I'm taking you to Séez, the little seminary at Séez. You'll spend the holidays there, you'll spend your whole life there.'

He grew animated and, his mouth full of stew, he said over and over again.

'Your whole life, by God, your whole life!'

Sébastien shuddered. He saw the school again in his mind's eye: stifling walls, wretched lessons; he saw the hateful pupils, vile teachers, the whole procession of deceit, pain and shame. He was determined not to return to the torment of that existence, on entering which he had glimpsed death and, on leaving, found dishonour and ignominy. He stood up full of courage, looked across the table at his father, whose face was livid and whose voice was hoarse with rage, and said in a calm, firm, definitive tone:

'I won't go.'

At these words, Monsieur Roch almost choked. He rolled bloodshot eyes, wide with fury.

'What did you say? What did you say?'

His words hissed, struggling to emerge from his tight throat.

Sébastien replied:

'I won't go.'

'You will, if I have to drag you there by your hair!'

'No, I won't go.'

Monsieur Roch lost the ounce of reason left to him. A hideous, murderous brute of violence was unleashed within him, baying for blood. Foaming at the mouth, his features crazed and twisted, he grabbed a knife from the table, hurled himself on his son and, his hand raised, his huge hand in which the steel blade gleamed and glittered, he roared:

'You will go or else!'

Then Sébastien knelt at his father's feet. With his head high, his gaze resolute, he presented his chest to the knife and calmly, his face only slightly pale, he said clearly:

'Kill me if you like, but I won't go.'

Defeated, quelled by the child's candid gaze, Monsieur Roch dropped the knife on the floor and fled.

BOOK II

CHAPTER I

Early July, 1870: the sky, at first threatening and cloudy, had
completely cleared by midday, and bright sunlight flooded the
countryside. Sébastien came out of his house, crossed the
town and went to the post office to visit Madame Lecautel.
The post office was closed from twelve o'clock until two and,
when the weather was fine, Madame Lecautel normally took
advantage of this daily break to take a brief walk with her
daughter. A few minutes later, all three were making their way
down the Rue de Paris towards the open fields.

Sébastien was twenty years old; he had grown a great deal,
but was still thin and pale. His posture was slightly stooped, his
step slow, even indolent. His eyes still shone with keen intelli-
gence, but that light often grew dull and veiled. The frank
gaze he had had as a boy was now mingled with mistrust and
covert disquiet, which added a hint of cowardice to his gen-
eral air of sadness. A few tardy tufts of beard were now evident
on his chin and cheeks, and the light down on his upper lip
was changing to the golden bristles of a moustache. Anyone
seeing him pass by would have thought him always weary, his
limbs seemed too long, too heavy to carry and drag along.

The three of them followed a little path, deeply enclosed
by greenery, which led towards the Saint-Jacques hills. Oak
trees grew on the high banks on either side, their trunks con-
cealed by clumps of wild viburnum, their branches forming
an arch above their heads, shading the path freckled with
sunlight.

'So,' said Madame Lecautel, 'have you done anything these
last few days?'

'I wanted to plant some flowers in the garden,' replied
Sébastien, 'some flowers that Father Vincent gave me, but my

father forbade me. You know how he hates flowers. He says they take up space and serve no purpose. So I went off into the woods instead and daydreamed.'

'That's all?'

'Yes, I'm afraid so. I'd have liked to read but I have no books.'

'You must be so bored.'

'Not really. I look, I think, and time passes. Yesterday, for instance, I watched an ants' nest all day. You can't imagine how beautiful and mysterious such a thing is, at least for someone like me who knows nothing about it. There's the most extraordinary life going on in there, a great social structure that would be far more interesting to learn about than the Athenian Republic. It's another of the thousands of things they don't teach you in school.'

Madame Lecautel rebuked him gently:

'That's all very well, Sébastien my dear, but you can't go on living like this. You're not a child any more, you know. Even here in your home town where you're well loved, people are beginning to whisper and say bad things about you. Believe me, you must make up your mind to do something with your life.'

'True,' sighed Sébastien, hanging his head as he walked and striking out at the grassy banks with the end of his stick. 'But what can I do? There's nothing that interests me.'

Madame Lecautel groaned.

'I find it so upsetting. A great big lad like you and so lazy!'

'I'm not lazy, honestly,' protested Sébastien. 'I'd like to do something. But what? You tell me. What?'

'How many times have I told you, and I'll tell you again. I can see only one way out of this situation in which you're getting more and more bogged down with each day that passes, and that's the army. With your intelligence, you'd soon get a commission. My husband signed up and at twenty-six, he was a captain, at forty-two a general.'

Sébastien pulled a wry face.

'A soldier. Oh God, no. I think that's what I'd hate the most. I'd prefer to beg for my bread on the streets.'

196

Somewhat piqued, Madame Lecautel retorted:

'You might well find yourself doing precisely that, my poor Sébastien.'

They fell silent. The path climbed, stony and steep. Madame Lecautel's pace slowed.

Marguerite had not uttered a word. She walked along, slim, supple, svelte, an utterly charming figure in a simple dress of cream muslin, caught in at the waist with a red sash. Her broad straw hat, also decorated with red ribbon, cast a translucent, gilded light onto the warm glow of her complexion. Although she was now a young woman, her eyes still retained the qualities they had had when she was a child: they had a troubling, unhealthy beauty, with a perverse and candid gaze. Surprised, inquisitive, unusually open to sensuality, they glimmered like two burning embers. Her mouth had bloomed, her lips plump and rosy as a poisonous flower. Her nostrils flared and quivered as she eagerly breathed in the perfumes wafted on the breeze as it moved from flower to flower, branch to branch, bearing with it passion and life. Occasionally, she stopped and leaned against the bank, plucked flowers to pin on her bodice with her lace-mittened hands, her movements revealing the delicate grace of her shoulders and the exquisite contour of her waist and breast, which was just beginning to reveal a more womanly figure.

Sébastien realised that he had wounded Madame Lecautel by his disdain for the military and attempted to mend the interrupted conversation.

'Is there anything in the news today?' he asked. 'My father as usual has taken the newspaper and I haven't seen it.'

'Much the same as ever,' replied Madame Lecautel, 'but now they're saying that war is inevitable.'

Madame Lecautel saw nothing improper in reading whichever newspapers she thought looked interesting before handing them over to the postman for delivery. This meant she was generally very well informed, particularly regarding military affairs, in which, owing to an as yet unbroken habit, she still took an interest.

'Listen, Sébastien,' she went on, 'if, as is very likely, we have

197

a war, since it seems to me national honour is now involved, wouldn't it be better if you had already been a soldier for some while?'

'But Sébastien has already paid for someone to go into the army instead of him, Mother,' cried Marguerite suddenly.

'Well, and what difference does that make? If there's a war, he'll have to join the army anyway.'

'But what about the man he paid?' said Marguerite, worried now.

'He'll be sent too.'

'What, both of them? But that's not fair. That's like stealing.'

Suddenly she laughed mischievously and brandished her parasol at her mother.

'Now then, Mama, tell me you've only said all that to frighten him.'

Her expression changed abruptly.

'War must be wonderful. All those men. The wounded to be tended, the wounded, all pale and gentle and weak. Oh, I'd look after them so well . . .'

The path led to a broad avenue of old chestnut trees and this, in turn, led to the Saint-Jacques spring which supplied the whole of Pervenchères with water. They followed the avenue and stopped near the spring, on a kind of knoll, from which the town could be glimpsed through the greenery, its crowded buildings bright in the sunlight. Madame Lecautel sat down on the grass in the shade of a tree. Marguerite looked for flowers.

'Sébastien!' she called out. 'Help me pick a bunch.'

There was a wheatfield nearby, with its shafts of ears and swaying stems, the green gilded with bright swirls of gold and, here and there, studded with blue and red flowers. Marguerite plunged in and almost disappeared amid the thick wheat. Only her hat, itself an enormous, whimsical flower, could be seen above the moving tips of the wheat, and her laughter rippled amongst the frail stems like the song of a bullfinch.

'Come on, Sébastien! Come on!'

Sébastien followed her, but when he was by her side, she stared at him hard, her eyes grave, and she said:

'You will come this evening, won't you?'

Her voice was proud, imperious, but then she shuddered.

'Marguerite,' begged Sébastien, whose face bore an expression of both fear and exasperation.

'I want you to! I want you to! I must talk to you.'

'Marguerite, just think for a moment. What if your mother found out?' insisted Sébastien.

'I want you to come. You will come, won't you?'

'All right.'

She started to pick flowers again. Her hat plunged into the sea of wheat and reappeared, shimmering in the sunlight, like a little mad boat, decked out with red bows. In the wake of her laughter, as she moved about the field, the wheat shifted and flattened and swelled like waves. She went back to her mother with a scented armful of flowers.

'There, Mama, a beautiful bouquet. I picked them all on my own. Sébastien didn't help at all. He doesn't know how.'

'That doesn't surprise me at all,' said Madame Lecautel, getting up with her daughter's help. 'He doubtless wasn't taught it at school.'

Sébastien took no offence at her ironical tone. Perhaps he didn't even notice. His face had darkened and his troubled expression returned, dulling the frank clarity of his gaze. Madame Lecautel, a little tired now, made a few lacklustre comments to which Sébastien barely responded, and they went home in silence. Only Marguerite hummed happily to herself as she arranged her bunch of flowers.

When Sébastien arrived home, Monsieur Roch was sitting on a bench in his garden near the steps to the house, reading his newspaper. He glanced up automatically at the sound of footsteps, saw his son, and immediately looked back down at the paper.

'Lovely weather,' he said.

'Yes, lovely weather,' agreed Sébastien.

Then he walked up the four steps to the front door and went and shut himself in his room.

CHAPTER II

In 1869, Sébastien started to keep a diary, noting down every thought and episode in his life. A few fragments of these fleeting pages are reproduced here, and they will reveal far better than we could hope to his state of mind following his return to his father's home.

2nd January, 1869

Why am I writing this? Is it because I am bored and have no serious occupation? Is it just to use up somehow the slow hours of the slow days, each of which I find such a burden to live through? Is it to try my hand at an art I admire, an attempt to do with literature what I have been unable to do with music or drawing? Is it to try and explain my own feelings to myself, when, in fact, I find them inexplicable? I don't know. In any case, is there any point in wondering? I will start this diary and perhaps never finish it, and I need no reason or excuse since I will write it for myself alone.

After the terrible scene when my father threatened to kill me, I was completely calm and felt quite liberated. I wonder what effect my cool, resolute resistance had on my father? I cannot say exactly, but I know that, from then on, I noted a change in his manner towards me. Not only did his anger, normally his routine state of mind, disappear, but from then on, he also spared me his lengthy pieces of criticism and advice. I felt he was embarrassed in my presence and that, if he had any feeling to express at all, it would have been stunned respect, a kind of astonishment and admiration, as one experiences sometimes in the face of a great show of physical strength.

There was no more mention of my going away to school; no more mention of anything. I saw very little of him at all, except at mealtimes, when he hardly ever spoke. He had

resumed his normal habits, spending part of his time at the town hall and part in his old shop, now run by his successor, where he compensated for his self-imposed silence at home with exuberant and interminable talk. As for me, I was free to do as I pleased, but for a long time I didn't dare go out. Shame kept me in my room; I could not steel myself to face the curious stares of my fellow townsfolk. The longest stroll I took was a tour of the paths in the garden; my only distraction was the goldfish pond – the goldfish had turned white. However, one morning, I plucked up courage, went out and nothing unpleasant happened. Everyone greeted me with smiles. Madame Lecautel received me with great affection and Marguerite, when she saw me, cried out:

'Oh, he has no beard! I so much wanted him to have a beard!'

Then she burst into tears and then started to laugh. I found her pretty, whimsical and highly-strung, just as before. Despite that, the long dress she was wearing, lilac I remember, in a lightweight fabric, made me feel such respect for her that, from that moment on, I addressed her formally, and spoke to her like an adult.

I was terribly bored.

I am going to say something which I suspect is very foolish. I blame the colour of the wallpaper in my room for my current gloom, self-disgust and moodiness. It is horrible paper, a dirty brown colour, the brown of burnt gravy, with floral designs which are not actually flowers but something that defies classification in the realms of interior decoration, a kind of muddy yellow, evoking only abject ideas and ignoble comparisons. This paper has always obsessed me. I see it all the time, since it is between these wallpapered walls that I live, and I have never been able to look at it without feeling an overwhelming, exasperating, annihilating sadness. Of course my experience of school has profoundly disturbed me, a catastrophe really. But if, when I left school, I had been transplanted into some other environment than this, I can't help thinking that my mind, sick with perfectly curable memories, might, in fact, have healed, and I might have been guided

along a better, more normal path. All the décor in the house is similarly gloomy and depressing and my father is very proud of it. The paint on the doors, the skirting boards and the staircase offends the eye and paralyses the brain. All people, especially young people, whose minds are just awakening, have a positive need for joy and gaiety and for things around them to be cheerful. There are certain colours, harmonies and shapes which are as necessary to mental development as bread and meat are to physical development. I do not demand luxurious drapes or gilded furniture or marble staircases, I would merely like to look at bright lights and harmonious shapes, so that I might absorb the healthy good cheer and sense of harmony that is essential to my well-being. Here, everyone is sad, horribly sad. The problem is that they are surrounded by ugliness in dark, grubby houses where nothing has been designed with a view to training the senses. Once they have paid for their food and their clothing and stuffed into padlocked drawers what is left of their money, they think they have fulfilled their social duties. The beautiful side of life, indeed, the intellectual side of life, is deemed superfluous, and it is even considered laudable to deprive oneself of it, when, in fact, it is only the superfluous that makes life worth living!

I have had to resign myself to the truly horrible, persecuting nature of that wallpaper, though I'll never get used to it. I had to resign myself to many other disagreeable things too. The house was very badly kept by old Madame Cébron, who was an excellent person, but a complete slattern. Her cleaning-rags were left all over the place; a vile odour of burnt fat rose from the kitchen to the rooms on the first floor and was as offensive to my nose as the wallpaper was to my eyes. One day, I caught the old woman washing something in the coffee-pot: it was a pair of stockings she had been wearing for the past month. These are details that must seem insignificant and vulgar, and the only reason I mention them here is because, for two years, I have been aware of myself only through the incessant sense of revulsion they provoked and the despondency and disgust they reflected back at me. Leaving aside the effect of the wallpaper and the petty daily

irritations of the household, my response to those vulgar pieces of furniture was, admittedly, mean-spirited. I felt disoriented, ashamed, as if I had been used to living in some magnificent palace.

School, and the conversations I had had there with rich schoolfellows, had revealed to me elegant ways of life that I could vividly imagine and which it pained me not to possess myself. Of course, I did nothing but stagnate in boredom. This inaction, combined with the depressing influence of the brown paper with the yellow flowers, stifled any impulse towards action and thought, and encouraged strange day-dreams. I often thought about Father de Kern, without indignation and sometimes with pleasure, lingering over certain memories, the very ones which made me the most ashamed and the most distressed. Eventually, I would get excited and indulge in shameful solitary acts, mindlessly lost in savage, animal pleasure. I experienced days, whole weeks – for I noticed that this effect came in waves – which I sacrificed entirely to this empty obscenity. Afterwards, I would be overwhelmed by melancholy, self-disgust and terrible remorse. My life was spent in satisfying furious desires and then regretting having done so, and the whole business made me extremely tired.

What astonished me was my father's behaviour towards me. He never addressed a remark to me, never enquired as to what I had been doing or, if I had come in late, where I had been. It was as if I no longer existed for him. In the evening, after supper, he unfolded his newspaper, which he had already read twice, and began to re-read it. For my part, I said good night to him and left the room. That was it. We never spoke. I was frustrated by this silent, indifferent attitude, irritated with him and unhappy with myself. It is true I never did anything to try and alter the situation. If he had a guest for dinner – which happened only rarely – and that person, out of a guest's natural politeness, asked after me, my father would reply evasively, with a sort of laconic benevolence which I found very wounding. Once someone asked him: 'Well now, what are we to do with this young man?' and my father said: 'When I am

gone, he'll have enough to live on without ever lifting a finger, won't he?' I nearly wept. The only occasion when my father felt obliged to address me directly was almost comical. Someone gave me a puppy. I brought it home, triumphant, pleased to have a companion; then my father, who was strolling in the garden, spotted it.

'What's that?' he asked me.

'A dog, Papa.'

'I don't want any dogs in my house. I don't like animals.'

This was true: he did not like animals or flowers. So I had to give the dog back.

Madame Lecautel was the only person I enjoyed seeing. What is more, she took an interest in me, showing me an almost maternal affection, which was like a balm to me and gave me a little self-esteem. Once, she made it clear to me that I could not continue in this state of degrading laziness and strongly advised me to go back to school and complete my studies. But I refused with such vehemence and horror that she did not mention it again. Then she decided that I should go into business and learn my father's trade. The idea did not appeal to me at all. However, I felt I should bow to Madame Lecautel's wishes. I mentioned it to my father and, immediately, but without any sign either of pleasure or displeasure, he took me to his successor and said: 'I've brought you an apprentice.' The shop has not changed. It is still painted green. The window offers the same display of symmetrically arranged objects; the interior contains the same pots and pans. At the back of the shop is the same glazed door opening onto the same back room, which, in turn, opens onto the same yard, enclosed by the same sweating walls. My father's successor is called François Trincard. He is a small, unctuous man, devout and clean-shaven, or rather, ill-shaven like the monks at the school, whose hesitant, timid manner he also shares. He is a beadle too and highly regarded in the town. He combines his main job as ironmonger with the sleazier and more lucrative one of short-term money-lender. François Trincard said to me: 'Well now, being in business is a fine occupation!' and made me work in the yard setting up some rusty, old fencing

which he had acquired from a demolition site. I spent a week sorting out this ironwork, sometimes assisted by Madame Trincard, a fat woman with greedy lips and shiny cheeks, who looked at me, laughing oddly. I could not help thinking: 'If my classmates in Vannes could see me now . . .' The idea made me blush. My father came over to the shop regularly every day at two o'clock. He would sit down and chat with Trincard about various matters. I would go off somewhere and keep my distance from him. He seemed not to see me and did not ask after my progress in the art of sorting out scrap iron. One day when my 'boss' was out, his wife called me into the back room. She beckoned me close and asked me briskly:

'Is it true, my little Sébastien, that you were caught with another lad in school?'

And when, caught off guard by this unexpected question, I blushed and did not answer, she went on:

'So it's true then? Well, that's very naughty. You little rascal!'

I saw her breast heave like the swell of a wave and felt her thick lips fasten on mine in an avid kiss, this kiss accompanied by a brazen, groping gesture.

'Let me go!' I said feebly.

In fact, I would have liked to continue, but for some reason I extricated myself from her embrace and fled.

That is how I came to quit commerce.

My father showed neither surprise nor anger. Madame Lecautel gave me a long lecture but, eager to find me a proper occupation, persuaded me to 'try my hand' at being a notary, since business did not seem to suit me. I mentioned it to my father, who, just as he had done with the ironmonger, took me to the notary, this time saying: 'I've brought you a clerk.' The notary, Monsieur Champier, was a very cheerful man, fond of jokes, who spent almost his entire day standing on his doorstep, whistling humorous songs and greeting passers-by. All he ever did was initial documents and sign certificates; so he initialed and signed as he whistled. He often went to Paris where, he said, he had important business. As for his office, he left all the administration of that to his principal clerk. He

welcomed me jovially: 'Well now, being a notary is a fine occupation!' he said and, whistling, led me into his office, where I spent a month copying out lists.

Madame Champier often visited the office. She was small, withered and dark, her skin coarse and swarthy, and she had large, moist eyes and an unhappy, distracted air.

'You have such lovely handwriting, Monsieur Sébastien,' she used to say, sighing and languorous. 'I'd love you to copy out this poem for me . . .'

And into the little notebook she had brought I would copy poems by Madame Tastu and Hégésippe Moreau.

When she came to collect my efforts, she would say with a groan:

'Poor young man! Such a sensitive soul! And he died so young! Thank you, Monsieur Sébastien.'

One day, when her husband had gone off to Paris on his important business, Madame Champier sent for me. She was dressed in a blue peignoir, which fitted very loosely and floated about her; the smell of newly-applied perfume wafted in the air. Just as the ironmonger's wife had done, she drew me to her and asked:

'Is it true, Sébastien, that you were caught at school with another boy?'

I had no time to recover from the confusion into which this question still plunged me.

'That is very naughty,' she sighed, 'very naughty. You young rascal . . .'

And I was obliged to leave the notary's office in exactly the same way as I had left the ironmonger's.

Madame Lecautel was annoyed by my behaviour and took no further interest in my career. Life went on as before, with its heavy, stuffy, stifling atmosphere, hideously overshadowed by the brown wallpaper with the yellow flowers.

3rd January

What has happened in my life since that already distant time? What have I become? What point have I reached? To other people I seem the same: sad, gentle and docile. I come

and go as before. However, some notable changes have taken place in me and, I am convinced, I suffer from mental disorders which are deeply significant. But, before confessing them, I must say a few words about my father.

I now know the reason for his attitude to me, an attitude which he has always taken, and which means that, living under the same roof, seeing each other every day, we are nevertheless complete strangers to one another, as if we had never met. This is the reason. I was a stimulus to my father's vanity, the promise of social elevation, the impersonal summation of his incoherent dreams and peculiar ambitions. I did not exist in myself; it was he who existed or rather re-existed through me. He did not love me; he loved himself in me. Strange as it may seem, I am sure that by sending me to school, my father, in all good faith, felt that he was going there himself; he imagined it was him receiving the benefits of an education which in his mind ought to lead to the highest positions in the land. From the day when it became clear that nothing of what he had dreamed for himself (not for me) could be realised, I resumed the role that in reality I had always held, that is, I no longer existed for him at all. Now he has started to see me only at more or less fixed times, and he thinks that is quite normal. But I am nothing in his life, no more than the milestone opposite our house, no more than the gilded cockerel on the church steeple, or the least of the inanimate objects he sees about him every day. Clearly, I have less importance in his mind than the cherry tree in the garden which supplies him with red, succulent cherries every year. Dare I admit it? This situation does not cause me any pain at all, which is strange, to say the least, and I have come to find it perfect, convenient and would not have it otherwise. It means that I do not have to make conversation or pretend filial sentiments towards him which I do not feel. Sometimes, at table, as I look at his poor, narrow skull, his smooth, flat forehead and those empty eyes, empty of thought and empty of love, I think sadly: 'What would we have to say to one another anyway? It's better like this.' However, I cannot help feeling a little pity for him. He has been ill recently and that did touch me.

I have slept a great deal, but it is a brutalising, torpid sleep. My vice, at first unleashed in irregular bouts, eventually settled and became a kind of normal bodily function for me. Then I read a great deal, with no particular plan, no selection, no method, all sorts of books, mainly novels and poetry. But the books which I could obtain here and there, borrowed at random, soon no longer sufficed. There was a void at their centre which left me completely unsatisfied and they often contained some sentimental or corrupting lie which angered me. Of course I was and still am very sensitive to beauty of form, but beneath the form, however beautiful, I demanded the substance of an idea, an explanation for my uncertainties, my ignorance, my embryonic feelings of revolt. I looked for some clear meaning in life and nature. It was impossible for me to get hold of any books containing anything like this, though I felt they must exist somewhere. It was equally impossible for me to meet anyone else, any individual in whom I might confide my urgent desire for self-instruction and self-knowledge. This lack of an intellectual companion is definitely what was most painful to me and what I missed most. So much so that each day I am learning to measure the extent of my ignorance by the multiplicity of the mysteries surrounding me, which increase with each passing day. I contemplate in vain the buds burgeoning on the tips of the branches, follow for days on end the work of ants and bees, but, in the end, who will explain to me how the buds burst into leaf and change into fruit, or which universal law of harmony those sublime artists, bees and ants obey? In effect, I am no farther forward than I was at school, and my inner torments are increasing. Barely noticed by me and almost unconsciously, a dull, continuous chaos reigns in my mind, making me think about many different things, without appreciable results; rebellion has broken out in me, setting everything I learned against what I see, battling against the prejudices engendered by my education. A vain rebellion, alas, and unproductive too. Often the prejudices are the stronger and prevail over certain ideas which I know to be generous and just. I cannot conceive, in however confused

a manner, of a moral system for the universe, free of all hypocrisies or religious, political, legal and social barbarities, without being instantly gripped by the same religious and social terrors inculcated in me at school. However brief the time I spent there, however apparently impervious I thought I was to that depressing and servile education, relying on my innate instinct for justice and pity, its terrors and slavery have soaked into my brain and poisoned my soul. They have made me too cowardly to think for myself. I cannot even imagine a form of art outside classical convention without immediately wondering: 'Is that a sin?' As for priests, they make me shudder. I can feel the deceit in what they preach, the deceit of the consolations they offer, the deceit behind the mad, implacable God they serve; I feel that priests are only here in society in order to keep man steeped in his intellectual filth and to create out of the enslaved multitudes a flock of brute idiots and cowards. Nevertheless, the imprint left on my heart is so ineradicable that I have often asked myself: 'If I were dying, what would I do?' and despite the protests of logic, I reply: 'I would call a priest.'

This morning I went to see Joseph Larroque, one of my friends from the local school. He is dying from a disease of the lungs. Last year, the terrible illness carried off his elder sister. His parents are labourers, poor, lazy and devout, who live off the parish. The father is a lay brother and hopes to become a sacristan. The priest takes an interest in him. He arranged for Joseph to enter the seminary, first as a junior, then as a senior, but the poor boy was unable to continue because of his illness. He came back home and took to his bed. I go to keep him company sometimes. He lies in a small room, which is dark, dirty and evil-smelling. He is not aware of his condition and keeps talking of going back to the seminary soon. His parents are distraught because they had been nursing special hopes. They had planned their old age around him: their son's presbytery, a pretty house with a large garden. The mother would have looked after the house and the father would have tended the garden. Now it is all slipping out of their grasp. Though the room is very cold, it has no fire. Now that their son has

been condemned to die, his mother sells the wood sent for him, and his father gets drunk every night on the bottles of tonic wine which a charitable organisation sends for the patient. Today, Joseph was sad and in low spirits.

'It's no good, no good,' he groaned. 'I've got an itch, here, right inside my lungs.'

His eyes burn with fever; his face is gaunt, horribly white; his chest wheezes, convulsed by coughing. In the room next door, his mother paces up and down and sighs.

'It's nothing,' I tell him, 'You're getting better.'

'No,' Joseph insists, 'I really am very ill. I'm finished. Yesterday I heard my mother say so – that I'm finished.'

I comfort him as best I can. The priest comes in at that moment. He is a fat fellow, solidly built, bursting with rowdy, noisy health.

'Ah, it's no good, no good,' murmurs Joseph to the priest.

The fellow responds with a huge laugh:

'Trickster! You want us to feel sorry for you and bring you treats!'

'No, really, honestly . . .'

'Get away with you. In a week you'll be on your feet. And shall I tell you what we'll do? Well, we'll go and have a rabbit supper with the priest in Coulonges. Ha! Ha! Ha!'

The poor devil's face lights up all of a sudden. He stops thinking about his illness. He says feebly:

'Yes, rabbit, we'll eat rabbit.'

'And we'll drink cider . . . some of his vintage cider.'

'Yes, yes, some of his vintage cider.'

He brightened up, filled with hope. Then the two of them, Joseph coughing and the priest laughing, began to talk about amusing episodes they remembered from the seminary.

I left with a heavy heart. This was a young man who was about to die. He was not completely brutish nor ignorant, he had read books and been to school. He must have had feelings and dreams. However poor, vulgar and unformed he was, he must have had some ideals. He was going to die and was in despair over it. But the mere promise of eating rabbit gave him the will to live.

How sad. What was sadder still is that it had to be so. There was no more effective or adequate hope to feed their mutual aspirations. This troubled me all day.

I went back home through the cold, silent streets.

The sky is dark and leaden. A few slanting snowflakes, driven by a bitter wind, whirl in the air. The houses are firmly sealed; I can just make out through obscured windows, a few sleepy, half-witted faces. A sort of angry pity seizes me for these people, lurking there in their dens, condemned by religious and civil laws to wallow eternally like beasts. Are there any passionate, thoughtful young people anywhere, young people who think and are working towards freeing themselves and us from the heavy, criminal, murderous hand of the church, so fatal to human intelligence? Young people who, faced with the moral law set up by priests and the civil law applied by the police, say to themselves resolutely: 'I will be immoral and I will rebel.' I wish I knew.

4th January

Snow has been falling all night and covers the earth. Idleness kept me in bed till quite late. I did not want to get up. There are times when I feel I could sleep for days, weeks, months, years. However, I did get up and, not knowing what to do, roamed about the house. My father is at the town hall. Old Madame Cébron is sweeping the dining room. My eyes happen upon my mother's photograph. In our new home she has been restored to her place between the blue vases on the mantelpiece. She is fading more and more and the background is quite yellow. You can no longer make out the pillars, pools and mountains. As for the image of my mother, I can only see the dress, the lace handkerchief and the long loops of hair, framing a face without features or shadows. The rest has almost disappeared. I pick up the photograph and stare at it for a few seconds, without emotion. Then suddenly I ask Madame Cébron:

'Didn't my father keep anything of hers?'

'Oh, he did. In the attic there's a trunk full of Madame's things.'

'I'd like to see them. Come with me, Madame Cébron.'

We find the trunk, stuffed under a sack of dried beans, the winter supplies. Four woollen dresses, three bonnets, a hat, a few chemises and that's all. Everything is worm-eaten, faded, mouldering. These thin shreds of fabric and rotting under-wear give off a sour, musty odour. Vainly I seek a shape, an indication of habit, something still living of the person who was my mother, something whose heart still beats beneath the rags which fray, disintegrate, shred and stick to my fingers. So I question Madame Cébron.

'She was a good woman, wasn't she?'

'Good? Of course she was good . . .'

The old woman's tone does not convince me. I persist:

'She can't have always been happy with my father . . .'

'Oh, of course she was happy with Monsieur. She did everything she wanted, the dear lady. She more or less led him by the nose. Ah, poor Monsieur . . . I can assure you there was never a peep from him with Madame . . . ! And then . . .'

Madame Cébron had stopped speaking. She didn't want to say any more. I am intrigued. That 'And then . . .' seems to me full of a mystery which suddenly makes me very interested in my mother. My imagination takes off into unlimited hypotheses. An idea takes hold, atrocious, sacrilegious and beguiling. Did my mother love someone else? And did this other person love her? As the idea takes shape in my mind, I find I love my mother, I love her with an immense love, a hitherto unknown love, which makes my heart swell. I am unable to question Madame Cébron directly so I ask in a roundabout way.

'Did we have many visitors to the house in the past?'

'Oh yes, people used to visit.'

'But did anyone in particular come?'

'No, no one in particular.'

But Madame Cébron is lying. Someone used to visit, and that person loved my mother and she loved him. So I take the few threadbare rags from the trunk and kiss them almost wildly, a long, horrible, incestuous kiss.

8th January

This morning I received a letter from Bolorec.

The letter is long, in cramped handwriting, full of strange, incomprehensible, disjointed spelling. I don't understand it all, but what I can't make out I can guess. It makes my heart leap for joy. Bolorec! In other words, the best of my memories of school. The only aspect of school which was not a disappointment. I can see him in my mind's eye coming to take his place between Kerral and me when we went for walks. I had disliked him at first, partly on account of his odd ugliness, but then I grew to love him. Despite our separation and the silence between us, I have always felt infinite tenderness towards this strange and uncommunicative companion of my darkest hours, and I can't really explain it. I feel that this affection grows in proportion to the as yet undeciphered enigma that is his personality and is actually strengthened by the real fear that he inspires in me. What kind of person is Bolorec exactly? I really don't know. How many times have I asked myself that question? How many times too have I written to him without ever receiving a reply? I thought he had forgotten me, and that hurt. And now at last a letter from him! A letter I read and re-read probably twenty times over. Bolorec is in Paris. How did he end up there? What has he been doing since our separation? He does not tell me. Bolorec writes as if we had last met the day before and as if I'm fully up to date with his life, his ideas, his plans. Every line contains some subtlety which I cannot make sense of, hidden allusions to episodes and situations of which I know nothing. The only thing I can make out at all clearly is that Bolorec is in Paris staying with a sculptor, 'who lives in a world of his own'. From what he tells me, he hardly does any sculpting himself, nor does this sculptor. It seems neither does any sculpting at all. During the day, they see the 'leaders' who gather at the studio and prepare for the 'great ideal'. In the evenings they go to clubs, where the sculptor talks about 'the great ideal'. What is this 'great ideal'? Bolorec does not explain at all but seems completely taken up with it. 'We're making progress, good progress.' When the time comes he will warn me. Finally, and

this is what completely confuses me, he has been selected to do some great thing which has nothing to do with the 'great ideal', but which will advance the cause of the 'great ideal'. It has not yet been arranged and will happen later.

One detail about his letter strikes me: almost every line contains the word *Justice*, and this word is more clearly written than the others, with firm, upright letters which create a strange and terrible effect amid the scribble surrounding them. There are occasional moments of great poignancy. Bolorec does not like Paris. He misses the Breton moorlands. But he has to stay. When the 'great ideal' comes to pass, then he will be able to go back and be happy. Sometimes he goes up onto the ramparts, sits in the grass and dreams of home. One morning, he saw a maidservant passing by with a soldier. She was a girl he knew from home and he hopes one day she'll pass by again on her own and he can speak to her. She is called Mathurine Gossec. Sadly, she has not passed by since then. Sometimes on a Sunday in the studio, the sculptor plays the Breton bagpipes and Bolorec sings Breton rounds. Poor Bolorec! I search in vain in the letter for some expression of friendship towards me or the desire to know something of my life. There is nothing of the kind. This makes me sad. But he was always like that and didn't love me any the less for it. At least, I think that's true. I'm not sure any more.

As I comb through his words over and over, I imagine his dear, comical features, often inscrutable and always baffling. Today his face seems even more haunting and pervasive because of the sense of some painful and tragic event to come. As I look through the incomprehensible pages where the letters crowd in together, jostle, clamber and heap up one on top of the other, twisted and bristling, but amongst which that word *Justice!* stands out, flapping like a banner, it seems I can see Bolorec on a barricade, amid the smoke, standing there wild-eyed, black with gunpowder, his hands bloodied. Now the joy at possessing something of Bolorec gives way to an inexpressible sadness. At that moment, I suffer two painful emotions: fear for the future of my friend and shame at my own uselessness and cowardice. Did he ever really care for me?

8th January, midnight

Bolorec's letter sticks in my mind and disturbs me. It is a curious thing but now the idea of Bolorec is entirely separate from the ideas which his letter has inspired. By dint of a kind of regressive egotism, I am obsessed and tormented by various questions about myself. Am I truly a coward?

I too used to want to devote myself to others, not in the way in which I suspect Bolorec is devoting himself; I wanted to devote myself through pity and reason. I soon realised it was absurd and pointless. Here I know everyone and I can get close to everyone if I wish. Restricted though this small town is, it still contains all the elements of normal society, but everything I see makes me despair and feel sickened. Fundamentally, all these people hate and despise one another. The bourgeoisie hate the workers, the workers hate the tramps: the tramps seek out other tramps more wretched than themselves so that they can have someone to hate and despise. Everyone struggles to maintain the fatal exclusivity of his own class, to make even narrower the prison cell in which he shakes his eternal chains. I am ignorant and guided only by instinct, but I have occasionally tried to point out to the miserable wretches the injustice of their condition and their inalienable right to revolt, tried to direct their hatred not lower but higher, but they only became suspicious and turned their backs on me, taking me for some dangerous madman. There is an inertia, strengthened by centuries and centuries of religious and authoritarian atavism, which it is impossible to overcome. Man would only have to stretch out his arms for his chains to fall away; he would only have to move his legs for his ball and chain to break; but he will never make that gesture towards freedom. He has been softened up, emasculated by the lie of 'finer feelings'; he is trapped in his moral abjection and slavish submission by the lie of charity. Ah, charity which I loved so much, charity which seemed to me so much more than mere human virtue, the direct and radiant emanation of God's immense love, charity, the secret of man's degradation. Through charity, the government and the priests perpetuate

215

poverty instead of relieving it, grinding down the souls of the poor instead of raising them up. The imbeciles feel bound to their suffering by this pernicious good deed, which of all social crimes is the greatest and most monstrous and the most ineradicable. I have said to them: 'Don't accept alms, reject charity, just take, take, because everything belongs to you anyway.' But they didn't understand. Dare I admit it? They don't interest me as much as I sometimes try to convince myself that they do. Often their vulgarity shocks and repels me, and certain kinds of wretchedness can arouse feelings of invincible disgust in me. Perhaps it was an artist's curiosity, and therefore something cruel, which drew me towards them in the first place? I have often enjoyed the terrible expressions and extraordinary deformations and the magnificent patina which suffering and hunger etch on the faces of the poor. Whatever the truth is, I do not feel drawn towards action and I do not envisage myself dying for an idea on the scaffold or on a barricade, not because of any fear of dying, but because of an equally bitter emotion which is taking over my spirit day by day: the feeling of futility. Anyway, these ideas only exist in me in a speculative, intermittent state. They haunt me when I am shut up in my room with nothing to do, or when the weather is gloomy and the skies grey and, above all, during meals because of my father's presence: he is the total negation of what I feel and dream and of what I believe matters to me. Outside in the sunshine, my ideas evaporate like mist over the sea. Nature takes hold of me completely and speaks another language to me, the language of the mystery it contains and of the love which is in me. I listen to it with delicious pleasure, this superhuman, supernatural language, and, as I listen, I experience again the original, untainted, confused, sublime sensations that I had as a little child, once upon a time.

These are moments of supreme happiness, when my soul tears itself away from the hateful carcass of my body and launches itself into the impalpable, the invisible, the unrevealed, with the breeze singing and all kinds of shapes wandering the incorruptible expanse of the sky. Ah, my plans, my dreams, the inspirations of a brain gladdened by the light!

My reinvigorated will plunges once more into the waves of this purifying dream. I become again a prey to chimeras. I want to embrace and conquer everything I see and hear. I will be a poet, a painter, a musician, a scientist. What do obstacles matter? I will thrust them aside. What does my intellectual solitude matter? I will people it with all the spirits that are in the voice of the wind, the shadows of the river, the dark depths of the woods, the scented breath of flowers, the magic of distant horizons. Sadly, these ecstasies last only a short while. I have no stamina for things which are beautiful or good. When I return from these transports, my arms are even wearier from having tried to embrace the impalpable, my soul is further sickened from having glimpsed the inaccessible path to pure joy and guilt-free happiness. I come crashing painfully down from on high into the dark shame of my incurable solitude.

Bolorec's letter is there open on the table. I read it again. Poor Bolorec. Perhaps I envy him though. At least he has a passion that fills his life. He is waiting for the 'great ideal', which doubtless will never come, but he waits, while I have nothing to look forward to, nothing at all.

10th January

It is now five years since I left school. In that time not one night has passed in which I did not dream about it. They are horribly painful dreams. Occasionally, they have a fantastical side with distortions of things and faces whose unreality seems to attenuate the tormenting nature of that near-reality. But normally I see the school more or less exactly as it was, with its classrooms, yards, hated faces, all the things which I really did endure and suffer. By day, the school maintains its dulling, implacable grip on me, undermining me psychologically. By night, as I sleep, I relive its horrors. One striking phenomenon is that my dream never varies. My father comes into my room. His face is twisted and harsh. He is wearing his formal frock coat and his top hat.

'Come on,' he says, 'it's time.'

We leave. We travel through a terrible black land where

ferocious dogs hunt down peasants. All along the roadside, perched on dolmen stones, immensely tall Jesuits lean towards us, laughing, flapping their soutanes like bats' wings. Some fly over the flat pools of water, spinning and turning. Then suddenly we're at the school with its creaking gates and cramped courtyard; in the background is the chapel dominated by the gold cross, then the door to the parlour on the right, guarded by hideous, crouching monks, then there are the corridors, the façade, the recreation yards. I turn around. My father has gone. A great shout goes up in the yards. Pupils, teachers, monks, everyone runs towards me, threatening, furious, brandishing spades, pitchforks, sticks, tripping me up with huge Latin tomes and stones.

'There he is!'

The Rector, Father de Marel, and Father de Kern lead the cruel mob. Then the hunt begins, ardent, fierce, where everything hateful I have known appears to me in terrifying but quite realistic form. I bump into confessional boxes, bang against chairs, stumble over altar steps, fall onto beds and there I am trampled, attacked, then pushed aside. I wake up, drenched in sweat, my chest heaving and I dare not go back to sleep.

I have tried everything to rid myself of these dreams which make it impossible to forget what I so long to forget. Before going to bed, I wear out my body and mind; I walk furiously in the countryside or else I seat myself at the table and work at writing down these pointless reminiscences. I have tried to call up other images, pleasant visions, happy, cheerful memories. I have tried to evoke passionate, sensual images, to distract myself entirely in obscene imaginings and so escape the horrible haunting of these dreams. It's no use. Now I dread sleep and put it off as long as possible. I prefer to endure the boredom of the long hours of the night, but they pass so very slowly.

Last night my dream was different though, and I make note of it here because its symbolism interested me. We were in the hall at Vannes: on the stage, right in the middle, there was a kind of tub filled to the brim with trembling, brilliantly

218

coloured butterflies. They were the souls of little children. The Rector, his sleeves rolled up and wearing a kitchen apron tied tight around his waist, was plunging his hands into the tub and drawing out fistfuls of sweet little souls that trembled and uttered soft, plaintive cries. Then he put them in a mortar, crushed them, and ground them up into a thick red paste which he spread on toast and threw to the dogs, huge, voracious dogs, wearing birettas and sitting up begging all around him.

Isn't that exactly what they do?

24th January

Today a regiment of dragoons passed through Pervenchères. This is an important event in a little town, a troop of soldiers passing through. People start talking about it a week in advance and everyone looks forward to it in a way I can scarcely understand and which it is impossible to share, but which is no less strong for all that it resides in the vulgar heart of the multitude. It is curious how the people respond to only two stimuli: religion and war, the two greatest enemies of moral development. Our house has been turned upside down and my father, in his role as magistrate, is very agitated. He is counting on receiving the colonel and offering him hospitality, so they are preparing a room for him. They have had to shift the furniture around, clean the staircase, polish the dining room furniture, rake the paths in the garden. From dawn onwards, my father goes back and forth between the town hall – where he is billeting the soldiers and checking on the stocks of bread – and the house, where he supervises Madame Cébron's tasks. He has taken the good dinner service out of the cupboard and ordered a lavish meal to be prepared. I did the same as every other layabout: I went to the outskirts of town and waited on the road to Bellême for the soldiers to come. There were lots of people there. Monsieur Champier was giving a speech to a group of people and gesticulating madly.

He had come straight from the house, wearing his slippers and a velvet cap. He declared:

'Soldiers always cheer me up. When I hear drums or bugles, believe me, it brings tears to my eyes. The army, ah, the army! There is nothing better. And France, what a wonderful thing . . . Monsieur Gambetta and his revolutionaries can say what they like and do what they like, France will always be France. The concept of patriotism will always survive.'

The others nodded their heads in agreement. Then they started discussing what for them best represented the idea of Country.

'For me, it's the cavalry,' professed Monsieur Champier.

'For me, it's the artillery,' said someone else, 'because without the artillery the cavalry are no use.'

A third exclaimed:

'And what about the infantry? The infantry, gentlemen! The French footsoldier.'

For a few moments, that was the only word that could be heard: 'French', resounding like a bugle call on the flabby, cowardly lips of those awful people. I would be interested in my father's opinion of it all. He must have plenty of admirable things to say about it. What a pity he's not here. I leave Monsieur Champier to drone on to his group of fellow patriots, while I go further along the road where I encounter only faces filled with the joy of anticipation.

It is a delightful morning, the air sweet and spring-like. A pale sun occasionally breaks through the silky white layer of clouds covering the sky. The distant hills go on for ever, delicate, pure, with shimmering scraps of cloud wafted along by gentle breezes. The pines along the horizon are peacock blue washed with liquid mother-of-pearl, as if bathed in muted rainbow colours. The hedgerows crisscross the fields with green, green sprinkled with pink, sometimes with the translucence of precious stones and sometimes like sea spray.

The crowd swells, filled by the same wild instinct. It really is a crowd now and it strikes me as absolutely hideous. It seems to me that I never before grasped so clearly the unerring stupidity of this human herd, the powerlessness of these creatures, so immune to natural beauty. To make them crawl out of their holes, to put those broad, atavistic, brutish smiles on

their faces, they have to be promised barbarous spectacles, degrading pleasures aimed only at the lowest and meanest amongst them.

Marguerite is there too, accompanied by her maid. Like everyone else, she is unusually excited; that depresses me. She barely notices my greeting.

'The advance guard arrived some time ago, you know,' she informs me.

She scrambles up a hillock to see further down the road. She normally rather embarrasses me with her persistently coquettish glances and overwhelms me with her silent gestures of affection; she usually tries to get close to me, to brush against me, but today she doesn't look at me at all. I feel somewhat slighted, jealous even. I speak to her, and she replies briefly or not all. Suddenly, on tiptoe and clapping her hands, she cries:

'Here they come!'

Far away on the road there is indeed something shining and glittering in the pale morning sun. Whatever it is grows to fill the road and is advancing. Marguerite shouts again:

'Here they come!'

I have never seen her like this before, so impatient, her eyes aglow and her whole body trembling with excitement, except when such behaviour is directed at me. I start to feel angry with her, angry that I am not part of the joy she displays or the passion she exudes. I am annoyed with Madame Lecautel for letting her come out here. I feel it is not suitable.

'Ah, here they come!'

They pass by, bolt upright on the harnessed haunches of their horses; they pass by, heavy, dazzling, magnificent, in a chaos of arms and a flash of metal. The ground shudders and groans. Beneath their sparkling helmets, their faces are sunburned, their jaw muscles taut; their chests are thrown out like armoured breastplates and the black, twisting, sinister plumes of their helmets brush their strong necks, recalling more barbaric times. I feel a shiver run through my veins.

I am gripped by emotion despite myself. It is neither pride,

nor admiration, nor a feeling of patriotism; it is a kind of vague, latent sense of heroism, and whatever there is in me of the bestial and savage is awoken by the sound of those clashing weapons; it is an instant return to the beast of combat, the cannon fodder from whom I descend. And I am just like the crowd I despise. The same soul that horrifies me is inside me, with all its brutishness, its love of violence and killing. They continue to pass. I watch Marguerite. She has not moved from her vantage point. Her face is grave, her body very upright, tense, as if waiting for a spasm of pain. Her nostrils breathe in the strong scent of all those males; and her gaze, now stripped of any shame, is a mixture of cruelty, savagery and submission, which strikes fear into my heart. She too has submitted to those square shoulders, strong chests, brown faces, that swaggering strength blazing in the sunshine; but she has submitted sexually. Just now I felt rising in me obscure, barely suppressed instincts to destroy; she feels obscure instincts too, but they are infinitely more powerful and human, stirring inside her, swelling her slim, fragile body with a bubbling up of powerful, sacred life. One soldier looked at her and smiled, an obscenely brutish smile. But she didn't notice. She has not seen and selected one particular man; she would like to surrender to every one of those men and be violated and crushed in a single embrace. I find her beautiful, more beautiful, almost divinely so, because I have just understood, through her, one of life's laws and, for the first time, I see Woman in her role of suffering, sublime creator. Marriage, which forces the marvellous fecundity of a woman's body to submit to the sterile fumblings of one man seems a monstrous thing to me, a crime against humanity. Suddenly, I feel pity and respect for those poor wretched women, despised and degraded, who haunt the highways and the forbidden quarters of the town, soliciting passers-by.

The soldiers have gone now. The crowd follows them. We go back to the town. Marguerite is quiet, a little tired, still grave. I soon start feeling differently. That image of love I grasped in a glimmer of reason or folly or whatever does not last. I return to lustful visions. It's always like that now.

Whenever I have a generous thought, some natural, detestable tendency in me forces me to spoil it.

All day I feel disgusted and gloomy. I cheer up a bit at dinner. The colonel did not accept the mayor's hospitality; he preferred to go to the army billet and eat with the officers. My father is furious. He watches me from his corner and I am sure he blames me for this disaster. When old Madame Cébron triumphantly brings in an enormous, golden, roast turkey, glistening with fat, my father cannot control his fury any longer.

'Take that thing away at once!' he yells.

'But Monsieur. . .'

'Take it away, I tell you!'

I think if my father had not thought it below his dignity to talk to me, the cavalry would have had a bad time of it.

25th January

Two or three times a week I visit Madame Lecautel. These visits are a diversion for me and alleviate my solitude a little. But I do not really enjoy them any more. Madame Lecautel is not as intelligent as I used to think. She is full of bourgeois prejudices and meanness of spirit and understands nothing of the feelings gnawing away at me. I do not speak to her about any of it. We speak of meaningless, random things, the only things she can talk about anyway. When I attempt to give voice to the ideas that torment me, I can sense that it frightens her and I say no more. It is terrible never to have a superior kind of person to talk to, or, if not that rare being, a simple, straightforward soul, full of goodness and pity to whom you could reveal yourself just as you are, and who would respond to what you feel and think, correct your errors, encourage you and direct you. Normally our conversation centres on the maids whom Madame Lecautel changes every month. The main idea dominating her life is that, soon, 'if things go on like this' it will be impossible to get a maid at all. She embroiders on this with endless economic variations. Whilst Madame Lecautel tells me of her domestic problems, I can't help thinking that she pays her maids twelve francs a month, hardly gives

them any food, treats them in a harsh, almost military fashion, demands in return a degrading obsequiousness, as well as the unselfish virtues, delicacy and skill of accomplished house-wives – and all for twelve francs a month. I do not discuss the matter; what would be the point? I agree with her: 'What a trial it must be . . .' Another of her great ideas is that I should be a soldier. She thinks nothing is finer than the military. At heart, I think her desire to see me wearing a greatcoat is merely a selfish pretext to relive her own brilliant past, nostalgia for her little former vanities, past honours and her husband's outstanding acts of valour. Ah, her husband. His portraits are everywhere in her house in normal or dress uniform, as a captain, as a colonel and as a general. They cover the walls, invade the dressing tables, besiege the furniture. He is a big, vulgarly fleshy fellow, his cap at an angle, or pulled on anyhow, his chest scored with medals, but looking rough and ready, his thick moustache blending into a pointed beard. I can almost hear him angrily cursing, his voice rasping and hoarse with absinthe. She thinks he is handsome, glorious and admirable. Once she said to me, obviously deeply moved, that in Algeria he had killed with his own hands, his very own hands, five Arabs, and ordered fifty others to be shot in one go; and she added:

'He may have had his faults, but, my God, he was a hero.'

Another time she said:

'Can you see the likeness between him and Marguerite?'

At first, this seemed a wholly inappropriate and mistaken comparison. When I looked carefully at the portraits, however, and compared them and Marguerite's strange, pretty, delicate face, I did eventually see a resemblance, distant it is true, moral rather than physical, but real. Both faces, the ruffian's and the charming child's, displayed a similar obstinacy; in the eyes there was a similarly wild, heroic look. One could sense that the father must have launched himself, head down, into battle and mayhem, and that the daughter would launch herself into love in the same way.

What do I really feel for Marguerite? Is it love or hate? Or is she simply a nuisance? I don't really know. It is something of

all those things and not quite any of them. In any case, she worries me. I think it would be impossible to meet a more ignorant girl. She knows nothing and has no desire to learn. Madame Lecautel did not want to send her daughter to the boarding school at Saint-Denis on account of her fragile health and the nervous crises which blighted her childhood and threatened her well-being. She took charge of the girl's education herself, an education that was of necessity intermittent and incomplete and which Marguerite had always resisted. In the face of her daughter's impatience, anger and rebellion she eventually had to give up even that rather vague teaching as she feared the recurrence of those crises. It does not seem to have been a problem or a disappointment for either. Madame Lecautel no longer notices her daughter's educational lacunae and now she has got into the habit of treating her as if she were ill, even though she is perfectly well. Sometimes Marguerite behaves like a child or a baby, full of meaningless chatter; sometimes she is worse than a fallen woman; at such times, her eyes gleam and glint with wild, savage, terrible depths. Sometimes she becomes suddenly effusive and affectionate; sometimes she maintains a gloomy silence and cannot be persuaded out of it. Sometimes she laughs and cries for no apparent reason. In my view she is made for love, and for love alone. Love possesses her in a way that perhaps it has never possessed any other poor human creature. It is love's power that circulates under her skin, burning like a fever, that fills and dilates her gaze, fills her lips with blood, winds about her hair, bows her neck; her whole body exudes it, like an overpowering perfume that is dangerous to breathe. It directs every one of her movements and her attitudes. Marguerite is its suffering, tortured slave. She does not kiss me as she used to before, but I can sense that her lips are ready for the same kisses. She no longer covers me with ardent, precipitous caresses, obviously avid for male flesh, as she did as a child; but her body seeks mine. When she comes towards me, she abandons herself completely; she makes unconscious gestures, arching her back, tensing her belly, gestures which undress her and reveal her in her ecstatic nudity.

As soon as I arrive, she becomes animated. Her eyes light up, a bright spot of red appears above each cheekbone, her eyelids acquire dark shadows; she is driven by a need for physical motion. She moves all the time, turns, leaps, happy but tense, a look of pain on her face. And her eyes remain obstinately fixed on me, so bold, so voracious that they make me blush and I cannot bear their dark brilliance. Madame Lecautel does not notice a thing. I suppose she interprets it all as the fantasies of a spoilt child, of no importance. She merely says to her in the same calm voice that she used when Marguerite was little:

'Come along now, my dear, don't get all worked up. Calm down.'

Often I am tempted to warn her but I dare not and, in any case, my own feelings are strange and complicated.

When I am not with her, I feel my heart swollen with a drunkenness that must be love, a physical confusion that grips my whole being, a confusion that is as strong and pleasurable as if life itself were erupting within me. There is not one atom of my body, not an infinitesimal part of my soul, which is not swamped by this and refreshed. At the same time, my thoughts are purified and my mind enlarged. Effortlessly, lightly, my unshackled thoughts take wing, I attain intellectual heights I have never known before. I feel that I embody sacred and idealised forms, that all humanity yet to come stirs in Marguerite and me, and that it would take only the shock of our lips meeting, the contact of our two bodies for it to spurt forth from us, proud creation, triumphant life. In those moments of exaltation I go and walk in the countryside. My distress disappears, everything seems more beautiful, supernaturally, splendidly beautiful. I speak to my brothers the trees; I sing psalms of nuptial joy to the flowers, my charmed sisters. I regain my innocence. Regenerative, powerful waves of strength and hope circulate in my veins.

When I am with her, I feel frozen. I see her and my enthusiasm evaporates; I set eyes on her and my heart instantly both swells and shuts: it is empty, empty of everything it held that was so strong, generous, warm. Often even her mere presence

– her delicious presence – irritates me. I can't bear her prowling about me, coming near me. Being near her is a torture; just the brush of her skirts against my legs makes my skin crawl. I avoid the touch of her hand, her breath, her gaze burning with passion. Twice, on the sly, she grasped my hand and squeezed it; I felt like hitting her. When she is near me, I feel for her a mixture of pity and revulsion. When I see the two of them side by side, the daughter, so pretty, so full of ardent youth, so desirable, and the mother, already old, her skin wrinkled, her body bent, her hair turning white, it is the mother, for some criminally perverse reason, some inexplicable madness of the senses, who attracts my desire and my lust. Her hands, whose joints are already knotted, her thickening waistline, her drooping haunches tempt me; I feel intoxicated, hatefully intoxicated at the sight of that poor, ruined, crumpling flesh, creased with venerable, maternal folds.

One day when her daughter was not there, I said to Madame Lecautel in a sly, cowardly way, hoping perhaps to realise these ignoble fantasies:

'I must not come to see you so often any more. It causes me much pain. I mustn't do it any more.'

'Why, my dear child?' she asked in surprise.

'Because,' said I, feigning embarrassment and shame, 'because people are gossiping, are saying that I . . . that you . . . well . . .'

I stopped as if I couldn't bring myself to say it.

'Saying what?' persisted Madame Lecautel, intrigued.

Still cowardly and sly, I dared to glance at her with a cruel, ambiguous expression and say:

'They say you are my mistress.'

'Be quiet! Oh, how monstrous!'

I will never forget the look she gave me, a look of revulsion and outraged modesty. Yes, it was the look of an honest woman in which, nevertheless, I glimpsed flattered sorrow, perhaps regret, certainly the furtive glimmer of lust. It broke my heart and, afterwards, I adored her for that look as if she were a saint. Yes, I loved her for that glance, in which I thought I saw for the first time, in all its poignant melancholy,

the infinite and immortal pity that resides in the heart of woman.

25th January

This morning I found my father's newspaper in the kitchen. I glanced through it and read the following:

'We are pleased to announce that the Reverend Father de Kern will give the Lenten address this year in the church of the Holy Trinity. The Reverend Father de Kern is one of the Society of Jesus' most eloquent preachers. We remind readers of his admirable and truly inspired sermons in Marseilles last year. To the wise and sharp dialectic found in the sermons of the Reverend Father Felix, the Reverend Father de Kern adds his particular gift for words which makes each of his sermons an almost classic piece of sacred literature. The eloquent preacher is tall and aristocratic in appearance. His face exudes lofty piety. A large congregation is expected.'

How ironic.

When the first moment of surprise had passed, I examined my own reactions. I felt no hatred towards Father de Kern; I do not hate his memory. Of course he did do me harm and the consequences of that harm are deeply rooted in me. But could I or should I have escaped that evil? Did I not already have the fatal germ of it inside me? A curious thing troubles me. Of all the priests I have known, I think he is the one I hate the least. I would love to hear him speak again. I can still hear the sound of his soft, penetrating voice.

After all, he may have been sincere when he said all those fine things to me, as we sat in the window seat, which I can still see under the night sky and which I sometimes recall with great nostalgia. Perhaps he has repented, who knows? Perhaps those inspired flights of eloquence are born of his repentance. My thoughts did not rest long on Father de Kern. They soon focussed entirely on the impassive face of the Rector, on those pale eyes, that ironical mouth, haughty and benevolent, but expressive of a benevolence that never pardons and eventually destroys. Did he know what he was doing when he expelled

me? He must have known. I am going to write to Bolorec and tell him to go to the church of Holy Trinity and hear Father de Kern and tell me what he is like now and what subjects he chose for his sermons.

25th February

Bolorec has not written and the paper carried no more news about Father de Kern. I often ask Madame Lecautel about it because she sees all the papers in the post office and is up to date with everything, but she knows no more about it either. That bothers me.

10th May

My first secret rendezvous with Marguerite! I wouldn't have thought it possible.

Yesterday, as we were walking back home alone along the street, she suddenly said to me, very quickly and quietly.

'This evening, at ten, be here on the road, opposite the Allée des Rouvraies.'

I was astonished at first, then I replied,

'No, Marguerite, we mustn't, I won't do that.'

'Oh do, please.'

Her voice grew louder and more impatient. I was afraid her mother might hear and that she might have a tantrum for she was very agitated, very excited.

'Very well,' I said.

'At ten.'

She closed the door.

The whole day I wondered whether I should turn up for that rendezvous. I couldn't leave her alone on the street, I couldn't. In any case, knowing as I do Marguerite's uncompromising character, I was worried that if she went out and failed to find me there, she would come to my house to get me. I promised myself to speak to her firmly. However, in my fantasies, as the hours went by, the other distant Marguerite gradually replaced the one I had just left. An awareness of her succeeded my feelings of disgust; an agreeable awareness, the anguish of delicious waiting, a longed-for mystery,

which made the hours pass slowly and the minutes seem eternal.

The night was dark and moonless. The earth exhaled a cool dampness and the air was full of perfumes. I was on the road a half hour early, getting used to the darkness, worried by the slightest noise, filled with a deep, unfocussed anxiety, like the masses of shadow around me, which seemed charged with passion. For, beneath the silent sky, there were areas of confused shadow and errant silhouettes, amongst which the road was a slightly paler line, the road on which Marguerite would appear at any moment, another furtive, shadowy silhouette, lost in the mystery of the night.

I heard her before I saw her: a fast, rhythmic cadence, urgent as the rustle of an animal escaping into the thicket; then I saw her, a vague shape, barely corporeal, disappearing and reappearing; then suddenly there she was, close to me. She had wrapped herself in a black shawl, so black that her face seemed almost to shine like a star in the darkness.

'I'm late,' she said, out of breath. 'I thought my mother would never go to bed.'

She seized my hand and drew me towards the side of the road.

'Let's go and sit on the bench in the avenue, shall we?'

When we were seated on the bench with her pressing against me, trembling and real, the charm evaporated. I violently regretted having kept our appointment and, suddenly horrified to be there, I pulled my hand away from hers sharply.

'We are doing a very wicked thing, Marguerite,' I said gravely. 'I should never have . . .'

But she interrupted softly:

'Shhh, don't say that. I've wanted so much to . . . You don't seem to understand. Be nice to me, don't tell me off. I'm so happy.'

She sighed.

'We're never alone together. I hate that. I've nothing to say to you and yet I've so much to say to you. Give me your hand.'

She spoke in a low voice, her head resting on my shoulder, her body leaning against mine, which was rigid and cold. I could feel her trembling, I could feel that young, sinuous, supple body; I could hear her breathing fast, sense her heart beating, feel her pressing against me. My skin crawled. From head to toe, I could feel a nervous itching all over my skin as if I had been forced to touch a filthy animal. I was truly physically disgusted by this female flesh throbbing against me. I could only think of one thing: to force her to go. I pulled away.

'First of all,' I said sternly, 'explain to me how you managed to get out of the house, Marguerite.'

'"Vous" . . . he calls me "vous". Please call me "tu" . . .'

'Please, Marguerite, tell me.'

She crept closer to me again and, laughing, child-like, in little fragmented phrases, she told me how for more than a month she had been oiling the hinges and locks of the doors every day. She had already tried it several times and it was easy to get out into the street quietly.

'I managed it without making a sound. I go barefoot for about fifty steps and then I put on my boots and I run.'

She sprang away and leaped up and in a wild gesture tossed one of her boots into the air and put her bare foot upon my thigh.

'Feel my foot,' she said, 'feel it.'

It was damp and cold and covered in sand.

'You're mad,' I said.

'I trod in a puddle. What does it matter? I had to see you. Feel it again. You're warming me up.'

I retrieved the boot from the middle of the avenue and put it back on her foot. She let me, happy to have me do something for her, something that felt like tenderness, and she meanwhile babbled on innocently. Perhaps it was this child-like babble which drove other thoughts from my head. My irritation melted away and gradually turned to sorrow and pity, a profound pity for this creature who was so pretty and irresponsible, whose lost future I could already glimpse, her life shadowed by irreparable catastrophes. I tried to make her

see reason, spoke to her gently, like a brother. Silent now, she huddled against me, her hand in mine, her eyes turned up to the sky which could be glimpsed between the leaves of the aspens, silvered by a glimmer growing stronger by the minute, the gleam of the moon which was still invisible, hidden behind the hills of Saint-Jacques.

'What if your mother notices you're gone, Marguerite, think how hurt she'll be. She'll die of shame. She loves you so much. When you were ill, remember how she cared for you, how she stayed by your bedside night and day, terrified to lose you. She only has you. You are her only consolation, her only reason for living. I am sure she gets up in the night to check on you, to listen to you breathing and watch you sleeping. Marguerite, you don't realise, but when she speaks of you, sometimes the poor woman cries. She says, "Yes, Marguerite is better, but she is so peculiar sometimes, so over-excited, I'm still afraid for her. She doesn't obey me, you know." Marguerite, think how terrible it would be for your mother at this very moment finding your room empty, crying out, calling you, mad with worry. Marguerite you must go home at once, don't waste a second, you must go home.'

I don't think she was even listening. She was soothed by the sound of my voice, but she did not hear the words emerging from my mouth. I felt her shivering, but with an emotion which was not the same as my own. Her fingers grasped mine, but they did not convey the affectionate pity I was feeling.

'You must go home, Marguerite,' I repeated. 'I promise I will come and see you tomorrow and we will see each other every day. Every day, I promise.'

She wasn't listening. As if emerging from a dream which my words had not disturbed for a single moment, she murmured in a distant, child-like voice:

'Guess what I've done.'

'Marguerite, you must go home,' I repeated, beginning to grow exasperated.

'Guess what I've done, go on, please, guess. You don't even want to try. You said the other day that you had no books and that upset you. Well, guess what I've done.'

'I did say that but . . .'

'I don't want anything to upset you and I want you to have books, so . . . Can't you guess?'

She leaped up from the bench, threw off the shawl wrapped round her, then rummaged around in the pocket of her dress with sharp, jerky, impatient gestures. Eventually she let out a little cry of triumph, sat down again beside me, opened my hand wide and placed some coins in it, saying:

'There, now you can have books, lots of books, and I'll be so pleased.'

At first, I was amazed, stunned, my hand outstretched, trembling slightly. The coins in my hand chinked together. There must have been five, six, possibly more, all gold coins. I looked from the coins to Marguerite, seeing neither the money nor her face in the darkness. I felt no anger or shame. I felt only a painful pity and respect for that child and her sublime recklessness. I stammered:

'Where did you get this money?'

'It's mine.' I drew her to me and held her against my chest. She wrapped her arms round my neck.

'Tell me the truth, Marguerite. You stole it from your mother, didn't you?'

'Well, are we not one and the same flesh, my mother and I?'

I slipped the money back into the pocket of her dress and said:

'The other day I was lying. I have plenty of books. You must put back everything you took. Promise?'

She seemed about to swoon, her waist pliant, her breath warm on my face.

'Why?'

I hugged her, kissed her forehead with an emotion greater than love, with forgiveness.

'Because I ask you to.'

We went back arm-in-arm, feeling drunk but pure. The moon rose high in the sky above the hills and was reflected in the glitter of the girl's tears.

After that, Sébastien gradually stopped keeping his diary. The

dates are further and further apart; impressions are recorded only rarely. The subject matter is the same: his struggle with his instincts and with his upbringing; his incomplete, impotent acts of rebellion, his mental problems. His personality is darkened and overshadowed by undefined fears. His energies decrease with each day that passes. He no longer has the courage to pursue an intellectual task nor any physical exercise beyond its beginning. Merely walking is onerous to him. He takes a few steps then stops, seized by an insurmountable laziness when faced with the long expanse of roads opening out before him, and the far horizons. He sits by the wayside, his elbows in the grass or stretches out on his back in the shade and stays there all day without thinking or suffering, dead to all that surrounds him. However, he notes here and there briefly the odd meeting with Marguerite. But he has never experienced again the feelings of the first evening. The meetings annoy him and upset him. Usually he does not speak and Marguerite hangs on his shoulder and weeps; he lets her cry and glimpses with disgust, almost terror, the day when tears will no longer be enough and she will demand kisses. Once Marguerite was bold enough to caress him, a brusque, violent caress that revealed all her repressed ardour. Sébastien pushed her roughly away and left her alone in the night, in the grip of a nervous crisis. He did not want to see her again, trying to take cowardly advantage of the incident to put a stop to the meetings altogether. Then he turned back to her, drawn by something good, tender and chaste which survives beneath his physical disgust and which is stronger than pity. Marguerite, overcome, began to cry again. She still prefers these sad encounters without a word of love spoken, without a single caress, to the thought of losing Sébastien and never resting her head on that dear shoulder, never having him near her. The hours spent like this wear her down and consume her. She grows thin; her eyes are ringed with even darker circles; she no longer has those sudden moods of wild joy.

From August until October, Sébastien was confined to his bed by an attack of typhoid fever which almost killed him. He notes later in his diary that his illness scarcely altered his state

of mind, that the delirium of fever was not noticeably more painful than his normal thought processes, nor more crazed than his normal dreams. His nightmares still pursued the usual round of unbearable visions: the school. He writes:

'During the month or so that the delirium reigned, I imagined I was reliving my years in Vannes and it was neither more painful nor more pointless than the years I really did spend at the school.'

However a change has taken place in his life. His father cared for him devotedly throughout the dangerous part of his illness, spending entire nights at his bedside, clearly worried and distressed. Madame Cébron caught him one morning in despair saying to himself: 'There's no hope for him.' Later, he watched over his convalescence with affection and tenderness. Sébastien writes:

'My father and I now go out together sometimes, arm-in-arm like old friends, something which seems to intrigue people from round here, for it is the first time since my return from school that they have seen it happen. We don't talk about the past any more, I think my father has forgotten it, nor the future: the future is the present. He is now accustomed to seeing me in a situation which he has come to consider natural and cannot conceive of any other existence for me. We scarcely talk at all and exchange few ideas. For my father, whatever I say is a riddle or evidence of madness. Basically, I think he fears me and perhaps respects me. He is slightly timid as if he is in the presence of someone dangerous and superior to him. He is careful how he expresses himself in front of me as if afraid of saying something stupid. I have noticed how limited his ideas are beneath his habitual rhetorical excesses. I think he has only three specific ideas in his head and he transposes them from the physical world to the abstract. These are height, breadth and price. That is the extent of his scientific and sentimental baggage. When we are in the countryside, I am struck by how little impression it seems to make on him.

He will never say, for instance, that a thing is green or blue, square or pointed, hard or soft, but he'll say: 'That's very tall,' or 'That's wide,' or 'That must be worth a lot of money.' One

evening, we were coming back at sunset, the sky was splendid, ᾽ ablaze with light, with glowing reds and trails of astonishingly vivid sulphurous yellow and pale green. Beneath the sky, the hills and fields seemed to be shrinking, drowned in deliciously unexpected, enchanting tones and layers of coloured, shifting mists. My father stood and watched the sky for some time. I thought he was moved by it and waited curiously for his response to this unusual emotion. After a few minutes, he turned towards me and asked me very seriously, 'Sébastien, do you think that the Saint-Jacques hills are as high as the Rambure hills? I think they're lower.' I simply can't be bothered with this kind of conversation. It annoys me. So I often end up replying to him in curt monosyllables. I shouldn't say so, but I miss that time when we lived side by side but never spoke to one another, when, in fact, we were no more strangers to one another than we are now that we do talk.'

In the midst of this jumble of thoughts and feelings, amidst his impressions of literature and sometimes strange attempts at drawing, is a constant preoccupation with society. He is torn between love and disgust for the poor, between the urge to rebellion towards which his instincts and thoughts drive him and the bourgeois prejudices of his upbringing.

He writes: 'Perhaps poverty is necessary for the equilibrium of the world. Perhaps the poor are necessary in order to feed the rich, the weak to strengthen the strong, just as little birds are necessary for the sparrowhawk. Is poverty the human fuel that keeps the great furnaces of life stoked? It is a terrible thing not to be sure, and the doubt caused by these endless, cruel questions stifles me.' And later: 'I think what distances me from the poor is something purely physiological: my extreme and unhealthily acute sense of smell. When I was a child, I would faint at the mere scent of a poppy. Now I even think according to my sense of smell and I often form an opinion on things through the smell they carry or simply evoke. I have never been able to overcome the offence that the smell of poverty gives me. I am like dogs that howl at beggars.' Later still: 'No, I can't keep seeking reasons and excuses, the truth is that I collapse whenever any effort is required of me.'

Sébastien's diary ends in January 1870 with this unfinished page:

18th January
Today I drew lots and I was unlucky. Despite Madame Lecautel's comments, my father doesn't want me to become a soldier. I don't think he has anything against the military as such: he could not imagine a more just, humane system than the one that already exists in society and which he serves without question. I think his decision is based on snobbery. He would hate it if people could say the son of Monsieur Joseph-Hippolyte-Elphège Roch was a simple square-basher like everyone else. My father bought a replacement for me. I'll never forget the face of that trafficker in men, in human flesh, when my father and he discussed the price of my purchase in a small room in the town hall. Stocky, tanned, muscular, with curly black hair, bright whites of the eye, a slightly hooked nose, and the sinister joviality of the slaver, he was just as I imagine traffickers in negro slaves to have been. He wore an astrakhan cap, heavy boots and his greenish overcoat brushed the mud-encrusted heels of his boots. His fingers were covered in rings and jewels. They bargained long and hard, franc by franc, sou by sou, losing their tempers, swearing, as if they were haggling over animal livestock, not over a man I do not know but feel that I love, a man who will suffer and perhaps die for me, because he has no money. Several times I was on the point of stopping this disgusting torment of an argument and shouting: 'Stop, I'll join up myself!' Cowardice held me back. In a flash of clarity I saw the dreadful existence of the barracks, the brutality of the officers, the barbaric despotism of discipline, the degeneracy of men reduced to the condition of beasts. I left the room, ashamed of myself, leaving my father and the slaver to wrangle over this disgraceful business. Half an hour later, my father came out into the street. He was red-faced and very upset, grumbling and shaking his head.

'Two thousand four hundred francs. He wouldn't take a penny less. It's daylight robbery.'

All day, Pervenchères has been in chaos. Bands of con-
scripts, wearing tricolour ribbons, their numbers proudly
pinned to their caps, have been running about the streets sing-
ing patriotic songs. I notice a young lad, the son of a local
farmer, and ask him:

'Why are you singing like that?'

'I dunno. I'm just singing.'

'So are you glad to be going into the army?'

'No, of course not. But I'm singing 'cos everyone else is.'

'And why is everyone else singing?'

'Dunno. 'Cos you do when you join the army.'

'Do you know what your "Country" is?'

He stares at me in astonishment. Clearly he has never con-
sidered the question.

'Well, lad, your "Country" is a few rogues who have taken
it upon themselves to make you into something less than a
man, less than an animal or a plant: a number.'

To emphasise what I'm saying, I rip off the number and rub
the lad's nose on it.

'In other words, for reasons of which you know nothing
and which are nothing to do with you, they'll take away your
job, your love, your freedom, your whole life. Do you
understand?'

But he's not listening, he's anxiously following with his
eyes the bit of card I'm waving in the air. In the end, he says
timidly:

'Can I have my number back now, Monsieur Sébastien?'

'So you really want it, do you?'

'Too right I do. I'll put it on the mantelpiece next to the
picture of my first communion.'

He pins it to his cap, rejoins his group and starts singing
again.

I saw him once more later that evening. He was drunk and
carrying a flag which trailed in the mud.

Sometimes I envy drunks.

CHAPTER III

After his illness, Sébastien managed to devise ways of avoiding those meetings in the avenue. First, he claimed that he was still weak and that his health was still poor; then that his father gave him little freedom. Marguerite had not insisted when offered the first excuse, but she was offended by the second. Did her mother give her any more freedom? Did she not find the means of escaping from the house, braving danger and surmounting all obstacles? Though he managed never to be alone with her, Marguerite proved astonishingly skilful at taking advantage of a moment's opportunity, a second when her mother's head was turned, in order to say something to Sébastien, usually a request, sometimes a threat. But he pretended not to hear. She was excitable, feverish; her dilated pupils burned with a dark energy.

'I really don't know what's the matter with Marguerite,' sighed Madame Lecautel. 'I find her so odd. Oh dear, I do hope that doesn't all start again.' One afternoon, Marguerite was sitting silent, motionless, her brow furrowed, a piece of tapestry work idle on her lap, when she suddenly got up from her chair, pinched Sébastien on the arm and slapped his face. Then she started yelling, stamping her feet and, finally, burst into tears. Madame Lecautel carried her daughter away, put her to bed and fussed over her.

'Marguerite, dear Marguerite, please, don't be like this. You're breaking my heart.'

All day, Marguerite said nothing but:

'I hate him. I hate him. I hate him.'

Sébastien wondered whether he should admit everything, not out of remorse, nor for Marguerite's sake, but purely in order to rid himself of her obsession, which was a torture to him. From one week to the next he put off the moment of

confession. Then, finally, one day, he made up his mind and said:

'Madame Lecautel, I have to tell you something very serious, something that has been tormenting me for a long while.'

'Tell me, child, tell me. What is this very serious matter?'

'It's . . . it's . . .'

He stopped, suddenly terrified by what he was about to reveal and realising that it would be cruel to make a mother suffer so much.

'It's nothing,' he said. 'It can wait.'

Madame Lecautel was used to Sébastien's ways. She knew how disjointed his feelings were, how he leaped from one idea to another. She showed no surprise and merely smiled sadly:

'I see that this serious matter is not so serious after all. What a funny fellow you are . . .'

He kept his visits to a minimum. But Marguerite wrote him letters, in a disguised, unrecognisable hand, brief, imperious letters, which he neither replied to nor acknowledged with a look or gesture when next they met. Once she asked him:

'Did you get my letters? Why don't you reply?'

Sébastien feigned astonishment and said:

'What letters? Did you write to me? No, I haven't received any letters.'

'You're lying.'

'Honestly. My father must be intercepting them.'

'Your father! That's just not true.'

'He'll hand them over to your mother, Marguerite, you'll see. It's madness.'

'Well, let him. So much the better.'

The letters had indeed intrigued Monsieur Roch, who waited for the postman every morning out on the street. He handed them to his son and remarked slyly:

'Ha, ha, my lad! Here's another of those letters if I'm not mistaken.'

Often he would add maliciously:

'Yesterday, I met the Champiers. Yes, Madame Champier spoke about you. Yes, indeed . . .'

240

Despite Monsieur Roch's high moral stance he would have been flattered to think that his son had some secret, guilty relationship with Madame Champier, the most elegant lady amongst the Pervenchères bourgeoisie and the most admired.

Sébastien was alarmed by Marguerite's boldness. He changed tactics towards her and decided to appease her by pretending affection. He tried to appear more involved, looked at her more tenderly, sometimes took her hand on the sly, embraced her in the corridor when he left her house. Marguerite abandoned herself to him instantly, moved, overcome, weak. She would say:

'Can I meet you soon?'

'Yes, yes, soon. Tomorrow. I'll tell you tomorrow.'

'Hurry then. It's been so long . . .'

'Yes, yes, too long . . .' Sébastien would say in a caressing voice.

She became more relaxed, happy, confident and outgoing. Her mother was glad to see the colour come back to her cheeks and her childish antics return. She said to Sébastien:

'Thank God, I think the crisis is past. She's much better, isn't she?'

So it went on, in Marguerite revolt alternated with submission, and in Sébastien the anguish of ideal love alternated with physical disgust, until that day in July when they both found themselves face to face in the wheatfield. That day, Marguerite spoke in an abrupt, imperious tone which brooked no discussion. She said:

'I want you to.' He realised that, from now on, she would not be content with the bait of promises constantly withdrawn, nor with the deceitful charity of his dilatory caresses. He would have to take a definitive stance: either finally break away from an unacceptable situation full of rancour or resume the gloomy nocturnal meetings in the avenue. There was still a remnant of pity behind even the most painful of his feelings, as well as fear of the possibly complicated and difficult consequences of rejection, and because of that he had not dared take on the responsibility of breaking it off. Again he had resigned himself to the demands of this small, mad, insatiable

creature. He had gone home after the walk unhappy, telling himself he was a coward, in the grip of a great depression. As he always did when assailed by unusual or particularly irksome problems, he stretched out on his bed, his legs apart, arms crossed behind his head. But even though it normally calmed him, he could not stay long in that position. The need for motion soon made him get up. Like a beast in a cage, he paced up and down in his cramped room, bumping into furniture, kicking chairs. Suddenly he remembered that the nights were bright and full of moonlight and that lovers walked arm-in-arm and made love in the fields, the woods and on the dusty roads and grassy pathways. Something horrible shifted in him and he shouted:

'Bitch! Bitch!'

Night came sooner than he would have wished. He felt that the minutes, usually so slow to pass, now devoured the hours.

When he went to the avenue, the moon was shining in a very clear, pale sky, cold and milky. Huge blue shadows billowed across the white road; the trees were sharply etched in the moonlight, their green colours still evident, but darker and sprinkled with silvery sequins. The fields and hills and the scattered houses were lightly robed in mystery, but looked almost as they did during the day.

In the avenue stood Marguerite, leaning against an aspen tree, watching the road. She was wearing her cream-coloured frock with a red sash again; over her head and shoulders she wore a kind of shawl in white silk which gleamed in the moonlight. The trunks of the aspens, clear and white, formed a high white barrier leading away into the distance, with shadow between them, a transparent shadow full of occasional starry pockets of brightness. As soon as Marguerite spotted Sébastien, she ran towards him and wordlessly embraced him, pressing her body against his, her lips against his. He pushed her away.

'Soon, soon,' he said. And then, harshly.

'I suppose you kept that dress on just so you could be seen all the better, and that shawl which shines out like a beacon . . .'

242

'It was just so that I could get here sooner, Sébastien,' replied Marguerite, whose passion had been frozen and abruptly reined in by that brutal welcome. 'Anyway, who's going to see us here, this late?'

'Who? Everyone, damn you, everyone. Let's not stay here.'

They walked to the bench and sat down. Marguerite could feel tears mounting, tears which never quite escaped but seemed to fill her veins, her heart, her throat and her brain; her ears hummed with the sound of rushing water. Nevertheless she had the strength to ask:

'Have I done something to hurt you, Sébastien?'

Brutally he replied:

'No, you haven't hurt me. Just tell me, what do you actually want?'

She leaned her head on his shoulder.

'Why do you use that tone with me? What do you mean, what do I want? I want you. I want to touch you, to be able to hold your hand without anyone else here to see us and disturb us. I just want to be here like we are now, Sébastien. My Sébastien . . .'

Her voice died away, blurred by tears.

'What do I want?' she managed to go on. 'I am burning with desire for you, suffocating. I can't sleep at night. I am going mad. If you only knew. But you don't understand, you don't understand anything. Often when my mother has gone to sleep, I leave my room and leave the house, where I feel I'm dying, and I run as if I were going to meet you. Sometimes I roam around outside your house. There was always a light on in your room whenever I looked up. What were you doing? I called you, I threw sand and pebbles against your window. If the gate had been open I would have gone in. I came and sat here for hours. Sébastien, say something to me, take me in your arms, Sébastien, I beg you, why won't you talk to me?'

Sébastien kept quiet, his face dark.

She spoke of her gestures of affection, always rejected, of her hopes, never realised, her pain, her anger, her dreams, her impulse to go to him, often so strong that she could barely repress the need to clasp him to her, kiss him, even in front of

her mother. But as he listened, and as he felt the warmth of her woman's flesh against his skin, permeating his body, he felt ever more horrified by that voice and wished he could stifle it, horrified at this unbearable physical contact with her, which he would have given anything to end. Everything she had meant to him, the ideas, thoughts, feelings which she had inspired, he forgot in his disgust at this sexual urge which seemed to pursue him and cover his skin like the stings of a thousand voracious bloodsuckers. He stared coldly at Marguerite, pale beneath the moon, pale with the pallor of the dead, her head on his shoulder, and he trembled. He trembled because, from the depths of his being, dark and unknown even to himself, an instinct had been awakened, had risen up, swelled and conquered him, a wild, powerful instinct, whose terrifying suggestions he was obeying for the first time. He no longer felt merely physical repulsion, at that moment, he felt hatred, not just hatred, more a sort of monstrous, deadly vindictiveness, amplified to the point of violence, which was driving him into the abyss with this frail child, not into the abyss of love, but into the abyss of murder. He, so sweet-natured, for whom the death of a bird was a source of sorrow, who could not, without feeling faint, bear the sight of a wound, a spot of blood, instantly admitted the possibility of Marguerite lying beneath him, her bones crushed, her face bloodied, gasping for breath. His dizziness increased; a red fury filled his brain, spurred his limbs to violent action. Suddenly he drew back sharply. His fists opened and closed in sinister, nervous movements. The moon continued its astral progress. A light breeze had arisen, shaking the leaves of the aspens, whose silvery undersides gleamed.

'Please, please speak to me,' begged Marguerite, who had eagerly crept closer to Sébastien. 'Take me in your arms. Are you leaving?'

'Shut up.'

'I'm being nice to you, aren't I? I'd like to be so nice that you would never want to leave me. I dream of us running away together. Say that you'd like us to do that.'

'Shut up! Shut up!'

He gripped her hands, her wrists and arms, and squeezed them hard enough to crush them, to draw blood. His hand flew to her shoulders, then he stopped, trembling, mesmerised by her throat.

'Yes, yes, I feel that urge too sometimes, as if I were suffocating. Touch me.'

Marguerite abandoned herself to him, delivered up her entire body to that murderous embrace she mistook for love, and whose pain she could not recognise, lost in the lust which had taken possession of her.

'Yes, touch me again. Then kiss me. Everyone kisses, I'm the only one . . .'

'Be quiet!'

But she would not keep quiet. She came closer, pressed her whole body against his, wrapped her arms round him and said:

'Take me, the way Jean takes his wife. I often see them from my room at night when they go to bed. They kiss, they caress. If you only knew . . . if you could see . . . Oh it's wonderful . . .'

Suddenly, at the idea of that sight, Sébastien's fingers released their grip and the terrible embrace turned into a caress. His voice still hoarse, but weaker, he said:

'You really see them when they go to bed?'

'Yes, I can see them.'

'And what do they do? Tell me, tell me everything.'

Whilst Marguerite spoke, he listened, his breath coming in quick gasps; he recalled all his own memories of lust, depraved desires, perverted fantasies. He summoned them from far, far off: ancient ghosts, from the depths of that room in the school, where the Jesuit had taken him, at the end of that corridor where the deed had been done, in the silence of the night and beneath the trembling light of the lamps. He recalled the act of corruption which had brought him to this point, poised between the abysses of blood and degradation.

'And what effect does it have on you to see all that?'

'Me? It makes me want it too.'

He heaped filth on himself and her, forcing her to defile herself with her own words. The violent desire for that flesh

245

he had condemned mounted in him, burning and biting; it was a desire in which violence still lurked, but a violence that no longer demanded death, only possession, the way the assassin's knife rushes at the throat of the victim. He kept questioning her, demanding more precise details, a clearer picture of them and of her reactions as she watched. Marguerite told of clothes thrown aside, nakedness, limbs entwined on the bed; he drew her to him, pressed her against his chest. Her hands ran over his whole body, she uttered abominable words, pulled clothing aside to reveal bare flesh, over which she lingered.

'Is that what they do?'

'Yes . . . isn't it wonderful?'

Their caresses grew bolder. Clumsily, roughly, he took her.

At first, it felt like surprise, like the brief fear one feels on awakening from a bad dream. For a few seconds, he felt afraid of the milky sky above him and the white trunks of the aspens piercing the pale night of the avenue like ghosts. Then he felt broken and terribly sad. Marguerite was beside him, on him, her two arms around his neck, speaking to him sweetly, idly, happily:

'Sébastien, dear, sweet Sébastien.'

He no longer felt anger or disgust, merely distress. The madness that had thrown a lurid light on the unhealthy depths of his psyche had receded. He was almost surprised to see Marguerite still there, and she was saying something. His thoughts were elsewhere, far off. His thoughts wandered the paths of memory: the window seat in the dormitory, the seashore, the pine forests, the seductive beauty of the voice mingling with the whisper of the sea and the wind. His thoughts were in that room, fixed on the small, capricious glow of a cigarette end, and he missed it. Did he really? He took pleasure in it and no longer cursed the thought. Was the fact that he no longer cursed it the same as missing it? He gently removed Marguerite's arms from round his neck and delicately pushed her away.

'Oh, why won't you let me stay like that?' she sighed. 'Am I tiring you?'

'No, Marguerite, you don't tire me.'

'Well, then, why? I love being with you like this.'

Her voice was as clear as morning birdsong. It was as if no evil had ever crossed her path. That child-like voice, like the ripple of water, touched Sébastien's heart. Overwhelmed by a vast sense of pity for her, for himself, condemned as they were to suffering of such opposite but similarly shameful kinds, he suddenly broke down and wept.

'You're crying,' exclaimed Marguerite. 'Do you think I don't love you any more?'

'No, no, it's not that. You poor little thing, you wouldn't understand.'

'So you don't love me, then?'

He threw his arms round her and held her in a chaste embrace.

'Of course I love you,' he said. 'I should always have loved you like this. I'm sorry, I'm just miserable because I can see how unhappy you are inside and, at this moment, I love you for your pain.'

He leaned his head on the girl's shoulder, gripped her hands and murmured:

'Don't speak, say nothing . . . your heart's beating so fast . . .'

Marguerite was a little afraid and started to stammer:

'Dear Sébastien . . .'

'No, don't speak . . .'

She obeyed and she too leaned against Sébastien. He felt like a little child she was rocking to sleep. Afraid to speak for fear of waking him, she sang lullabies in her head, like a child playing with a doll, delighted that Sébastien should ask for her protection.

'There now, go to sleepybyes . . .'

Gradually, soothed by her own songs, she grew drowsy, closed her eyes and fell asleep, the calm sleep of a child.

Sébastien did not sleep. Despite his distress he felt great physical well-being, resting like that on Marguerite's shoulder, near that peaceful heart which he could hear beating. The tears he continued to shed were almost pleasurable. For a long while, he sat quietly, huddled against her. In the silence full of tiny sounds and the gentle glow of the moon, the ugly images

in his mind evaporated one by one, but other thoughts came to him, sad thoughts, though not entirely devoid of hope. He sensed something vague and possible, a slow regaining of his own sanity, a slow return of the senses to peace, a place for his injured heart to rest in calm and purity, with no dark, constraining horizons. He suddenly experienced again old feelings of enthusiasm and generosity, lovely shapes, affections, sounds, scents, noble desires, ascensions into light, and love, a boundless love for those who suffer. All this came from something within himself, his generous, good self. It rose, trembled and took flight, just as in blossoming fields and on sunny moorlands, flocks of singing birds rise and fly off. Lost in the wave of his future redemption, he did not notice the minutes and the hours passing.

As time passed, slowly, gradually, his whole life appeared to him in a succession of images, from the untroubled days when he went to school in the town to that painful night when he was there weeping on Marguerite's shoulder. He had never before seen so clearly how empty, useless and guilty his life had been, how it was constantly threatened by the vice of inaction, which left him defenceless, powerless, prey to every mental depravity, to every emotional perversity. He was disgusted by it and thought:

'I'm twenty years old and I have done nothing with my life yet. Everyone works, completes his daily task, however humble. I have never worked, never completed any task. I have dragged myself like an invalid from one street to the next, from one room to the next, weighed down, damned. I have been a coward, a coward to myself, to other people, to this poor child here, to my life devastated by my own inaction and madness. I must make up my mind not to waste my manhood in the same way as I've wasted my adolescence. I mustn't . . .'

He imagined vague, grandiose missions, mingled with incredible artistic achievements, which were even vaguer. It all seemed simple and inevitable.

'I want to love the poor and no longer exclude them from my life, as Kerdaniel and the others excluded me. I want to love them and make them happy. I'll go into their homes, sit at

their bare tables and teach them and comfort them and talk to them as brothers in pain. I'll . . .' He wanted everything to be grand, sublime, redemptive, vague, making no attempt to define or develop those fleeting dreams which refreshed his soul just as Marguerite's sleeping breath cooled his forehead.

The moon dimmed; a pink glow appeared in the east: dawn was approaching. Marguerite was still asleep. Worried, Sébastien woke her.

'Marguerite, we must go back. It's morning.'

On the road at the end of the avenue voices could be heard, and the heavy step of workers on their way to the fields.

'Marguerite, listen. It's morning.'

From the depths of the limpid darkness, the cool, damp breeze containing the first drops of dew carried with it a faint hum, the light, diffuse rustling of people and things stretching, bestirring themselves, waking up. The high branches of the aspens began to take on a barely perceptible rosy tinge.

'Marguerite. It's getting light . . .'

At first, she seemed stunned by the sky, the trees, the ghostly pallor, by him and his voice. Then, shivering with cold, she uttered a small cry like a bird greeting the dawn and threw herself into Sébastien's arms.

'Light? Already? What does it matter, let's stay here a while longer.'

'We can't. It'll be broad daylight soon. Look, the moon's fading, and the woodcutters are on their way to the forest. Marguerite . . .'

She embraced him passionately and said again:

'What does it matter?'

'People will see you, Marguerite, don't you understand?'

'What do I care? Kiss me.'

Sébastien got up, gathered up the white silk shawl, which was trailing on the ground, and wrapped it round Marguerite, who was still shivering.

'Please, we must go back,' he begged. 'You're frozen, your hair's damp.'

Sadly, she replied:

249

'No, it's going home that chills my blood.' She got up too and grabbed Sébastien's arm.

'Now, promise me one thing. Promise me we will come here every night. Promise me.'

Sébastien did not want to hurt her, nor anger her, for he was familiar with her stubborn moods, her sudden shifts from joy to rage, submission to rebellion, laughter to tears.

'I promise.'

'Really, every evening? Kiss me again.'

He clasped her to his chest in a sudden surge of impotent pity.

The pink light was spreading and deepening, filling the entire horizon. The stars flickered like little lamps about to go out.

'Very well then, let's go back,' said Marguerite.

A man passed by on the road, whistling. They had to wait till his footsteps died away. Then they set off down the little side lanes surrounding the town. Alert and lively, Marguerite chattered merrily.

'Do you know what I think? I'd like people to see us together. Then we wouldn't need to hide any more and I could come and live with you or you could come and live with me. It would be wonderful, being able to kiss all the time.'

Suddenly stopping, laughing and mischievous, she said:

'You really hurt me, you know.'

Sébastien was puzzled and looked at her uncomprehending, but she pulled him towards her and kissed him on the forehead.

'You dear, dear man. I do love you so.'

He left her at the entrance to the little alleyway which led to the post office. He stayed there as if in a dream, following her shadow until it was swallowed up in deeper shadow, a fleeting speck of pale fabric in the dark, until he could no longer hear her light step on the cobbles.

He went back home, his heart filled with remorse. He did not want to go to sleep, so he opened his window and watched the day appearing, bursting into bright light. He was

unhappy and shaken by the violent emotions of the night, his head empty.

Towards eight o'clock, Monsieur Roch came into his room. He was very pale and was holding a newspaper. He did not notice that his son's bed had not been slept in and flopped into a chair with a sigh.

'War's been declared. It's all over. Read this.'

He handed the paper to Sébastien, muttering:

'Two thousand four hundred francs. I paid two thousand four hundred francs. I can't bear it. And all for nothing.'

Whilst Sébastien, who was also somewhat pale now and trembling, glanced rapidly through the paper, Monsieur Roch gave him a sideways glance full of harsh reproach, as if he were calculating all the money his son had cost him. . .and all for nothing.

In the evening, Sébastien wrote in his diary:

'For part of the day I wandered through the town. People are excited. Everyone's out on their doorstep talking about the news. Most are unaware who the enemy is. I keep hearing things like:

"So is it the Russians or the English who hate us?"

On the whole, people are worried and sad, but resigned. Nevertheless, there's a band of young lads roaming the streets, wrapped in flags and singing. They were dispersed, but gathered again in the taverns and were yelling at the top of their voices until night-time. Why are they singing? They know nothing. They know less than that little conscript who had drawn the wrong number, but was singing his heart out when he should have been crying. I have noticed that patriotism is the crudest and most irrational of the feelings that move the masses: it always ends up in drunkenness. As for me, I didn't dare go round to Madame Lecautel's. I'm worried that Marguerite will give herself away, and that would be a useless and troublesome complication. Should we tell? From the moment my father came into my room, Marguerite became only the most distant of concerns for me, virtually forgotten, insignificant. War makes me feel something though: revulsion and fear. I cannot accept the idea of a man

running straight towards the muzzle of a cannon or offering his chest to bayonets, without even knowing why. And he will never know. Such courage – of which I am totally incapable – strikes me as absurd, inferior and vulgar, and I suppose that in normal life, a man possessing such courage would be locked in the deepest dungeon. I've often thought about war; I've often tried to imagine it. I close my eyes and attempt to call up images of slaughter. My impressions never vary: I am revolted and I feel afraid, not just for myself, but for everyone, for whom I tremble. Despite my upbringing I cannot accept military heroism as a virtue, it just seems like a more dangerous and disturbing form of banditry and murder. I can understand that people of the same country should fight and kill one another to gain freedom or rights, the right to live, eat, think; I can't understand fighting people you know nothing about, with whom you share no common interests, and whom you cannot hate because you don't know them. I've read that there are superior laws in life and that war is one of them, and that it is necessary in order to maintain a balance between nations and to spread civilisation; but no reasonable man could support that idea. Epidemics and marriage seem to me perfectly sufficient means of controlling the human population. War only destroys the youngest, strongest elements of the population; it destroys hope and humanity.

I'm going to war to fight. I don't know why I'm going. I'll just be told: "Kill and be killed, the rest is our concern." Well, I'm not going to kill anyone. I may get myself killed. I'll go off to battle with my rifle on my shoulder and it'll never know bullets or powder. I will not kill . . .

My father saddens me. There's something comical about the poor man which makes me unutterably depressed. He's not downcast as he was this morning when he brought me the newspaper. I think he's almost forgotten the two thousand four hundred francs I've cost him. At least, he hasn't spoken to me about it again or reproached me with it. He is extraordinarily tense. He can't keep still, but he's become imperious and eloquent again, even with me. He has realised that the war will

252

mean new responsibilities for him, a higher level of authority and add a touch of the military to his civic functions, and this has given him back his self-respect. He's already talking about calling in the national guard and inspecting the firemen. He's decided that the town council should be in permanent session. Joy overflows from his words, his gestures, his eyes, he's busying himself with requisitions, instructions, official matters, meetings with superior officers of the security police, all things he loves and which he thinks give him great status. At the same time, he reassures people, seems to say to them: "What are you worrying about? I'm here." He actually had read out in the streets by the town crier a kind of order of the day, a very impressive affair reminiscent of Napoleon's proclamations.

At dinner, he said:

"We may have already crossed the Rhine by now. We're going to run a tight campaign, so we are. First, there's Prussia. But what are they? They're just a nation like any other. Nothing to worry about."

Monsieur Champier, the notary came over, very enthusiastic. He poured himself a whole glass of gin and said with a shrug:

"Bismarck! Pah! We'll shoot him."

There's one thing I feel guilty about now. Madame Lecautel and Marguerite came round at two o'clock and rang at the door. I saw them and told Madame Cébron to tell them no one was in. They went away, Marguerite looking very pale, staring obstinately up at the windows of my room, Madame Lecautel looking very sad in her black shawl, shoulders hunched. I love them, I love them both, but I don't think I have the courage to see them again.'

Two days later, Sébastien received the order to report to Mortagne, where the battalion was forming of which he was to be part. Monsieur Roch decided to come with him.

'I'll get to see the sub-prefect,' he said. 'I'll confer with him and with your commander. Don't worry. I'm sure that, at this very moment, our army is already victorious all along the

front. Anyway, every man's got to do his duty. I do mine, old man that I am. After all, France is France.'

He then asked him:

'Have you everything you need? Have you said goodbye to everyone? To Madame Lecautel?'

Sébastien blushed. He realised that avoiding them in such a serious situation was absurd and unpleasant, but, his heart breaking from his own cowardice, he replied:

'Yes, Father, I have.'

Sébastien spent a month at Mortagne in training for the forthcoming campaign. Although the active, purely physical existence and the continuous exhaustion engendered by long marches and incessant practice manoeuvres did nothing to alter his frame of mind, they nevertheless slowed his thought processes and calmed him down. He had no time left to think. His father came to visit every Sunday and spent the day with him. Monsieur Roch's mood of exultation was long past. The French forces' abrupt defeat and successive disasters had affected him badly, and he was beginning to be seriously concerned for Sébastien's safety. He no longer spoke of 'getting organised', but planned instead to abandon the office of mayor, which had become burdensome, along with responsibilities of all kinds.

In the last week, he did not leave Mortagne. He could be seen wandering about the training field or else stationed on the roads watching the battalion march by.

'Do you need anything?' he kept asking, anxious and tender. 'I'd hate anyone to say that my son lacked for anything.'

One day, he asked:

'What have you done to Madame Lecautel? She's not at all pleased with you. Apparently you didn't say goodbye to her. Did you realise that little Marguerite has been very ill?'

'Marguerite?' echoed Sébastien, feeling a shaft of remorse pierce his heart.

'Yes, very ill indeed, feverish, coughing, raving. Her mother is at her wits' end. You really should have said goodbye.'

Despite his fear of war, Sébastien was now almost glad to set

off. He found his father too affectionate and Marguerite too close for comfort. He felt debilitated by it all.

His battalion set out to join a brigade that was massing at Le Mans.

CHAPTER IV

They had joined battle the day before just outside a little village in Loire-et-Cher. The day did not finish decisively and so the troops camped in their positions that night. On the following morning, on the desolate, sombre plain, two farms could be seen still burning, set alight by cannon fire. The reveille sounded at five o'clock. It had been a hard night: the men had been unable to sleep, half-frozen in their tents with not even straw for bedding, half-starved too, because, in the expectation of a more rapid defeat, provisions had not been sent and the order for retreat was received just as the victuals were being distributed. They packed up their tents and bags. A few fires still burned and, around them, dark, human shapes were crouched, hunched and shivering. Here and there bayonets gave off a sinister gleam and the bugle calls replying to one another were the only sounds breaking the gloomy silence of the camp.

Sébastien had spent part of the night guarding the rifles. He was utterly exhausted, shivering with cold, and his eyelids burned as if they had been dipped in acid. The day before, for the first time, he had been involved in a brief engagement with gunners. He had kept his word and had not fired once. Apart from anything else, he wasn't sure what he was supposed to be shooting at. He had seen nothing but smoke and he had walked with his head down against the bullets whistling and raining about him, his chest tight with fear. He would have had difficulty isolating and analysing his impressions. In reality, he remembered nothing, only the smoke and his fear, a strange kind of fear, which was not like the fear of death, it was worse. Already he had stopped thinking for himself, but lived mechanically, dragged along by some blind force which had taken the place of his intelligence, sensitivity and will. Overwhelmed by fatigue and the daily privations, infected by the

general mood of demoralisation, he carried on in a sort of mental darkness, a night of the intellect, completely unaware of himself, forgetting that, behind him, he had left a family, friends, a past life.

He tried unsuccessfully to get near one of the fires, which was surrounded ten deep by men, whose thin, weary faces were lit by the sinister, dancing flicker of the flames. He was pushed roughly aside, so he decided to walk briskly, to run, so as to warm himself up, stamping his feet on the hard, echoing earth. It was a dark night. The still glowing debris of the two farms, finally burning out, bled sadly into the surrounding gloom; and on the hills far off, beyond the black plain, little luminous points of light, like glimmering stars, indicated the enemy camp. The bugles continued to sound and every note made him jump, stop for a moment and then continue walking, his skin pinched and chapped by the cold beneath his torn, threadbare woollen jerkin. From time to time he heard troops clattering past in the darkness and moving off into the distance on the plain, and his whole body shuddered horribly. He realised it would soon be his turn. A companion came to join him and ran alongside him.

'I think things are going to hot up today,' he said, gasping for breath as he ran.

Sébastien did not reply. After a silence, the man went on:

'Did you know Gautier didn't show up for roll call?'

'Is he dead?' asked Sébastien casually.

'Nah, he scarpered, he did. He's been saying for ages he was going to. This bloody war'll go on for ever.'

Both sighed and said no more.

Day was slow to dawn. First, the plain appeared, brown, bare, flat and trampled, like a field used for practice manoeuvres. A scattering of palefaced horsemen galloped across it, rifles in hand, cloaks flying. The dark, deep masses of infantry became visible and seemed to draw nearer. On the right, a battery made its way towards a wooded hill and made a metallic noise on the frozen ground, the din of steel plates clashing. The hills were still steeped in disquieting shadows, full of the mystery of that invisible army that was soon to descend onto

the plain, bringing death. The sky above was a uniform grey tinged with verdigris, presaging snow. A few flakes drifted in the air. Every other minute, across the vast expanse of field, came the sound of gunshots, sharp, far-off cracks like the sound of a whip.

'I think things are going to hot up today,' said the man again, looking very pale.

Sébastien was surprised not to have seen Bolorec anywhere. He had last seen him the day before. His battalion was encamped near his own and, after they left Le Mans together, they used to meet every evening, apart from the days when they were on guard duty. Bolorec was his only reason to live. Through him he maintained an awareness of his real self, the self that had feelings and thoughts. What would become of him without Bolorec?

After a three day forced march, they had arrived at Le Mans, which was overflowing with disbanded and displaced troops, and the first face Sébastien saw was Bolorec's. Bolorec had been called up too! There was Bolorec standing in front of a bookshop and looking at the pictures in illustrated journals.

'Bolorec!' he had shouted, faint with joy.

Bolorec had turned round and immediately recognised Sébastien, who was waving his rifle in the air to attract his attention. He had joined him, falling in beside him in the ranks. Overcome with emotion, Sébastien had only been able to stammer: 'Is it you, Bolorec? Is it you?' And Bolorec, cutting a comic figure in his voluminous Breton conscript's greatcoat, smiled his familiar, wry, enigmatic smile. Looking at his friend marching beside him in the ranks, Sébastien could not help thinking of their walks at school and feeling happy.

'Do you remember, Bolorec?' he said. 'Do you remember when you used to carve bits of wood and sing me Breton songs? Do you remember?'

'Yes, of course,' replied Bolorec, attempting to keep step.

He had not changed at all. He had grown slightly taller but was still stocky, shambling along on his short legs. His hair was still frizzy, his cheeks still soft, round and beardless.

'How come you're here?'

'We've come from the battle at Conlie. Loads of men have died already.'

'Did you fight?'

'No, people died from fever and hunger . . . Lots of local boys died . . . friends. It's not right . . .'

'Why did you never write back to me?'

'Because . . .'

They had reached Pontlieue, on the outskirts of Le Mans, where a camp had been set up on the right bank of the Sarthe.

'We're camped over there as well,' Bolorec said.

What joy the next day when they found out they were in the same brigade. From that moment they hardly left each other's side. Whilst they were at Le Mans, they went out together and wandered round the town. On marches they met when the armies halted. In the evening, Bolorec often slipped into Sébastien's tent and brought him pieces of salami and white bread which he stole from heaven knows where. They stayed together as long as possible, speaking rarely but united by a strong affection, by bonds of unspoken suffering, infinitely powerful and unbreakable. Sometimes Sébastien questioned Bolorec:

'So, what were you up to in Paris?'

'I'm . . . you'll see.'

He was still impenetrable, mysterious, replying only with meaningful gestures and vague, incomplete allusions to things that Sébastien did not understand.

He asked him:

'What about the war? Are you afraid?'

'No, I hate it because it's unjust, but I'm not afraid.'

'But what if you get killed?'

'So? I shall die . . .'

'And if I were there . . .?'

'Well, you'd die too.'

'Tell me what this "great ideal" is.'

Grimacing, eyes blazing, Bolorec said in a harsh voice:

'It's justice! You'll see . . . you'll see . . .'

As he ran, Sébastien recalled all this and many other more distant memories and worried that he had not seen Bolorec

since the previous day. Suddenly a bugle call that he recognised only too well made him stop with a jolt. Men reluctantly left their positions, and he too, crippled with fear, went to rejoin his company, soon to make their way towards the wooded hillock on the right of which the artillery were setting up their guns. Soldiers were there digging the ground, which was hard as granite, and constructing escarpments to protect the cannon. Sébastien was delighted to find Bolorec there armed with a spade, vainly attacking the frozen ground. He was given an axe and the two companies mingled, so he went to work next to Bolorec beneath the black maw of the cannon, as yet silent but sinister. The captain walked about amongst the soldiers, smoking his pipe, looking worried. He was grim-faced because he knew that all resistance was pointless. From time to time, he peered through his binoculars at the movements of the enemy army and shook his head. He was a short man, fat and paunchy, with a roguish face and bristly grey moustaches. He loved his white horse, which was short like himself, with solid haunches; it was kept tethered to an ammunition vehicle with an orderly to look after it. He often went and tickled the horse's belly, as if to cheer it up. He treated the men in a fatherly manner and chatted with them, moved no doubt by all those lives sacrificed for nothing.

'Come on lads, let's get a move on,' he was saying.

But the work was making no progress at all because the ground was so hard that the points of the picks kept breaking. Now, the enemy hills, stripped of their envelope of mist, were like a swarming ants' nest, an accumulation of countless black insects covering the distant slopes with their dark shapes and turning the horizon into something living and shifting, advancing towards them. On the plain, the regiments continued to move, like little hedges on the march, and between them galloped horsemen and generals' escorts, recognisable by their banners drifting in the squalid air beneath the low, tragically pale sky.

While the men were working, backs bent, a cart driven by an ambulanceman drove up from the plain and stopped beside Bolorec and Sébastien. The ambulanceman asked for a light

for his pipe and some gin as his canteen was empty. Sébastien passed him his own. The cart was full of dead men: a hideous chaos of stiff twisted limbs, broken arms and protruding legs; amongst them could be glimpsed swollen faces, daubed with dried, blackened blood. On the top was a corpse lying on its back, eyes open, dressed in the grey uniform of the papal zouaves, its arm sticking straight up like a flagpole. Sébastien went pale. He had just recognised Guy de Kerdaniel. The dead man's face was calm, only slightly paler than normal, and beneath his blond beard, sprinkled with frost and earth, his expression still bore his old insolent, malicious grace. It was clear that Guy had been killed point blank by a bullet to the throat. The bullet had taken with it a piece of his necktie which was lying across the wound, its edges stained pink. Sébastien suddenly felt profound pity. He forgot how he had suffered because of Guy de Kerdaniel and he took his cap off in piety and respect before that rigid corpse which he felt like embracing. Bolorec looked at the corpse too, but he was cool and calm.

'Don't you recognise him?' asked Sébastien.

'Of course,' replied Bolorec.

'Poor Guy,' sighed Sébastien, tears filling his eyes.

But Bolorec grabbed his arm and pointed at all the bewildered conscripts working away, the sons of peasants and the poor.

'What about them? Is that right? Soon most of them will be dead. He . . .'

He turned round towards the cart, which was moving away, jolting over the clods of earth.

'He was rich, noble, and an evil man. It's right that he should die. Come on, let's dig.'

He hacked away with the pickaxe. In the distance, there was the occasional sound of gunfire.

During this time, an officer had arrived, galloping flat out. He got off his horse and chatted for a few minutes with the captain, who grew increasingly animated and, making angry gestures, suddenly leaped onto his white horse and disappeared, also at the gallop. The officer was a very young man,

frail and pretty as a girl, with his yellow boots, soft leather gloves, and tightly-belted jacket edged with astrakhan. He went over to the cannon and seemed very interested in what the men were doing. His lieutenant accompanied him.

'May I fire the cannon once?' he asked.

'If you like, help yourself.'

'Thanks. I'd love to give those Prussians a bit of a fright. Don't you think that'd be a lark?'

They both laughed softly. The young man pointed the cannon and asked for fire. The shell landed on the plain where it burst five hundred metres from the Prussian line.

That was taken as the signal for battle to commence.

Suddenly the horizon caught fire, instantly veiled in smoke and, shot by shot, five shells landed and exploded in the midst of the conscripts as they worked. The officer was already flat on the ground, face down, crouched behind his horse's neck. The men flung themselves down and the battery boomed endlessly, the earth shaking with its furious roar. Sébastien and Bolorec were next to one another, stretched out, chins on the ground. They could see nothing, only huge columns of smoke which spread and filled the atmosphere, constantly breached by shells and bullets. On the plain, the shaken troops opened fire with their muskets.

'Hey,' said Bolorec.

Sébastien did not reply.

Behind them, despite the tremors and the screaming explosions, they could hear the clamour of voices, bugle calls, galloping hooves, heavy vehicles on the move.

'Hey,' said Bolorec again.

Sébastien did not reply.

Bolorec got up, turned around and glimpsed the battery, a nightmare vision of red fog, in the midst of which was the captain, who had returned, sitting up straight on his horse, brandishing his sabre and shouting commands at the dark agitated shapes of the soldiers. One man fell, then another, a horse collapsed, then another. Bolorec flung himself down again beside Sébastien.

'Hey, I want to tell you something. Are you listening?'

'Yes, I'm listening,' murmured Sébastien weakly.

Very calmly, Bolorec continued.

'My captain was a local fellow. You saw him, didn't you? A little dark fellow, nervy, insolent. He was from my village, he was an aristocrat, very cruel and much disliked because he drove the poor away from his chateau and forbade people to go walking in his wood on Sundays. I had permission because my father was on his side, but I never went because I hated him. He was called the Count de Laric. Are you listening?'

Sébastien murmured:

'Yes, I'm listening.'

Bolorec pulled himself half up on his elbows and rested his head on his two clasped hands.

'Three weeks ago we were on a march. Little Leguen, the son of a worker from the village was tired and sick and couldn't go on. So the Captain said, "March!" and Leguen said, "I'm ill." So the captain insulted him, calling him a filthy slob and punched him hard in the back. Leguen fell. I was there. I didn't say anything but I made myself a promise. I promised myself this . . .'

A shell exploded near them, covering them in earth. Bolorec carried on:

'This thing I promised myself . . . are you listening?'

Sébastien groaned:

'Yes, yes, I'm listening.'

'This thing,' and he moved even closer to Sébastien and whispered in his ear:

'Well it's done: yesterday, I killed the captain.'

'You killed him?'

'In battle yesterday, he was in front of me. I shot him in the back. He fell straight forward and never moved.'

'You killed him,' repeated Sébastien mechanically.

'Point blank. It was only right.'

Bolorec fell silent and stared at the plain.

The musketry kept returning fire and the thunder from the cannon was intensifying. There was a constant, dull, rumbling noise, punctuated by missiles that seemed to tear the sky like fabric and accompanied by terrifying tremors that seemed to

delve into the very depths of the earth. All around, shells ploughed into the earth, the shrill, sinister laughter of their explosions was like deafening bursts of gunfire. The battery now responded only feebly at irregular and ever longer intervals. Already three gun carriages had fallen apart, and stood broken and silent. The smoke was getting thicker and thicker, hiding the horizon and the sky and drowning the fields in a reddish-brown fog that was growing ever denser. Bolorec could see spectral forms walking through the fog, greatcoats flapping, panic-stricken backs, desperate flight, an army in retreat. There was a constant stream of people passing, one by one to begin with, then in groups, then whole columns in disarray, shouting. They were broken, crazed figures, bizarre silhouettes, a confused, drifting, black, jostling mass; horses without riders, their stirrups flying, necks outstretched, manes streaming, surged into the chaos of men, at a furious, nightmarish gallop. Soldiers stepped over the disordered lines of conscripts, who were lying on the ground, without bags, without guns, without caps.

Sébastien lay motionless, his face on the ground. He could no longer see, hear or think. At first, he had tried to control himself, to be brave like Bolorec. He summoned up memories that might distract him from the horrible present. But the memories fled or became instantly transformed into terrifying images. He tried in vain to cling to the remnants of his courage, to gather what was left of his scattered energies, his mental strength, but fear overtook him, crushed him, fastened him to the earth. Occasionally, motionless, in a trembling voice, he called out for Bolorec, assured himself that his friend was still there, alive, still next to him. This need to feel protected – the only feeling he had left, his willpower completely destroyed – soon disappeared too. He felt as if he were in an abyss, in a tomb, dead, and could hear above him indistinct, muted sounds, the sounds of a distant, lost life, carrying on without him. He didn't even notice when right next to him a running man suddenly collapsed and fell, his arms outstretched, while a rivulet of blood flowed from beneath his body, growing and spreading.

The battery fire slowed and died away. Eventually there was complete silence, a silence made all the more sinister as the enemy fire redoubled. The signal for retreat was sounded.

'Get up,' said Bolorec.

Sébastien did not move.

'Get up, I said.'

Sébastien did not move.

Bolorec shook him roughly.

'Get up, damn you.'

Then Sébastien, eyes staring, barely recognising Bolorec, who was supporting him under the arms as if he were wounded, got slowly and mechanically to his feet, like a sleepwalker.

Just then, there was a spurt of smoke, a sudden wild flare of light, and an explosion blinded Bolorec and showered him with burning powder and gravel. He managed to remain standing, stunned, breathless, as if battling against a fierce wind. Then he realised that Sébastien had suddenly slipped from his grasp and fallen. He looked down. Sébastien lay motionless, his skull smashed. His brain was trickling out of his skull through a hideous red hole. The conscripts had fled. Bolorec was alone. Shadows of men ran and disappeared out of sight in the smoke. He leaned over Sébastien's body and touched it, then he knelt, deathly pale, in the blood, which gave off a brief purplish steam.

'Sébastien!'

But Sébastien could not hear. He was dead.

Bolorec put his arms around the corpse and attempted to lift it. He was weak and the corpse was heavy. Endless silhouettes streamed past.

'Help me!' shouted Bolorec.

No one stopped.

Figures went by and vanished like hallucinations in a fever.

'Help me!'

He flung down his rifle and his rucksack, and making a tremendous effort, managed to lift Sébastien and carry him in his arms. He staggered along with him, his face running with sweat, his chest heaving, his back bent beneath the dead

weight, stumbling as he walked. Thus he reached the battery and placed Sébastien across the broken mount of a cannon. The battery had been abandoned. A debris of wheels, crumpled gun carriages, twisted metal and corpses of men and horses was strewn over the churned-up, bloody earth. Nearby, the captain lay next to his white horse, disembowelled.

'It's not right,' murmured Bolorec in a halting voice.

He leaned over the corpse and said again as if Sébastien could hear:

'It's not right, but things will change, you'll see.'

Then, when he had recovered his breath, he lifted his friend's body onto his back again and very slowly, very painfully, both men, the living and the dead, made their way through the bullets and the shells into the smoke.

Menton, November 1888
Les Damps, November 1889